CAUGHT
IN THE
WEB

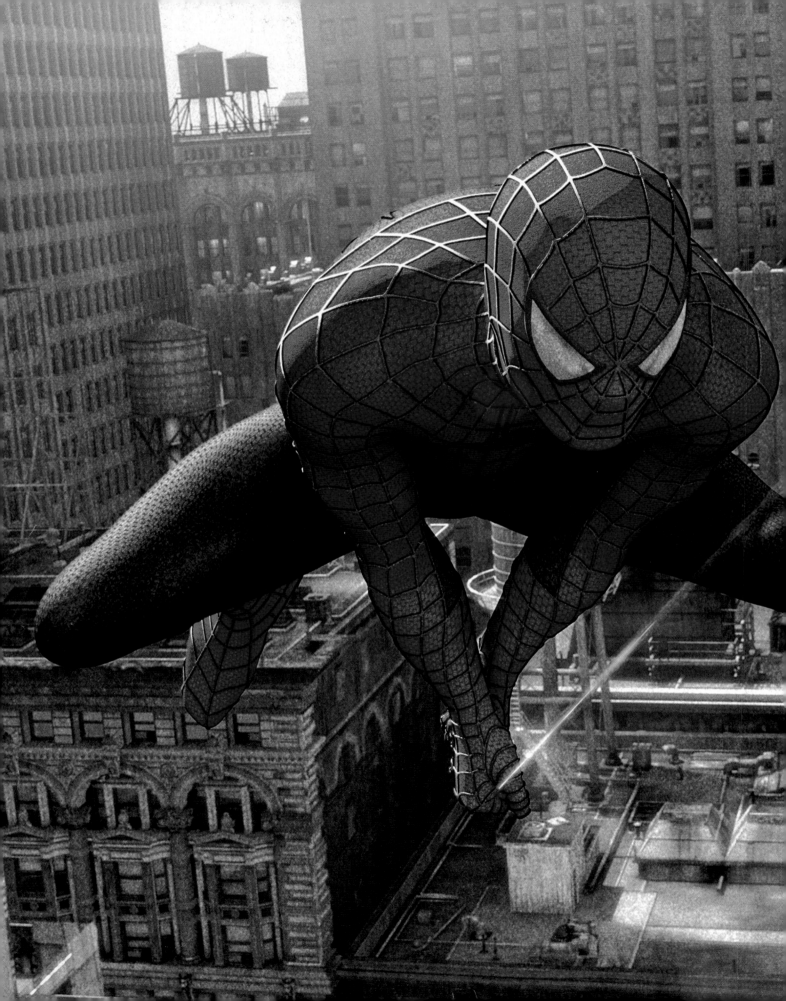

CAUGHT IN THE WEB

DREAMING UP THE WORLD OF *SPIDER-MAN 2*

Mark Cotta Vaz

DEL REY

BALLANTINE BOOKS • NEW YORK

To Sam Raimi, Neil Spisak, and all the talented artists behind *Spider-Man 2* . . . And to Ralph McQuarrie, one of the great artists behind the magic of movies.

A Del Rey® Book
Published by The Random House Publishing Group

www.sony.com/Spider-Man

Super Hero is a co-owned registered trademark.

Del Rey is a registered trademark and the Del Rey colophon is a trademark of Random House, Inc.

www.delreydigital.com

Library of Congress Control Number: 2003116006

ISBN 0-345-47050-8

Interior design by Michaelis/Carpelis Design Assoc. Inc.

Manufactured in the United States of America

First Edition: May 2004

10 9 8 7 6 5 4 3 2 1

CONTENTS

"Being Spider-Man has brought me nothing but unhappiness! In order to satisfy my craving for excitement I've jeopardized everything that really matters . . . Aunt May . . . my friends . . . the girls in my life . . . and for what?? Can I be sure my only motive was the conquest of crime? Or was it the heady thrill of battle, the precious taste of triumph . . . the paranoiac thirst for power which can never be quenched??"

—*PETER PARKER* IN THE AMAZING SPIDER-MAN #50, JULY 1967

My appreciation to the *Spider-Man 2* production in general but especially to Neil Spisak and his art department for being gracious hosts and making me feel welcome during my Sony visits. Special thanks to Jan O'Connell for all her help, particularly for her time in pulling a stellar selection of art from which I selected the images for this book. Thanks also to Theresa Greene for helping with logistics. Thanks to Becky Chaires for facilitating connections with Sam Raimi and to Rachel Schwartz for doing the same with Avi Arad. (By the way, those interested in the battle for Marvel that Arad alludes to in the opening of this book should check out Dan Raviv's *Comic Wars*—Wall Street intrigue at its finest.) Thanks also to Ozzy Inguanzo for storyboards and artwork.

My appreciation to Sam Raimi, Grant Curtis, and all the production principals who gave of their time. I'm most grateful to the artists and art directors who contributed their art and insights—this book is yours.

On the Sony side, Cindy Irwin was the greatest, as usual. Kudos to the Sony stills department, especially Andrew Pack, who assisted me in my visit to the stills department, and to Jerry Schmitz, who connected me with the genius guys at Sony Pictures Imageworks. And here's a thanks and a shout-out to Grace Ressler, Christiane Friess, and Ric Wolfe.

And exalted among the True Believers is Steve Saffel, editorial wizard behind the curtain of this publishing enterprise, who sends me on these cool missions— Excelsior! And more of the same to the guardians of the mythology at Marvel. And the look of this book is simply super, thanks to Sylvain Michaelis of Michaelis/ Carpelis Design Associates. Sylvain is one of the best designers in the business and his handiwork is beautifully evident herein. And before I exit stage left, here's a bouquet to Victoria Shoemaker, my literary agent and another True Believer at heart, a salute to Joe Spieler, a high five to Bob Wyatt, and a raised glass to Mike Wigner (may your bicycle tires always be fat and the road home straight and paved). Love to my parents and brothers and sisters. And to Spider-Man—keep swinging, pal.

Following art by James Carson.

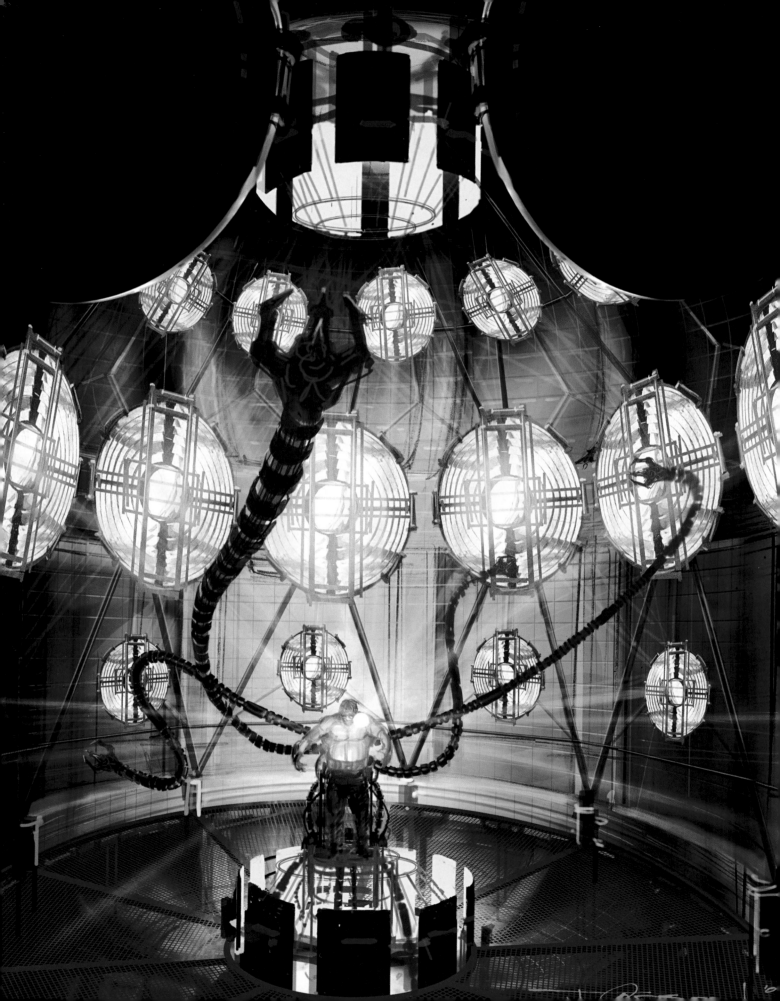

CAUGHT
IN THE
WEB

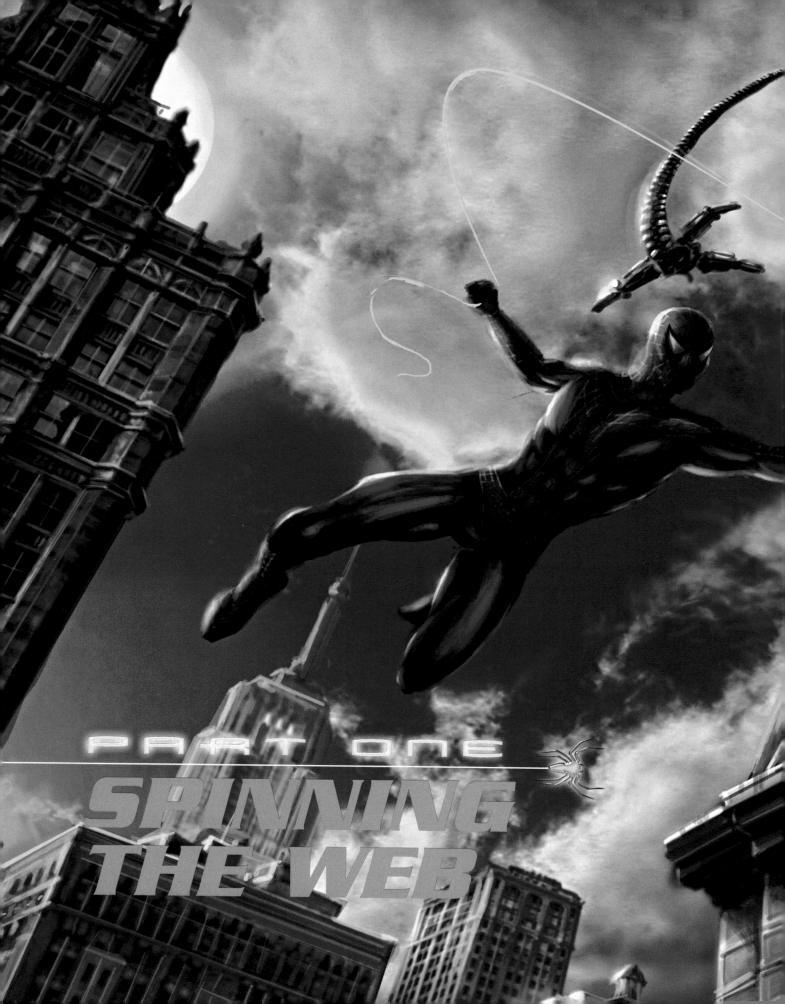

PART ONE

SPINNING THE WEB

The Los Angeles headquarters of the Marvel Entertainment Group doesn't fit the traditional image of the Tinseltown power center of legend. There's no gurgling water fountain or cathedral-domed lobby, no rich carpets or chic antiques on display, no endless corridors leading to secret sanctums.

Indeed, the Marvel offices are located on the second floor of an unassuming building, down a narrow corridor lined with plain office doors. But behind one of those doors there lies a nexus point of the Marvel universe, a place of imagination where Super Heroes are transported off the comics pages and into other media. Here there's a sensory assault of color and iconic imagery: toy action figures posed on shelves and desks; walls decorated with posters of the vampire slayer Blade, the Incredible Hulk, the Uncanny X-Men, and other Marvel heroes who have, in their own unique way, become movie stars.

In this office one balmy day in September 2003, there was a scent of the approaching autumn in the air—and a palpable sense of anticipation. Principal photography for *Spider-Man 2* was a month from wrapping and Avi Arad—the former toy designer and Toy Biz partner, now one of the architects of the Marvel universe and a producer for the *Spider-Man* sequel—was sitting behind his desk, musing that making a movie was much like designing a toy.

Arad held up a six-inch Spider-Man action figure, an ingenious wind-up toy with a little projector built into the chest. There was no reel of film in this projector, but the toy was a curious little piece of history. The action figure was stamped MARVEL and TOY BIZ and was copyrighted in 1994, the year once-mighty Marvel's stock had started dropping and the company began a precipitous slide into bankruptcy.

The subsequent Wall Street power struggle might have led to Marvel's own mythic Ragnarok, Twilight of the Gods for its pantheon of Super Heroes. It all boiled down to

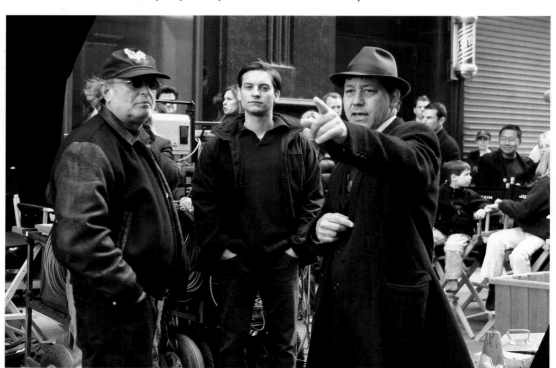

Previous spread art by Wil Rees.

Director Sam Raimi makes a point to producer Avi Arad and star Tobey Maguire. Photo by Melissa Moseley.

dueling visions, one put forth by billionaire corporate raider Carl Icahn, who'd become Marvel's chairman in 1997, the other by Arad and Toy Biz. It was Arad's dream that the Marvel heroes be given the opportunity to realize their true potential as major movie and merchandising properties. Thus, a key battle for control of the Marvel empire was held in a roomful of investment bankers, where Arad declared that Marvel had a vibrant future, and that Spider-Man alone was worth a *billion* dollars.

"It was my vision versus Carl Icahn's cash and in this world, man, it's tough to replace cash." Arad smiled. "Those bankers were looking at me as if I'd lost my marbles. 'What do you mean, a billion dollars—*for just one character?*' But I wanted them to believe . . . to take a little time and consider that this literature is amazing, the metaphors for our Super Heroes are amazing.

"Thank God, they didn't throw me out. This was a pretty cold audience—of investment bankers and MBAs—but there were also people there who actually *read* comics. And enough of them trusted me.

"That was the turning point, the day that I got 'em."

Before it was over, though, there would be legal challenges that would have sent Sergeant Fury and his Howling Commandoes ducking for cover—including a tangled web of movie rights for Spider-Man himself. But Arad would be vindicated, his prophecy fulfilled: In 2002, under the banner of Sony Pictures Entertainment's Columbia Pictures division, *Spider-Man* had the biggest opening day and the most successful opening weekend in Hollywood history, en route to more than $820 million worldwide box office. Subsequent DVD and VHS editions of the movie sold 11 million copies the first three days in stores, accounting for $190 million. That, combined with the box office total, neatly achieved the cool billion Arad had envisioned.

Spider-Man had struck box office gold, and the film struck a nerve in audiences with its tale of Peter Parker, the awkward high school senior suddenly gifted—or

cursed—with the overwhelming responsibility of superpowers. And so, almost immediately, *Spider-Man 2* appeared on the horizon.

Most of the key production principals who had worked their magic on the first film would return for the 2004 sequel. The creative team was led by Sam Raimi, the director whose work ranged from such cult classics as 1982's *The Evil Dead* to the critically acclaimed 1998 thriller *A Simple Plan*. Raimi's original *Spider-Man* assignment was the stuff of Hollywood legend—he was an

Columbia Pictures Theatrical Teaser Poster.

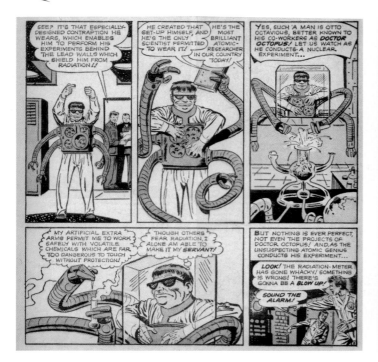

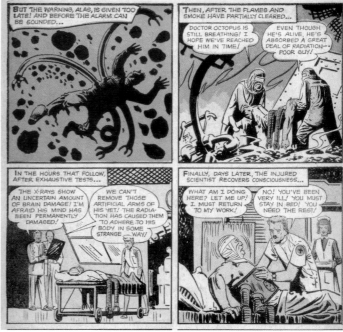

Above: His fellow scientists look in awe at the amazing genius of the nuclear scientist known as "Doc Ock"—until the accident that weds him to his artificial arms in the origin story. *The Amazing Spider-Man*, #3, July 1963, "Spider-Man versus Doctor Octopus," select panels. Artist: Steve Ditko.

Right: Doc Ock is eventually separated from his mechanical arms. Pity that the police don't realize the evil scientist has mental control over the arms—as Spider-Man later discovers for himself. This notion of a mental connection between Doc Ock and his living tentacles would be enlarged upon for *Spider-Man 2*. *The Amazing Spider-Man*, Annual #1, 1964, "The Sinister Six," select panels. Artist: Steve Ditko.

unabashed fan of the *Spider-Man* comics who, in a high-level meeting with Avi Arad, Sony Pictures Entertainment chairman John Calley, and Columbia Pictures chairman Amy Pascal, won the plum directorial job by admitting that as a kid he had pinned a picture of Spider-Man over his bed, and he related to Peter Parker.

Other returning *Spider-Man* veterans included producers Arad and Laura Ziskin, production designer Neil Spisak heading up the art department, costume designer James Acheson, and visual-effects designer John Dykstra helming Sony Pictures Imageworks' 3-D computer graphics (CG) work. In front of the camera, stars Tobey Maguire and Kirsten Dunst reunited as star-crossed lovers Peter Parker and Mary Jane Watson, James Franco was back as troubled Harry Osborn, as were Rosemary Harris as beloved Aunt May Parker, and J. K. Simmons as irascible *Daily Bugle* publisher J. Jonah Jameson.

Alfred Molina, a new addition to the cast, would star as Dr. Otto Octavius, best known to generations of Spider-Man fans as Doctor Octopus. The character's cavalier nickname, "Doc Ock," belied his stature as one of Spider-Man's deadliest foes, an ego-

centric scientist who, in the comics, suffered an accident during a nuclear experiment that caused four mechanical arms to adhere to his body, which came alive under the control of his damaged mind.

The entire *Spider-Man 2* production would find itself under the gun to duplicate the success of the first film, but Arad himself just shrugged off the pressure. Orson Welles once likened moviemaking to "the biggest electric train a boy ever had," but to Arad it was more like the ultimate toy box, especially when it came to creating the

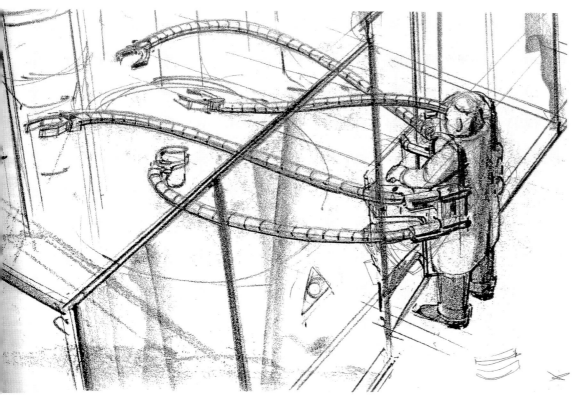

The conceptual art for Doc Ock actually began to be created during the first *Spider-Man,* when the classic villain was first considered as a potential foe. Some seminal images from the first film.

Left: Art by James Carson.

Below: Art by Jim Martin.

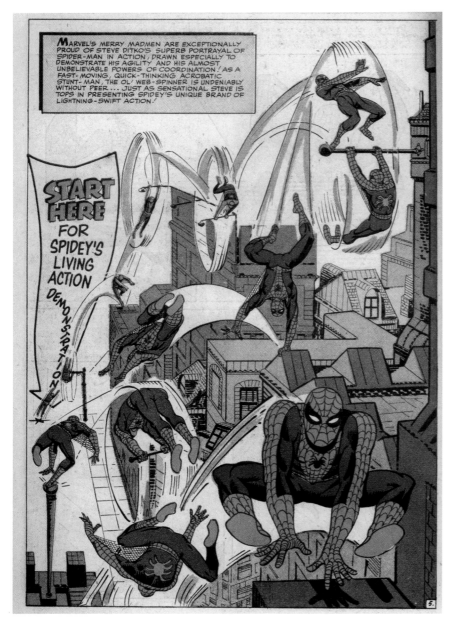

This classic comics montage by seminal *Spider-Man* artist Steve Ditko sums up the dynamic athleticism of the character, which the production had to translate into both live-action and CG Spider-Man performances. *The Amazing Spider-Man* Annual #1, 1964, "The Secrets of Spider-Man" feature. Artist: Steve Ditko.

visual aspect of the film. "That's the joy of being involved in these kinds of movies, because when you look at the [*Spider-Man 2*] art department people like Neil and his staff, basically it's toy design. There's the same visual commitment."

Arad moved from behind his desk and gestured to a sculpted prototype action figure of the X-Men's Wolverine that was based on actor Hugh Jackman, who played the Super Hero in the first two *X-Men* movies. "For this prototype you scan the actor and make the maquette, you build the charac-

ter," Arad explained. "What gets translated in the movie process is similar. The CGI [computer generated imagery] of a character begins with doing the scanning [of the live performer], the 3-D modeling, and so forth."

The essence of that "visual commitment" Arad mentioned weaves in and out of every aspect of the filmmaking process. It's fair to say that the spearhead for an entire production is its art department. That's where the director's vision and the words from the script first take form in concept sketches, paintings, 3-D renderings, architectural blueprints, models, and literally thousands of other pieces of artwork. Production design, conceptual art, and storyboarding are all inextricably connected to every aspect of a production, from visual effects and costumes to set construction and cinematography. In *Spider-Man 2,* they were all caught in a web of dreams and designs.

Doc Ock would prove to be one of the major design challenges for the *Spider-Man 2* team. The character made his debut way back in 1963, in the pages of *The Amazing Spider-Man* #3, only a year after the world's first commercial satellite had been launched and six years before the first moon landing.

Fast-forward forty years to today's modern audiences, steeped in a high-tech culture that was the stuff of science fiction back in '63, and it became clear that Doc Ock, like Spider-Man before him, would have to evolve. A complex new creature would have to be created. His very reason for being, as a scientist, would have to transform, and a fusion energy device replaced the atomic research of the Cold War era. And those four famous mechanical tentacles would be revamped, to accommodate neural connections and artificial intelligence. Challenges such as these would test the moviemakers every step of the way.

"You miniaturize life—that's how you make a toy. But in a movie you want to take it further," Arad elaborated. "Our movies need a lot of conceptual art and present unique design opportunities. This movie is

Producer Avi Arad. Photo by Melissa Moseley.

being released in 2004, it's a big movie with a big director, and you want to push the envelope. If you look at Doc Ock in the books it's the spirit of what happened to him, but in the movie it's the detailing—what does it *mean* to be fused? What does it do to you? Robots today have artificial intelligence, there are conversations about nanotechnology, you have prosthetics for arm replacements that can pick up a peanut. Doc Ock is unique in that he's almost real in a way."

The famous Spider-Man outfit—one of the major design challenges of the first film—would receive a bit of a makeover for the new production as well. "There's a different spider on him, we added more detailing on the hands and neck, we made the costume's colors brighter," Arad said. "The look is so in-your-face and full of confidence—but the man inside is full of doubts.

"Spider-Man operates in the real world and we keep him in the real world. He's not a night stalker, one of those mysterious night creatures. So, for this movie we put him even more into the daylight, and to do that took tremendous planning and judgment and artistry just in designing the set pieces."

But while the details were important, Arad also wanted to retain the spirit of the source material, to see the energy and visual dynamics of classic comics panels translated to film frames. "We have the 2-D drawings and words from the comics, years of how Spidey moves, so we don't need to reinvent that. You just want to enhance it, bring it to life.

"All of our Marvel movies have this challenge of taking the mechanical 2-D description and bringing it to 3-D. *Spider-Man 2* was an interesting opportunity for everybody involved, to take the incredible artistry of the comics and in 3-D lift it, make it bigger than anybody can imagine."

THE ART DEPARTMENT

The Sony Pictures complex in Culver City, California, covers a wide swath of movie history. There's Sony's Culver Studios on Washington Boulevard, the venerable lot that once was the home for picture pioneers from Thomas Ince and Cecil B. DeMille to David O. Selznick, and where immortal movies like *King Kong* and *Gone With the Wind* were filmed.

If Culver Studios represents the past, directly across a side street, on Ince Boulevard, sits the future, the building complex of Sony Pictures Imageworks, where glowing computer workstations conjured the virtual New York and CG super characters for both *Spider-Man* and *Spider-Man 2*.

Farther west down Washington Boulevard lies the main Sony Pictures studio lot, home to the Columbia Pictures division and what's left of the fabled grounds of MGM. Some of the glory from the Golden Age of the studio system remains, notably the Thalberg Building, built in 1937 and a vision of another time with its art deco elegance

and manicured grounds with flowering trees shading the pedestrian pathway that leads into the studio's fiefdom.

Past the Thalberg Building, and through twin portals decorated with poster art of the Columbia classics *Lost Horizon* and *Lawrence of Arabia,* the path becomes Main Street, with buildings done up like fanciful slices of a mythic America, as if Bedford Falls from director Frank Capra's *It's a Wonderful Life* had magically materialized. Indeed, a miniature village square features a columned structure etched with the name CAPRA BUILDING.

Straight ahead, in the center of the lot, loom the soundstages in which fantastic sets have been constructed for productions from MGM's *The Wizard of Oz* to the first *Spider-Man,* only to be broken down and swept away. In the midst of those soundstages there stands an unassuming two-story wooden building that looks every inch the World War I army barrack it once was. The story is that MGM mogul Louis B. Mayer

bought this structure and had it trucked over and set down on the lot back in the Golden Age. They call it the Heidelberg Building, and it was here that in the summer of 2002 the *Spider-Man 2* art department and production designer Neil Spisak took up residence—the "hub," as it was dubbed, where the movie's vision was to be spun.

A side door, unmarked except for a spider decal, opened onto a staircase leading to the top, a second-floor level of wooden walls and old vents and windows—and dazzling visions of art everywhere: illustrations of a beautiful clock tower and architectural drawings of the *Daily Bugle* building, full-color images of Peter Parker's apartment lit in moody "magic hour" light, black-and-white sketches of Spider-Man and Doc Ock facing off atop the roof of a speeding train....

This top floor, some one hundred feet long by fifty feet wide and divided into two large rooms, had been previously used as storage and first had to be made ready for the *Spider-Man 2* art team, a task that fell to art department coordinator Jan O'Connell and assistant Mark Taylor. They made the barrack clean and tidy, full of open space and bare walls, like a blank page.

"I always call it a little company," said O'Connell, explaining the genesis of a movie production. "You start off with nothing, just four walls and a budget, and you bring it up, ordering office furniture and drafting tables and paper and supplies and everything."

In the early days, the art department achieved a seminal take on the physical look for Doc Ock when apprentice editor Aaron Scully stood in a corner of the Heidelberg Building, outfitted with Doc Ock's trademark dark glasses, with plastic tubing representing tentacles hung from the ceiling on nearly invisible fishing lines. "One of the first things we did in this building was Jan and [art director] Steve Saklad and I had Aaron Scully fixed up like Doc Ock, right here in this office—I went out myself to an irrigation supply place to get the flexible tubes we used for the arms," recalled Tom

Left: *Spider-Man 2* production designer Neil Spisak. Photo by Melissa Moseley.

Bottom: Apprentice editor Aaron Scully strikes a pose in the *Spider-Man 2* art department in the production's first physical manifestation of Doc Ock. (Art department coordinator Jan O'Connell is busy at work at far left.) Scully, in full Doc Ock regalia, was also taken out into the sunshine of the Sony lot.

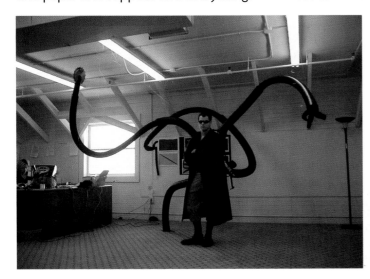

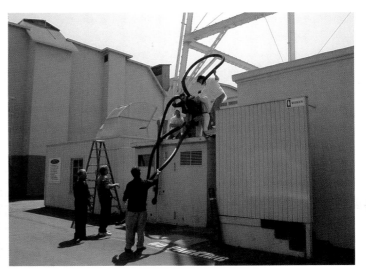

Top: Visual-effects designer John Dykstra. Photo by Melissa Moseley.

Bottom left: Many a time in the comics Spider-Man has swung into the *Bugle* to confront J. Jonah Jameson—to the cathartic delight of his fans. *The Amazing Spider-Man* #13, June 1964, "The Miracle of Mysterio," select panels. Artist: Steve Ditko.

Bottom right: Spider-Man serves up a few web-balls against Dr. Doom in this classic comics sequence. The visual-effects artists at Sony Pictures Imageworks were intent on producing some of Spider-Man's patented web gimmicks for the new movie. "Spider-Man does more sophisticated things with his web than in the first movie," visual-effects supervisor Scott Stokdyk said. "He'll be able to grab heavier objects and he'll also shoot web balls for the first time in this movie." *The Amazing Spider-Man* #5, October 1963, "Marked for Destruction by Dr. Doom!" select panels. Artist: Steve Ditko.

Wilkins, one of the production's five art directors working under Spisak.

Soon a long conference table, a couch, and bookcases were brought in, and in this corner as many as thirty people would gather for meetings led by Sam Raimi, producers Arad and Ziskin, Neil Spisak, James Acheson, and John Dykstra.

The art department kept growing as the production ramped up. There was an energy-fix pit stop area, featuring shelves stocked with snacks and coffee, coolers full of bottled waters and soft drinks. Additional worktables, desks, and fifteen drafting tables were moved in. The top floor became so crowded that the department's set designers had to be quartered on the studio lot in the nearby Barrymore Building. And as the painted illustrations and architectural plans began filling the walls, scale models crowded shelves and table space.

Thus, the conjuring began. Dreams and designs started to take shape.

In a creative process as organic as conceptualizing a movie, ideas can be explored in illustrations and models, architectural plans can be drawn up—and the concept still might not make it to the shooting stage. Such was a *Daily Bugle* sequence supervised by art director Tom Wilkins.

"Alex [Tavoularis] did the drawings of the statues, then we had a sculptor do a maquette of it and Rob Woodruff built it into a 3-D model of the *Bugle* building," Tom Wilkins explained. "Meanwhile, storyboard guys were working on boards we could re-create in 3-D with specific camera positions

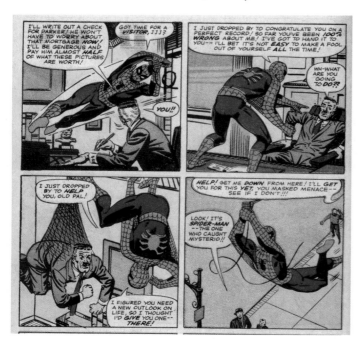

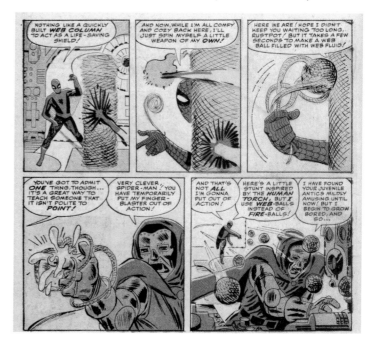

and lenses. We went into this detail because it related to how much scenery might have had to be built. So our 3-D concepts were actually previsualizing what they would have had to shoot in New York for the background plate photography.

"This kind of CG concept work is new inside of the art department. I'd say for high-end movies it's come on within the last five years," Wilkins added. "How much of it we used depended on how much the director and director of photography (DP) needed to figure out in advance. But it can save a lot of time and money because the filmmakers don't have to figure out issues such as how far out the window the camera needed to be."

Bill Pope, director of photography. Photo by Melissa Moseley.

"I definitely work with the illustrators in the art department, because they're lighting the sets [in their conceptual work]. We'll talk to them first about what the lighting should be. Sometimes they'll go off in a different direction and it'll look great. Or, perhaps, instead of showing a light source from a window they'll design it as coming from a lighting fixture from the top of a set, which would change the way the whole space is sculpted, so they'll be asked to redo the illustration with that in mind. The storyboards are the only thing that really shows where the camera should go and the illustrations come from the storyboards and how Sam covers a scene, what he'd likely want to see.
I like to work hand in hand with the production designer—neither department can move ahead without the other. That's how it always should be. I certainly can't photograph nothing, but if a set's built and it's not photographed correctly, you're wasting your time. The color and light I can put on a set can alter it immensely and vice versa. Do you light with paint or paint with light? You have to work side by side, it's a symbiotic relationship."

—*BILL POPE, DIRECTOR OF PHOTOGRAPHY*

Not far from the Heidelberg Building, across the narrow avenues of the soundstage area, lay the mill and craft department, a building the size of an airport hangar and the center for set construction work. "This is where all the nuts and bolts happens," Neil Spisak commented.

Though plain on the outside, inside it looked like Santa's proverbial workshop, an airy place where set pieces and props were molded and crafted, where painters mixed their colors and worked their magic. A saw was buzzing and grinding over a rock-and-roll riff playing from a hidden stereo, as Spisak pointed out the torso of a winged angel statue made of sculpted foam and concrete. This chunk of movie magic had adorned the so-called battle building and had saved Aunt May from a fatal fall in the film. The angel now sat near a row of pylons and other props for Doc Ock's pier lair, its close-up for the cameras long since completed. Spisak stopped in front of a cast-iron beam for the pier set, which was actually made of wood, and pointed to the fake rivets and bolts that had been molded and cast and stapled on. "Millions and millions of pieces of things," Spisak said, smiling.

At a far side of the hangar was the paint area. This was head painter John Snow's domain. Moviemaking is one endless meeting, and Spisak often huddled with Snow and art director Tom Wilkins and painter David Clark, all gathering around a table to contemplate the endless detail work. For one such meeting Spisak held up one of the hundreds of precut Plexiglas panes that would have to be tinted with different degrees of opacity and then chipped and busted to fit into the window frames on the set. A color idea was swiftly mixed and applied by Spisak. He held the pane up to the light, discussing possible streaks of paint that would achieve just the right opacity.

The color palette that had been established across the entire film inevitably figured into these discussions. "I wanted a gray movie," Spisak said. Spread out on the table in the paint department was what Spisak called "the Bible," the photos and drawings and paint colors for each set.

"Grays are tricky," Snow mused. "There are violet grays, blue grays, and green grays. Camera tests showed our film stock tended to shift blue, so green grays were favorable. The pier set for Ock's hideout and secret laboratory was the biggest challenge to deliver a predominantly gray background and yet present a dilapidated and corroded warehouse on the East River. We had to avoid being too colorful with our rusting and oxidizing techniques but achieve a believable setting."

Neil Spisak elaborated upon the color palette, which he explained was the visual foundation of the entire film and the subtle aesthetic that drove the story line. The beginnings of this aesthetic could be found on a blackboard back in the Heidelberg Building, a color scheme that began to be developed in June of 2002. Plastered on the board were photos of turbines and industrial images chosen not for their Machine Age forms but for the varying tones of gray that would become the color palette of Spider-Man's New York. The photos had areas marked with circles that focused in on specific gradations and from which color swatches were made and mixed. Ultimately, these paint samples formed the vocabulary of color that was translated to all the sets. The final color scheme resulted in, for example, making Peter Parker's apartment a particular beige, while the palette brushed Dr. Otto Octavius's Manhattan lab with a warm gray.

Director of photography Bill Pope, whose work includes the *Matrix* trilogy, explained that the color tone for individual sets also necessitated his shooting actual test footage of four-foot-by-eight-foot plywood boards. "Whenever the art depart-

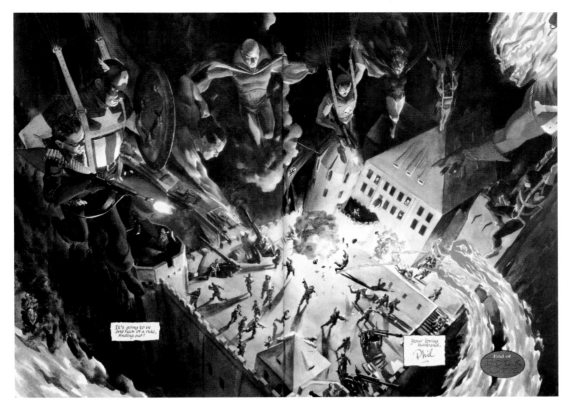

This dramatic Alex Ross painting from the *Marvels* limited series was marked by head painter John Snow as one of many inspirational references for the gray-tone palette Neil Spisak wanted applied throughout the movie's sets. *Marvels* Book One: "A Time of Marvels," January 1994.

ment came up with an idea for a set, they'd first come up with maybe fifteen different boards that might be painted or have a piece of tile or painted cloth or drapery."

Pope revealed that an early influence in establishing the look of a cool, gray New York came as a result of the first actual filming for the production. He and his camera crew had gone to Chicago in November of 2002 to shoot "background plates" for a major special-effects sequence—Spider-Man and Doc Ock fighting atop a speeding elevated train. The live-action footage would be handed over to John Dykstra's visual-effects team. They would then scan it into their computers to allow for the compositing of blue screen shots of the live actors and CG figures of Spider-Man and Ock—some one hundred visual-effects

shots for that sequence alone, according to visual-effects supervisor Scott Stokdyk.

"Shooting the plates for the fight on top of the train inspired us further in developing the color palette for the entire film," Pope noted. "It was cold and overcast that week in Chicago, and that's actually similar to Manhattan, which only lets in shafts of sunlight because of its tall buildings. So, we were starting to establish a palette for the film way back in November, when we shot those background plates."

"The color and tone of the light was very specific to this movie, and Bill did a beautiful job," Spisak concluded. "There was a language of light that was continuous through the whole movie, that kept everything tied together."

THE VIRTUAL REALM

The computer isn't the exclusive property of those famous wizards of visual effects who create synthetic skylines or animate computer-generated models. Nowadays, every aspect of conceptual art passes through what's called the virtual realm. Software programs such as Adobe After Effects allow 2-D drawings to be scanned, and foregrounds and backgrounds separated for animatics that rough out a 3-D motion, providing a down-and-dirty look at shot composition and camera movement. Then there's precise CG animated "pre-visualization," or "pre-viz," which can vary from rough polygonal shapes to high-resolution renderings, displaying all the detailed action and camera movement of a high-end video game, and which can even serve as the template for a final effects sequence.

Spider-Man 2 co-producer Grant Curtis, a veteran of numerous Sam Raimi movies, including the first *Spider-Man*, noted that the full range of conceptual art was vital to the realization of the movie. "It's a combination of Sam taking inspiration from Neil's artists, [while] other times he'll get location and set photos and go from there to set up shots [with his storyboard artists]. Sam will board a sequence and if it's action-based or has complicated CGI or mechanical effects, he'll take that to the animatics stage where they add animation and movement. If it needs to be *very* specific and account for camera angles, we'll have John Dykstra pre-viz that at Imageworks."

There were, of course, a few examples of traditional artistry in the *Spider-Man 2* art department, from illustrator Alex Tavoularis's artwork (which would be scanned into the computer for coloring and other effects) to lead set designer Andrea Dopaso's set plans, to physical models. "Neil and Sam both like working with physical models, being able to touch something and move it around in space, take the walls off and check camera

angles with a little viewfinder," lead model maker Tom Frohling noted. "I think, at least for this movie, that people really liked the visceral aspect and sense of texture of a physical model, that it *didn't* lock you down to a specific camera angle."

Still, Frohling admitted, the craft of physical model making was inevitably giving way to computer modeling. "Physical models once were *the* way to do it, but now it's become more about making models in the computer because filmmakers can see a set on a computer screen and have some sense of film ratio."

Digital set designers J. Andre Chaintreuil and Robert Woodruff were part of this new wave in the *Spider-Man 2* art department. "I'm a set designer who uses the computer to create 3-D designs to analyze sets, backings, props, vehicles, special effects, or to just get an idea of what the end product will look like through the lens of a camera," Chaintreuil explained. "We used computers for set design for *Spider-Man 2* to provide key frame looks at sets, and for virtual walk-throughs. One way this would help us was to see if a staircase was too high or low, or whether we needed to build a set wall higher."

One beauty of such digital work, Chaintreuil explained, was that his digital files would be compatible with the needs and tools of other departments, including the storyboard department and the computer graphics modelers and pre-viz folks at Imageworks. "The pre-viz department could borrow those CG files, which saved them a step and ensured they were working within the limits that the production designer and the art department wanted to establish."

Chaintreuil and Woodruff also worked in tandem with art department illustrators such as Wil Rees and James Carson. "It's now an interesting combination of art and the computer," observed Tom Wilkins. "The digital set designers working in 3-D modeling

programs could give illustrators an image done in the computer, the illustrators could do a pencil sketch over it, scan that in, and add color and other elements."

An important digital tool for illustrators is Adobe Photoshop, famed not only for its image-processing "cut and paste" compositing capability, but for 2-D painting tools as well. On the first *Spider-Man,* illustrator James Carson worked like Alex Tavoularis, creating pencil sketches, which he'd scan and develop in the computer. For *Spider-Man 2,* Carson used the computer for his entire creative process, beginning his initial sketches in Photoshop and continuing to develop the image in the virtual realm.

Wil Rees, another veteran of the first *Spider-Man* art department, had also done traditional illustrating on the first film, producing line drawings by hand and applying highlights with gouaches. But for the new production he, too, made the move to digital. "I liked what other illustrators had been doing in the computer with Photoshop and I found it a great tool," Rees noted. "But I did try to retain my own style and not rely on the look of certain tools in Photoshop. For example, Photoshop has tools that blend colors, but I'd instead paint gradations by hand [in the computer]. Basically, I treated Photoshop as a brush, and my computer's twenty-two-inch plasma screen as the canvas."

Paul Catling, a London-based artist working for costume designer James Acheson, whose work was integral to the look of Doc Ock, explained that he'd been using computers as an art tool for fifteen years, but most intensively since 1996. "I use a PC laptop running 3D Studio Max, Painter 7, and Photoshop," Catling explained. "The majority of my sketches are done directly in the computer using a Wacom [electronic] tablet and pen. The ability to infinitely change and experiment with artwork on the computer—mainly facilitated by the undo button—usually outweighs any notions I might have about missing the feel of real pencil on real paper."

The computer was also important for integrating sets with photographic backings and blue screens. "In the past we would test the look and size of a backing by placing a photographic print around a small study model of the set," art director Tom Valentine explained. "Now we can create an accurate model inside the computer and stand inside our virtual set long before it's actually built. We get a clear view through the windows to check out the backing composition and sightlines. Also, now the director can have more involvement in the design process, with an early glimpse of how the set is going to look."

"The computer is being used everywhere nowadays," visual-effects designer John Dykstra agreed. "Storyboard artists are working in the computer and doing animatics instead of traditional drawn boards, conceptual artists who did conventional illustrating rely on the computer as a medium. But the computer is a tool, it's like a hammer—it doesn't by itself know how to build a house until somebody puts their hand to it. Concept illustrations, for the most part, are a visual shorthand that provide key frames that set the tone for the visual while storyboards interpret the script and bring it into some kind of temporal landscape, which animatics refines and pre-viz refines even further—but you can make an about-face at any of those steps and go back to square one. Or the director will respond to some new bit of visual information or the story changes to accommodate some new piece of an actor's performance or a new camera move idea. It's a volatile creative process.

"But I think the whole CGI business *does* bridge the gap between drawing motion and animation. Things like pre-visualization allow more sophisticated screen direction and editing. On this movie it was an interesting process for Doc Ock in particular, because even in animatics they could create rudimentary CG tentacles. So, Doc Ock started out in the written form of the script, went into conceptual illustrations, and then came to life."

THE RETURN OF SPIDER-MAN

When the first *Spider-Man* film was released worldwide, director Sam Raimi embarked on a global jaunt to promote the film, with stops that included Japan, Great Britain, and Australia. When he returned home to California, there was no time off—Raimi immediately jumped into *Spider-Man 2*. "He came back and got into prep because the studio wanted it for summer of 2004," producer Laura Ziskin recalled. "The only way possible to meet that date was [for us] to start conceiving some of the big set pieces before we had the whole story worked out. Things were evolving and being created from the storytelling side, and all the departments had to catch up."

"We had tremendous time constraints, we had to begin designing sequences before we really had a story or script," Raimi agreed. "I

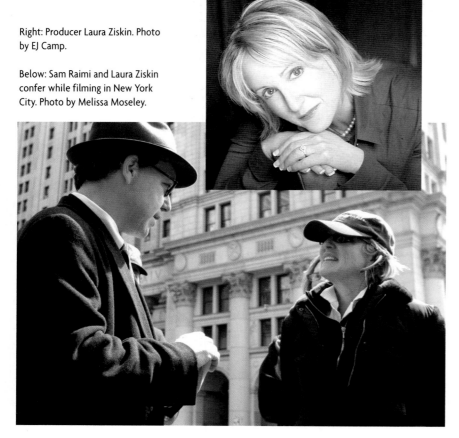

Right: Producer Laura Ziskin. Photo by EJ Camp.

Below: Sam Raimi and Laura Ziskin confer while filming in New York City. Photo by Melissa Moseley.

began working with artists developing ideas for scenes I wanted without having a context to put them in. I had the theme of the piece, but not the actual narrative itself."

"When I started on *Spider-Man 2,* the script hadn't been finalized," Neil Spisak added. "Script ideas were being added, subtracted, and juggled, and visual ideas were being added, subtracted, and juggled. So, at the same time Sam was talking to the writers he was giving ideas to the art department. At that point, it was a trial and error of looking at a sequence visually before Sam wrote it into the movie."

"We did run into a lot of dead ends, but we actually had some things going for us," producer Ziskin explained, adding that although it seemed as if the production were flying "on a wing and a prayer," there were assumptions, guiding principles, and built-in advantages for the new production and the story they wanted to tell.

The design of imagined set pieces was a starting point, with Raimi envisioning Doc Ock's pier laboratory, the speeding train upon which Spider-Man and Doc Ock would battle, and other dramatic locations. Of course, the key was the early assumption that Dr. Ock would be the villain, and the earliest conceptual meetings took place in the hub of the art department, focusing on the character's four mechanical arms, the look of his environment, and the nature of the experiment that would meld man and machine.

"The *big* advantage was we had a production team in place, a lot of the same people who'd made the first film together, so we knew things about the character and how to work together," Ziskin said. "If we hadn't had this team in place, this [accelerated production] wouldn't have been possible.

"Actually, our situation wasn't unlike that of Spider-Man himself—the success of the first film was both a gift and a curse," she observed. "The bad news was, the studio was hungry for the second film. The good

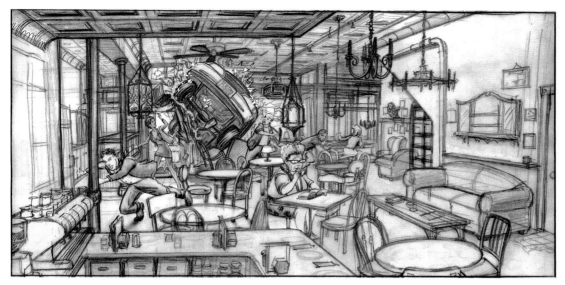

Left: Conceptual drawing of deli scene by Jamie Rama.

Below: Storyboard artist David Lowery works out the car-crashing-through-the-deli scene.

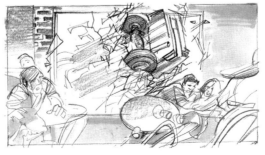

news was, they trusted us, they had confidence because of what we did on the first movie, so it was an easier process, in a way. We also benefited because the first film was an origin story and there were a lot of questions left for characters the audience cared about. To adapt a comic-book character for the movies, you push the values of the characters and, fortunately, the characters in *Spider-Man* are so interesting. There's subtext to everything, which makes it fun, you can keep digging and find more to explore."

Director of photography Bill Pope was a new member of the *Spider-Man* team, but he was seasoned in working with Raimi, having shot his first and third films for the director (*Darkman* and *Army of Darkness*, respectively). Pope noted that although Raimi had graduated from smaller-scale films to blockbusters—the first *Spider-Man* reportedly cost upward of $100 million— the director hadn't changed in his grasp of the overall demands of a production.

"The big difference is in the early days Sam tended to have his hand in everything and now he trusts people more, which he's had to do as things have gotten so much bigger," Pope noted. "I think he also knows that if you let people go, they'll bring you their best and then you're free to take it or leave it or alter it. In the old days he was more concerned with having kinetic fun—he *still* has kinetic fun. But now he's far more

interested in actors, emotions, and story."

In Pope's view, there was an organic quality inherent to Raimi's filmmaking that was perfectly suited to flying on that wing and a prayer. Regardless, making a movie was by its very nature an organic process, a collab-

orative effort in which an entire world in all its textures is conjured and, as a production is born, opens up with unlimited possibilities to the filmmakers as they begin to feel at home in that world.

"There's nothing linear about a movie production," Pope emphasized. "Sam's process itself is so organic and drawn out that it's impossible to get too much of a run-up on things. You start with a thousand different things and you sift through everything, things percolate—*everything* inspired us."

Key to the realization of Raimi's vision were the conceptual designs of Neil Spisak's art department. And when it came down to channeling that inspiration into what would go before the camera, Raimi leaned on the storyboard and animatics department. "It's always storyboard intensive on a Sam Raimi film," Grant Curtis explained. "Storyboards are the lifeblood for his films, and are disseminated for the crew."

"Sam storyboards a sequence and re-storyboards a sequence and gets people's input—and re-storyboards after that," Pope said. "It's a long process of refinement and even expansion. No matter how much lead time you might have you'll *always* be given a brand-new set of boards the day before you shoot, if not on the day itself. Sam might wake up in the middle of the night with an idea that'll change an entire scene, so he's constantly refining. Now, he's a practical filmmaker, so he's not going to shoot himself in the foot. But you can't plan everything to the smallest detail and walk away from it—*every* scene is alive. So, I don't know that if this show had a longer lead time whether we'd have done anything differently. More lead time might have been easier on Neil, because he had to build a lot of sets at the last minute."

And then Pope pointed to the saving grace of the whole truncated production calendar: "A lot of things were known from the first *Spider-Man* movie."

One of the known factors was the underlying theme, noted by Sam Raimi, which was at the heart of the character himself, the enduring and guiding principle summed up in the words that appeared at the end of the character's first comic book appearance and in the lesson imparted by Peter Parker's beloved Uncle Ben in the first movie: "With great power there must come great responsibility."

For the filmmakers, the burden of great responsibility began and ended with Raimi himself. For example, in September of 2003, he was contemplating the big finale he'd have to shoot on the pier set, one of those main set pieces he'd dreamed up at the beginning and which was now finally taking form. Raimi was asked if he was thrilled at this awesome example of movie magic as it was materializing on Stage 30 on the Sony lot.

There was a long . . . pause.

"It's frightening!" he said finally. "You think, oh my God, they took me seriously. They really built it!" Raimi smiled. "Now I've got to make a great scene here, a great finale for this picture. I think about how much did we spend, and will it be good enough, and can I make the scene great? I very seldom stand back and marvel at the wonder of it all. I'm too busy running scared. Fear drives me.

"The pier was one of the biggest challenges. It's the biggest set I've had built and the largest expenditure of capital toward a set that I've asked for and the most tremendous amount of manpower going into something that I'd requested—and the scene wasn't fully written yet. But I got a handle on it and the other sets, with the help of a talented team of artists. That's what gives me comfort. I have a great team of storyboard artists. I run my ideas by them and they run their ideas by me and I slowly work my way through and develop the scene, bit by bit, shot by shot. I try to close my eyes to the overwhelming truth and focus on the journey one step at a time."

A brief hiatus was built into the schedule while the pier was being constructed, allowing production principals to catch their breath and come, rested and ready, to shoot the actual scene. But even though live-action filming would wrap with the pier, the making of the movie would only have reached about

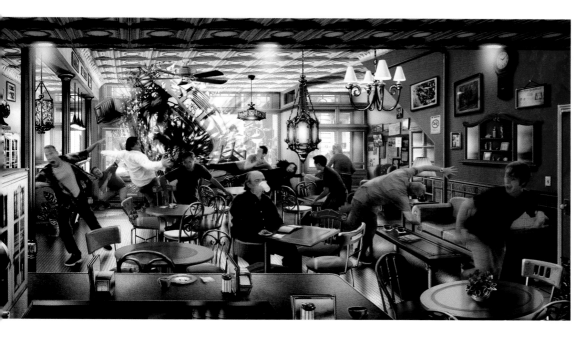

Doc Ock sends a car flying through the café window, sending *Spider-Man 2* art department artists and staff scattering (except for Alex Tavoularis, who's deep into his java). Left to right: Steve Saklad, Wil Zakis, Tom Wilkins, Mick Cukurs, Alex Tavoularis, Mark Taylor, Patte Strong-Lord, Jamie Rama, Jan O'Connell, Neil Spisak, C. Scott Baker. Photoshop art by Jamie Rama.

the halfway point, with a huge slate of complex visual effects shots still in the pipeline, music and sound to be scored and mixed, the editing to be completed, and release prints to be struck for the thousands of theaters that would screen the film.

Raimi likened this point in the production process to being at the crest of a roller coaster, chugging to the top for the last vertiginous plunge. "At this point in time, the film's still in the birth throes, writhing about and trying to be born, and the birth process is not a pretty sight. I do have the great faith it'll grow up to be a fine motion picture. I was equally terrified at this phase on the first one. I think this production is a little more daunting because of the sheer volume of visual effects and the scope of the [CG] animation.

"But, actually, I feel it's a more coherent and singular vision than the first *Spider-Man,* and by singular vision I'm not referring to myself or Neil's work. I'm referring to *all* the artists who are working toward a common, much clearer goal, which I think they've been more successful in achieving in this second film. Everyone, mostly Neil, had to struggle long and hard to come up with the look on the first film. Now we could stand on its shoulders and go to the next plateau, which is much easier than creating something from scratch."

The key to the sequel, in Spisak's view, was pushing the humanity of the characters. "I think we hit a certain sort of reality in the first film because Sam had the ability to be perfectly honest with all the characters and their emotions," Spisak noted. "To understand and preserve that reality but still make things a little better was the pressure for this production. I felt we needed to go to the next level on *Spider-Man 2* in terms of a more sophisticated approach to the characters, to do what we did in the first film but do it a little better."

"It's not about saving the world or just getting the girl," mused Avi Arad. "It's about the kid who stays home because someone is sick in the family or can't go to college in the big city because there was a flood the year before and he has to stay behind to help with the crops. Those are the things that change your life forever. It's the responsibilities you feel toward someone else that are deep enough to make you sacrifice your own ambitions—and that's the Peter Parker in all of us.

"The message of Spider-Man is you don't need to shoot webs or climb buildings to be a hero. As a matter of fact, the test of the hero is when you're an underdog and are called to duty. And Peter Parker has to face up to challenges in this movie and find the hero within himself."

THE ART OF
SPIDER-MAN 2

Part of Spider-Man's appeal—and one reason Peter Parker's emotional struggles carry such resonance—is that his world isn't a fantastical setting, but a reflection of the real world. New York is Spider-Man's home, from the skyscrapers of midtown Manhattan to the quiet residential street in Queens where Peter Parker was raised by Ben and May Parker.

But it's also a Super Hero fantasy, so Neil Spisak's challenge in the first film had been to create a design aesthetic for a world that mixed the ordinary and extraordinary. Design choices ranged from choosing a "house-proud" neighborhood location for the Parker household to envisioning wealthy Norman Osborn's penthouse home as a "castle in the sky" and brushing his inner sanctum with a color palette of green to subtly evoke Norman's Green Goblin persona. To capture the saga's more fantastic aspects, Spisak's art department favored beaux arts architecture and pushed elaborate, surreal stone carvings in the skyscraper heights that ordinary citizens could only imagine, but were reachable for our cos-tumed wall-crawler and the glider-powered Goblin.

For James Acheson, the Oscar-winning costume designer on such productions as Bernardo Bertolucci's epic *The Last Emperor,* his work on the first *Spider-Man* had been a chance to get back to his fantasy roots, which began with the *Dr. Who* TV series. Acheson had also seen Spider-Man within the larger pantheon of fantastic characters, imagining him as an urban Tarzan swinging from Manhattan's skyscraper heights.

The Spider-Man costume for the first production had been designed to embody the requisite Super Hero musculature but also the character's lithe athleticism. The process had been an arduous creative journey, from reference photos of Tobey Maguire to concept illustrations, to life casts of Maguire and Spider-Man stunt double Chris Daniels, and a final process that utilized muscle patterns that were worked out in Sony Pictures Imageworks computers and were realized in a silk screen process that produced a 3-D trompe l'oeil musculature effect.

On *Spider-Man 2,* the costume designer

Previous spread art by James Carson.

Right: Osborn apartment balcony set. Photo by Melissa Moseley.

recalls, Avi Arad was keen that the new movie deserved a new look Spider-Man costume. But Sam Raimi, and to a lesser extent producer Laura Ziskin, were concerned about messing with success. Acheson recalled, "The concern, and the dilemma, was that a new costume could spoil the Peter Parker story. We had to respect the fact that Peter Parker is from Queens and is struggling and to have a more elaborate costume would beg the question: 'Where did he get the suit?'"

Acheson himself "wanted to tinker" with the costume, but not to the dramatic length seen in the *Batman* movies, in which the Caped Crusader's costume became increasingly sculpted and glossy. In the end, though, Spider-Man's entire costume was completely, although subtly, redesigned. The redesign was itself a key to the entire look of the movie. "In the last movie, Neil Spisak had the idea of keeping the look of the sets monochromatic so Spidey could *jump* out on screen," Acheson noted. "This movie did what Neil wanted."

The major change in the Spider-Man costume itself was its color scheme, a process in which Acheson worked closely with Bill Pope. By the time he came onto the production, Pope noted, the major Spider-Man costume changes had been decided, including the notion of pushing the costume's colors. But the cinematographer was vital in helping the production achieve its new look Spider-Man. "Bill Pope was much more daring in letting us push the red of the costume to the reddest red possible and the bluest blue, almost a blue black," Acheson explained. "It's a fine line, because reds are very different on camera and tend to pop. On video [VHS and DVD releases], they tend to bleed. We took it right up to that edge, but we tested it enough—long and endless tests!—to know we'd be fine."

Pope's own palette, his use of lighting and particular film stock, also allowed the production to behold Spider-Man in, literally, a new light.

"It was a learning process from the first movie," Pope explained. "In the first film,

The "house proud" neighborhood location for Aunt May's home. Photo by Melissa Moseley.

Spider-Man's costume was lit with a warmish orange look that I felt clashed with the red and blue of the costume. I felt a more neutral light would bring out the reds and blues. Sam also likes the heroic look of sunset magic hour light, which I felt should be more yellow in this movie, like in the comic books. So, instead of the warm, orangey look of the first film, we decided on a New York that was colder and grayer—which tended to pop the costume against that more neutral background."

"Bill Pope and I worked together on this palette in terms of keeping it desaturated and grayed out, with Spidey coming forward in backlights and sidelights," Spisak added. "This film has a slightly more serious tone. Peter Parker becomes more of the fabric of New York, he moves through the city and meshes with it, so the world is a little grayer and drained of color a bit. This contrasts with the appearances of Spider-Man, with Jim Acheson slightly intensifying the red and blue of the costume, while I went in the opposite direction and slightly desaturated the color scheme of the world around him. The hope was that when we see Peter Parker he's more integrated into the city, and when he appears as Spider-Man he comes forward a bit more than in the first film."

"Whatever life holds in store for me I will never forget these words: 'With great power comes great responsibility.' This is my gift, my curse. Who am I? I'm Spider-Man!"

Those were the last thoughts of Tobey Maguire's Peter Parker as he walked away from Kirsten Dunst's Mary Jane and the grave of Ben Parker at the conclusion of *Spider-Man*. The grave site was a meeting place of the two great forces in Peter's life—the love of his life and his tortured guilt over the death of the beloved uncle who'd taught him that lesson about power and responsibility. He'd paid respect to his uncle's memory, and then embraced life itself when he held and kissed MJ.

And then Peter Parker said good-bye, walking away with a heavy heart, knowing he could never reveal to the woman he loved that secret side of himself. But there was also the emotional uplift that Peter had finally come to terms with himself, that he

was now on a path that was certain and true.

But in *Spider-Man 2,* Peter discovers it's not that simple to be responsible to his superpower. It's not so easy to walk away from the love of his life. He's trying to make it on his own. He's moved out of the comfortable loft he shared with his wealthy friend Harry Osborn, and into a cheap apartment. He's barely making ends meet

Right: Peter peers through his apartment window. Photo by Melissa Moseley.

Below: Robbery Rooftop concept art by Wil Rees. This concept was developed but not used in the final film.

Opposite: Several conceptual stages of Peter's apartment by Tom Valentine. Illustrations by Jamie Rama.

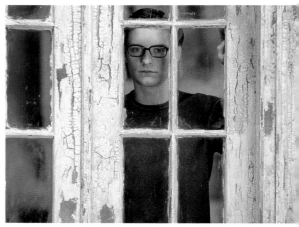

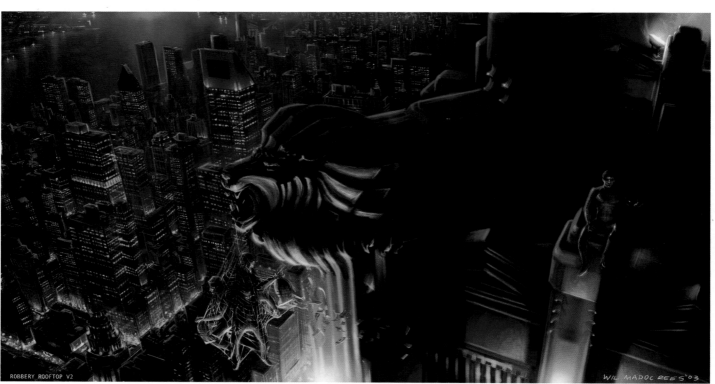

ROBBERY ROOFTOP V2

WIL MADOC REES '03

with a minimum-wage job as a pizza delivery boy and his schoolwork at the university is suffering.

"In terms of Peter Parker being a regular guy to whom an extraordinary thing has happened, the themes of the second film headed organically to that end statement of the first movie—that this is his gift, and it's also his curse," Laura Ziskin explained. "Sam and I talked about how at the ending of the first film Peter is like Atlas holding up the world. That seemed like a logical place to go for the second film. In this movie, it's like the weight of the world has become too much, he's almost on the floor. It's really about what we all face in terms of the choices we make and then living with the consequences of those choices."

"Isn't that the theme of the Spider-Man comics, isn't that what Peter Parker *does*—struggle?" Neil Spisak smiled. "This movie is about that struggle and whether Peter wants to pursue being Spider-Man or whether he should give that up. He wants to properly take care of his aunt May, have a

"In the first film we were searching for Spider-Man's world. We wanted audiences to identify with Peter Parker as a real person in a real world, yet we couldn't put him directly into our world, we had to learn how to refine his fantastic aspects and make them credible. This new production, from an architectural viewpoint, wasn't just about the style of a house, but designing that space for the people living there and suiting it to their specific needs. It's a much more refined movement toward creating sets and the feel for the entire picture. We didn't have to create the world from the ground up, so this time it became a search for the right feel within that world."

—*Sam Raimi, DIRECTOR*

A. "View Toward Peter's Apt." (Original Concept)

B. Selected N.Y. Skyline for Background Plate

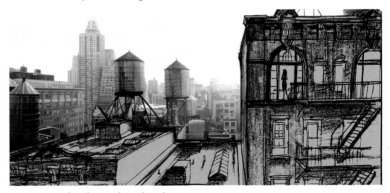

C. Concept and Background Combined

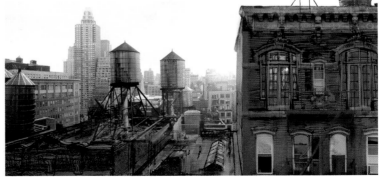

D. Further Development of Peter's Apt. in Foreground

One of Sam Raimi's first ideas was to have MJ gazing out a window as Spider-Man swung away. Jeffrey Lynch roughed out this storyboard, and Wil Rees took that seminal visual idea to this finished illustration.

> **"Once you narrow this world to the color palette you see what scenes fit with this palette or whether you need to expand the palette out for a particular scene. But the overall tone of this world was gray. So, instead of a green, the color palette might be gray-green; instead of pure red, it would be a reddish gray."**
>
> —BILL POPE, *DIRECTOR OF PHOTOGRAPHY*

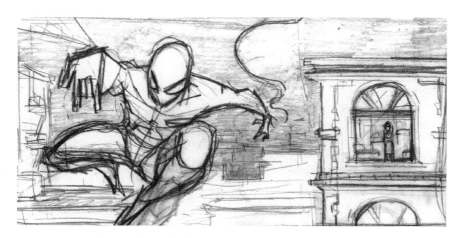

relationship with MJ, keep his education going, hold a job—all the things the Spider-Man portion of his life seems to be getting in the way of. So, we needed to show that Peter *was* struggling. We felt he needed to be on his own, so he's found his own place, but all he can afford is an apartment, a rooming house kind of situation."

Although concept illustrators had a chance to read the first *Spider-Man* script, security was tightened for the second film, so illustrators were given only general descriptions for scenes or pertinent script pages. When Wil Rees worked out illustrations for Peter Parker's apartment building, an early concept imagined an old TV repair shop on the ground floor, with Peter living three flights up. Working in Photoshop, Rees could cut and paste his own work, from adding or subtracting some men playing cards to removing a wall and adding a hallway.

"Neil was very specific about what he wanted for Peter's apartment," Rees recalled. "He didn't want a lot of furniture. In fact, he wanted this barren look, as if Peter had just moved in. Neil would ask for

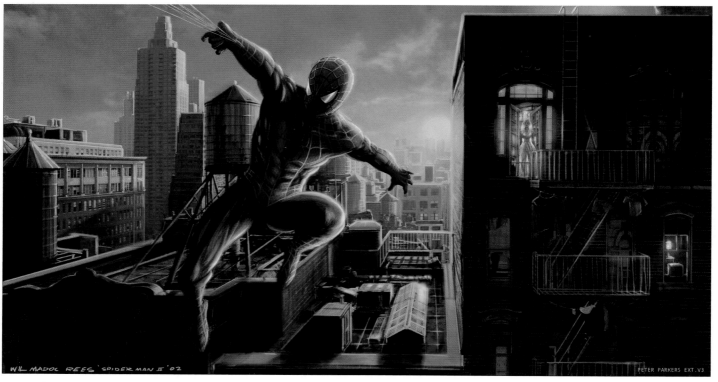

WIL MADOC REES 'SPIDER MAN II '02 PETER PARKERS EXT.V3

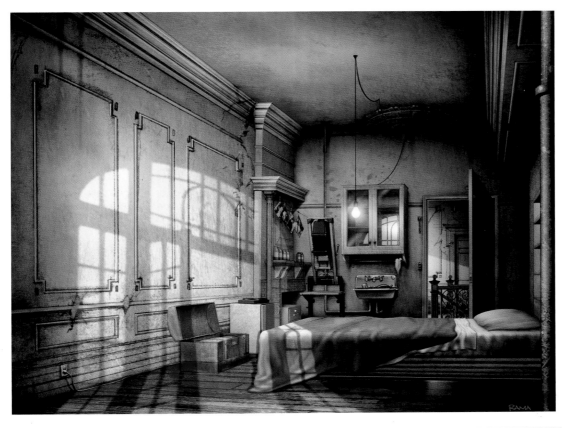

Top and bottom left: Concept art of Peter Parker's apartment by Jamie Rama.

Below right: Peter Parker in his apartment as it appears in the film. Photo by Melissa Moseley.

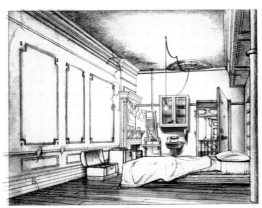

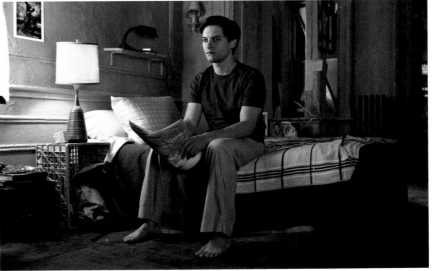

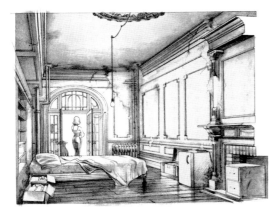

specific things, but there were also set parameters. The color palette for the whole film was definitely grayed out. Neil also wanted this beautiful yellowish light to flow in Peter's room."

Neil Spisak was asked whether the production design had cast a dark cloud, so to speak, over the Parker family household.

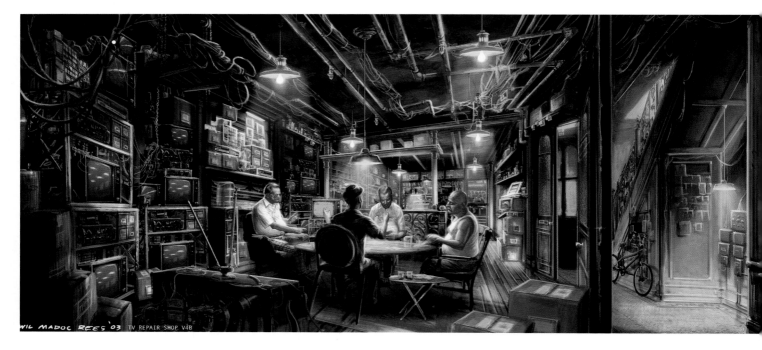

WIL MADOC REES '03 TV REPAIR SHOP V4B

Top: TV repair shop with men playing cards. Art by Wil Rees. This particular TV repair shop concept for the basement of Peter Parker's apartment was developed but never used in the final film.

Opposite top: Aunt May and Peter spend a quiet moment in the Parker household. The interior for the Parker home was the original set used in the first *Spider-Man;* the decision had been made to save it. Photos by Melissa Moseley.

Opposite bottom: Photographic set backings for the front and back yard of the Parker household in Queens were created for *Spider-Man,* with the front yard being reused for the sequel.

How does Aunt May hold up in this movie, facing life without her beloved Ben? "This is *Aunt May!*" Spisak laughed. "What's wrong with you? She's a plucky gal and she's very busy in this movie, she's involved in a lot of stuff. We did soften the colors in her house, but it was pretty subtle."

One of the great illusions of *Spider-Man 2* was conjuring up the cityscape of New York on a soundstage, and integral to that

> **"It was interesting to watch Neil pick the color palette for this movie, pulling color samples for the painter. I think one of the most powerful reasons this movie looks so good is the color palette that was done so early on and which got reflected in all the sets that were built. The colors and tone answered so many questions and always provided a reference point, how things would interact with costumes and props to make the total visual manifestation."**
>
> **—TOM WILKINS,** *ART DIRECTOR*

magic act were the backings, photographic (or painted) representations of the view that would appear outside the window of a set, and blue screen, the neutral color fabric onto which visual-effects artists would later composite computer-generated or digitally processed imagery, providing a backdrop for the live-action scene that's been filmed.

"There are a huge number of technical variables to consider in determining the size and actual placement on stage," Tom Valentine explained. "Blue screens and backings share similar requirements of camera coverage and rigging, but the lighting packages differ greatly. Stage space is almost always a problem. One major consideration for backlit photo-backings is that the sun and shadows on the buildings in the backing should match the lighting on the set. What time of day is it? Where is sunlight coming from? It can take months of lead time to produce a backing, so you've got to sort out those basic questions very early in the game."

In creating a backing, Valentine usually sent a storyboard or illustration of a proposed view to New York location manager John Fedynich. Hundreds of location photos would come back, allowing Valentine and the art department to piece together an idealized view of New York, even shuffling

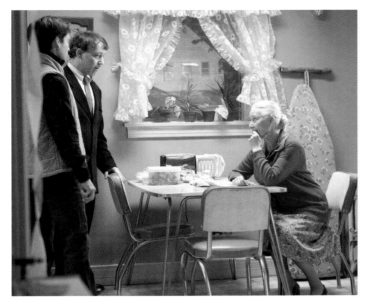

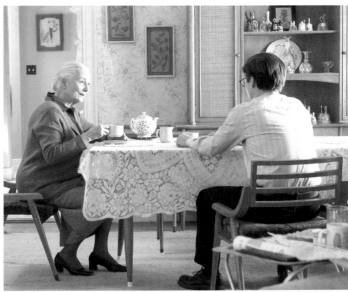

Scale: 1/4" = 1'-0"

1" Gap between backing & stage fl

Parker House - Back Yard 30' x 15' *15' x 15'*

Horizon 98" (38" + 5')

Horizon 92" (38" + 4'6")

38" Interior floor level
above stage floor

1" Gap between backing & stage floor

Parker House - Front Yard 64' x 24' *50' x 20'*

Stage Floor

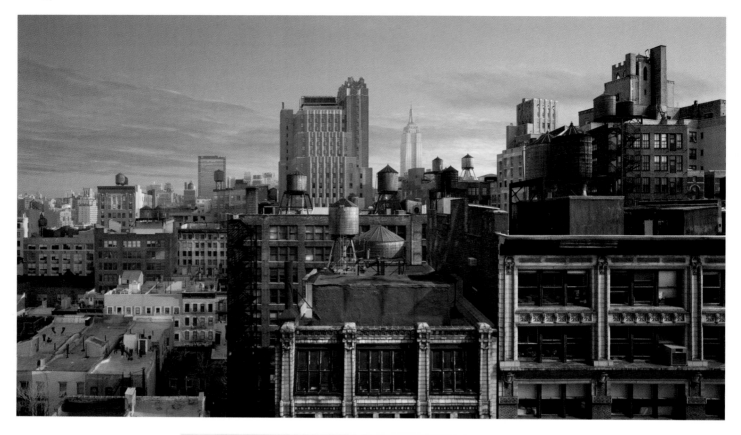

Top and opposite: The final backings for Peter's apartment, pieced together from multiple locations. Left side: day. Right side: night. Photos by Richard Lund.

Bottom: Photo composite of exterior of Peter's apartment. Art by Tom Valentine.

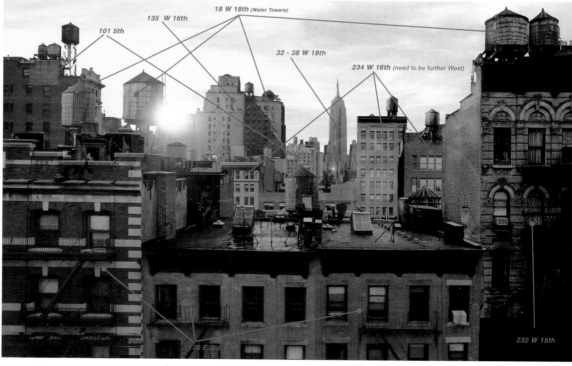

101 5th

135 W 16th

18 W 18th (Water Towers)

32 - 38 W 18th

234 W 16th (need to be further West)

76 E 3rd

232 W 15th

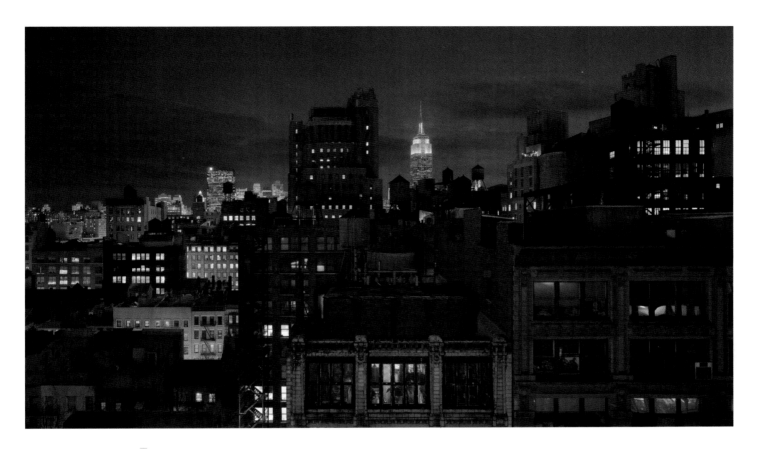

around iconic structures like the Empire State Building. "For the south view from Peter's apartment, I composited three different locations," Valentine explained. For the *Bugle,* I used six! For the most part, we create an idealized view. There are actually very few perfect cityscape compositions you can simply shoot and use as is. Nowadays there might be some big tower blocking the view of a beautiful old building, or maybe the sun angle doesn't quite work."

Valentine often worked with the digital artists to achieve the precision demanded by a set backing, both in the nature of the final image and in its placement. "I worked a lot with Tom Valentine, creating digital sets. Tom and I could walk through the digital set models and study the placement and composition of the backings for accuracy," digital set designer J. Andre Chaintreuil explained. "We could take location photos shot in New York, and in the computer figure the exact view out the window for the backings. You really have to be accurate, because these large photographic backings can be sixty or seventy feet long and thirty feet high. You want to make sure they're perfect."

"Only a few years ago we'd just go shoot a view of the skyline—we wouldn't have been able to pursue this approach of blending together different locations," Valentine added. But now we can achieve a nearly perfect view. Also, in every one of our back-

Right: The art department's modelers, headed by Tom Frohling, worked up physical models for many city street scenes.

Bottom: Exterior bank model by Tom Frohling and Brett Phillips. The bank was a setting for one of the dramatic encounters between Spider-Man and Doc Ock.

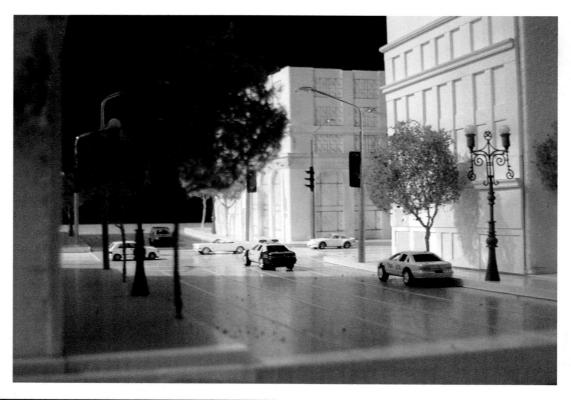

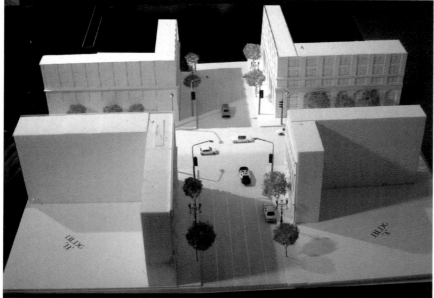

> **"This is *Spider-Man*, and you want a lyrical quality to the skyline, you want the city to look like the image of New York you carry around in your mind."**
>
> —TOM VALENTINE, *ART DIRECTOR*

grounds, we have digitally replaced the sky with cloud formations that complement the movie. We weren't stuck with the sky [as it appeared on] the day they shot the pictures. It's almost like the technology has upped the bar on how good these images can be."

"Neil Spisak was great for this show because he loves New York and that really came through in his production designs," lead model maker Tom Frohling observed. "There's more of a sense of texture in this film than in the first one, a rougher quality that comes through in the lighting, which gave a more visceral feeling to the designs."

"The approach for this film was the same as the first *Spider-Man* in that it's always based in reality, and that approach comes from Sam," added lead set designer Andrea Dopaso. "He always wanted to make Spider-Man feel as if he's in the real world, even though the sets are big and fantastic, with huge spaces and details. But the idea was everything should feel like a real city,

where you could walk outside and find that space. It's not a completely surreal fantasy world."

In addition to location photography, Sony Pictures Imageworks again created a virtual version of Spider-Man's New York City, particularly for sequences in which their CG Spider-Man would be swinging on his spider's web through the steel and concrete canyons. But the scale and scope was enlarged upon, both in the number and detailing and image resolution of the "hero" buildings.

"There were fifteen hero buildings in the first film and another twenty to twenty-five medium, low-resolution ones—we had *twice* as many CG buildings on this show," explained visual-effects supervisor Scott Stokdyk. "In the first movie Neil Spisak picked out real buildings in New York and we went and surveyed and photographed them, got all the information we needed to build them in the computer. The process was the same for this movie. There were particular buildings Neil and his art department looked at and redesigned, there was a good back and forth. Basically, both the new

and old CG buildings were designed as our best-guess use in the movie and for full-screen resolution. But we do upgrades depending on the shots. In this sense, our buildings are continually evolving, they incrementally get better and better the more shots that we do."

"We used all the older buildings from the first movie but upgraded them—and we didn't raise the rents at all!" visual-effects designer John Dykstra added with a grin.

Right: The *Daily Bugle* set as it appears in the film. Photo by Melissa Moseley.

Below: Virtual *Bugle* building interior by J. Andre Chaintreuil.

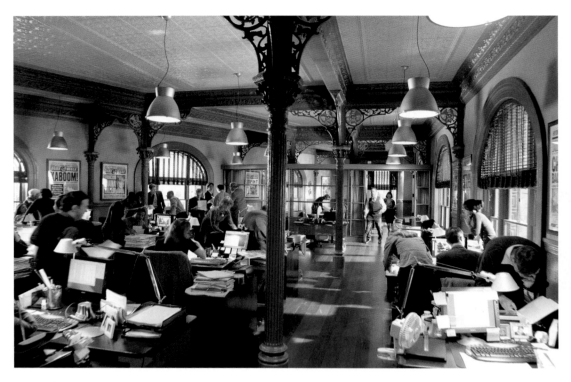

"They all have varying levels of detail, but you couldn't or wouldn't want to take them all to the high-resolution level of detail to allow for close scrutiny. It would be impractical to waste data putting in every little streak of rust or stain. But we did get close to some of these buildings and in some cases Spider-Man lands on them. For those shots the CG buildings have tremendous details—but if you could pan one window over on that model there'd be a flat, 2-D texture. But these buildings are organic. They start out with low details and then more details are added."

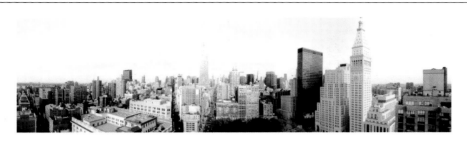

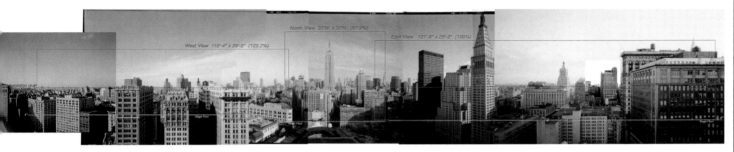

One of the challenges for the *Bugle* office set design was it had rows of windows that had to be accounted for in the photographic backing views. Since the backings were flat, 2-D images, they had to be perfectly placed so that when actors and cameras passed the windows there wouldn't be an obvious parallax shift in the background.

"The *Bugle* set had so many windows that we needed more buildings to extend the length of the backing," Valentine explained. "Even though we went to the Flatiron Building in New York and shot the 270-degree skyline from the roof, we actually needed twice the imagery that the location could give us. It took five additional locations, pieced together, to extend the image into one giant compelling view.

"We couldn't go just anywhere in New York to shoot the other locations, either. The *Bugle* newspaper office has an early-twentieth-century flavor, so the view out the window had to reflect the nature of that neighborhood."

The *Daily Bugle* set backings.

Top: The 270-degree view from the Flatiron Building in New York, the production's idealized location for the *Bugle*.

Middle: Rough composite of the extended image from six locations.

Bottom: The final view—a composite of six locations plus sky replacement ready to print on back-lit vinyl. Photography by Richard Lund.

DR. O's FUSION ??

Mary Jane has always haunted Peter Parker's dreams, but in *Spider-Man 2* MJ becomes a dream girl for all of New York, with advertising images of her face adorning everything from rooftop billboards to subway signs. MJ's dream from the first film was to become an actress and she's making it, garnering a role in an off-Broadway production of Oscar Wilde's romantic comedy *The Importance of Being Earnest*. MJ invites Peter to one of her performances, but Peter is more focused on the importance of being Spider-Man and the sense that it takes priority over everything else—that he has no choice. Alas, he arrives too late to make the opening curtain and a snooty usher refuses to seat him, despite Peter's pleadings.

Outside, standing in the shadows after the show, Peter watches MJ leave the theater, where she's surprised by the sudden appearance of a handsome young man. MJ is hurt that Peter hasn't shown up, but has still been looking for him, wondering if he'll suddenly appear out of nowhere, as usual. But there's no Peter Parker in sight—so she takes

the arm of the young man and the couple disappears into the night.

Think things couldn't get worse for Peter Parker? The handsome fellow who's surprised Mary Jane at the stage door is John Jameson (Daniel Gillies), a serious rival for her affections—and son of J. Jonah Jameson, *Daily Bugle* publisher and Spider-Man's media nemesis.

"One thing we focused on was to give MJ her due in the film, that she'd have a real arc to her story," Laura Ziskin explained. "But, basically, this second movie is the chance to advance everybody's story. I like that *everybody* is going through something, and it's all integrated. Peter Parker has been bitten by a spider and becomes Spider-Man and because of that everybody's lives—Mary Jane, Harry Osborn, Aunt May, even Jameson—have been impacted and they're all dealing with the fallout of that, including Peter himself. Of course, none of them knows that—they *can't* know—but Peter knows, and it's another weight on his shoulders."

Right: Classic *Spider-Man* comics artist John Romita takes Peter Parker's seat in the classroom of Dr. Connors, Peter Parker's professor and a colleague of Dr. Otto Octavius. Photo by Melissa Moseley.

Top: Peter Parker has "MJ" on his mind, as revealed in his school notebook doodling. Artwork by Alex Tavoularis.

MJ (Kirsten Dunst) appears prominently in the advertising campaign for Emma Rose Parfumerie.

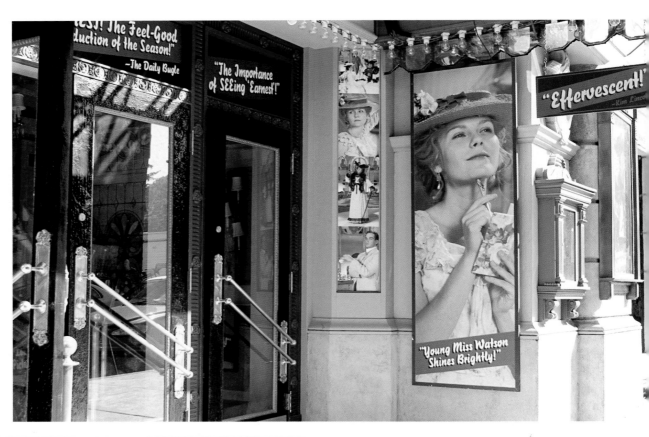

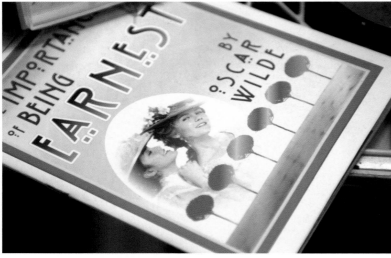

Above: Final set exterior for Lyric
Theater, including rave notice for MJ:
"Young Miss Watson Shines Brightly!"
Photo by Melissa Moseley.

Below: Program cover for MJ's big off-
Broadway debut. Photo by Melissa
Moseley.

"If there's a falseness to the look
of something in a movie, it'll pull
you away from that environment
and out of the story. Some shows
put less money into their art
department and the look of a film,
so you're lucky to get on a show
like *Spider-Man 2* where they care
about the look. Take John Snow,
who painted the sets on this show.
The camera loves him because he
knows how to put the paint in the
right spot with the right textures
so it visually reads. And the joy of
it is that an audience member isn't
even supposed to think about
things like how that set is
painted!"

—*TOM FROHLING, LEAD MODEL MAKER*

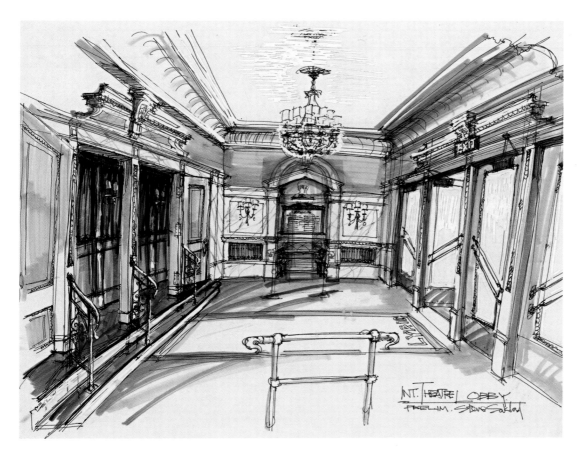

Top: Interior of Lyric Theater lobby. Preliminary sketch by art director Steve Saklad.

Bottom: Final Lyric Theater lobby set. Photo by Melissa Moseley.

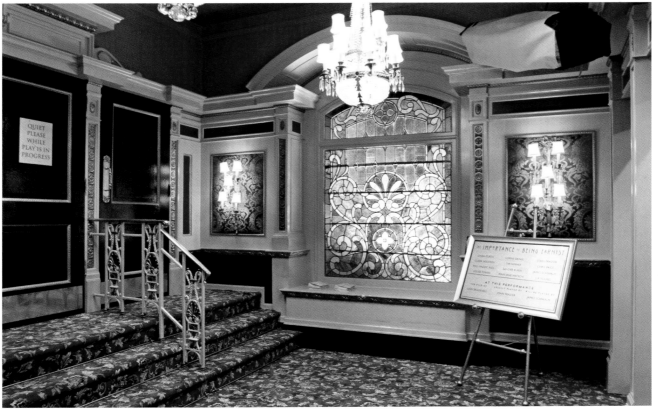

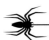
Right: Lyric Theater exterior as it appears in the film. Photo by Melissa Moseley.

Bottom: Concept art by Wil Rees. Conceptual artists can produce dozens of different versions of a single scene, but Wil Rees did only two or three of Peter Parker outside the Lyric Theater. "Neil basically wanted a sense of Peter being removed from the theater and isolated, in the shadows," Rees said.

Middle left: Exterior of Lyric Theater. Preliminary sketch by Steve Saklad.

Middle right: Since Peter Parker has failed to meet her as promised, MJ turns to the arms John Jameson (Daniel Gillies). Photo by Melissa Moseley.

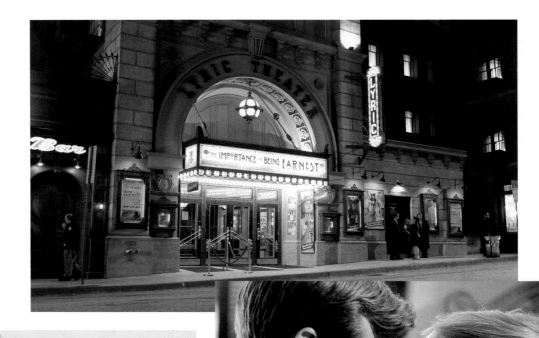

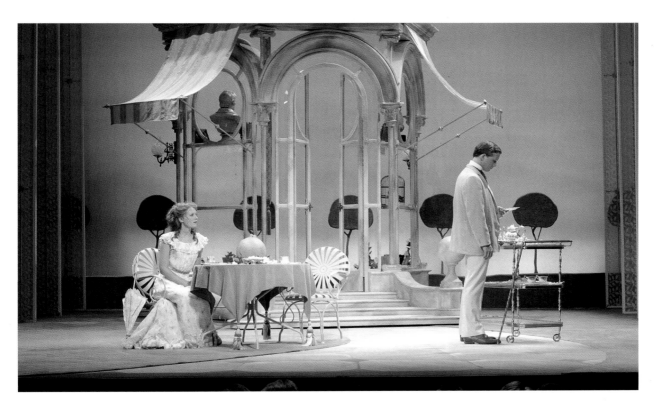

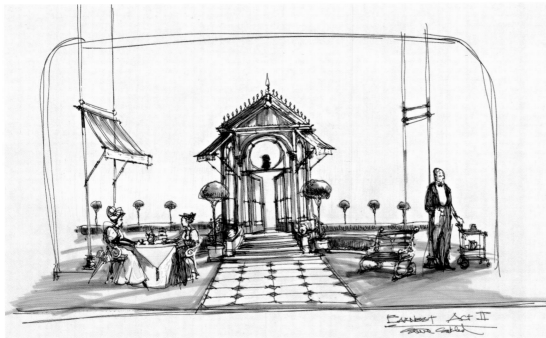

Top: MJ in the role of Cecily Cardew in the off-Broadway production of *The Importance of Being Earnest*. The male actor onstage is Reed Diamond in the role of Algernon. Photo by Melissa Moseley.

Bottom: Steve Saklad concept sketch for the play within the movie.

THE BIG ANNOUNCEMENT

The Rose Center, a planetarium and exhibition hall dedicated to the study of the cosmos, opened in 2000 as a new facility of the American Museum of Natural History in New York. Behind a curtain of glass the facility is dominated by the eighty-seven-foot-diameter Hayden Planetarium, a spherical structure in which visitors can see a simulation of the universe spreading out before them, time-travel to the seminal moment a point of energy exploded in the Big Bang, or wander below hanging models of the planets in our solar system.

During a high-society party at this dramatic setting, MJ descends a glittering staircase on the arm of young Jameson—and the announcement is made that they're engaged to be married.

The Rose Center for Earth and Space in New York. Photo by Melissa Moseley.

"We shot the exterior of the party scene at the planetarium and the production wanted to shoot the interior, but it turned out to be prohibitively expensive," art director Wilkins recalled. "One of the things driving the design was this big staircase, so we scouted locations in the L.A. area and decided to do it at the Anaheim Convention Center. We did a lot of renderings from photos taken at the location which were scanned into the computer and Photoshopped by Wil Rees. Then we found out we couldn't get that location for the days we needed. It costs about twice as much to create a set as turn an existing location into a set, but we had to do it."

Cosmas Demetriou, an assistant art director on most of the sets Wilkins was

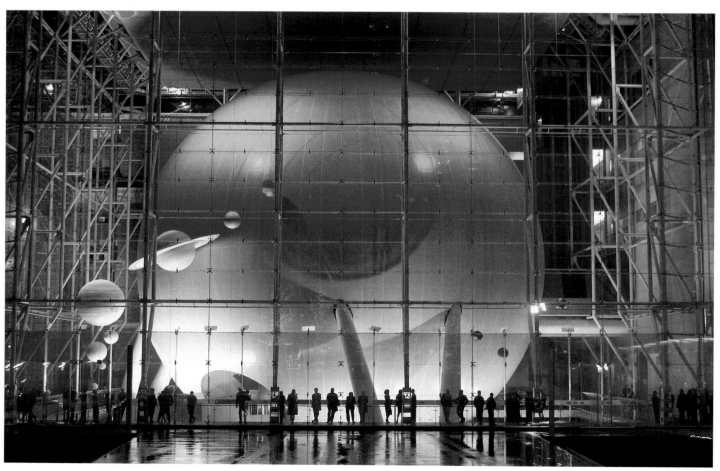

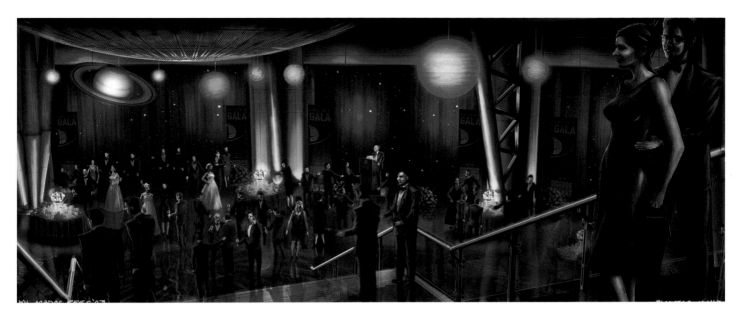

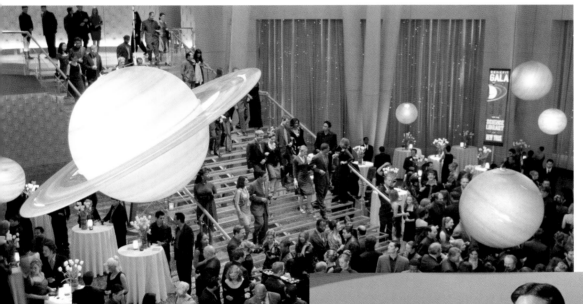

Top: Final approved planetarium party set design; art by Wil Rees. "We emulated the look of the real planetarium," art director Tom Wilkins noted, "with the set dressing department hanging these self-illuminating spheres of the planets."

Middle: Final planetarium party set, showing staircase.

Bottom: A radiant MJ and Captain John Jameson descend the staircase. Photos by Melissa Moseley.

assigned, worked with both Wilkins and Spisak to approximate the desired location. Building the planetarium interior on Sony's Stage 27 had to come together quickly, and did, with the construction crew headed by Jim Ondrejko (who did the honors for the first *Spider-Man*). "The set was a big circle inside an octagon, and each facet of the octagon was thirty-two feet, so it was a big space," Wilkins recalled.

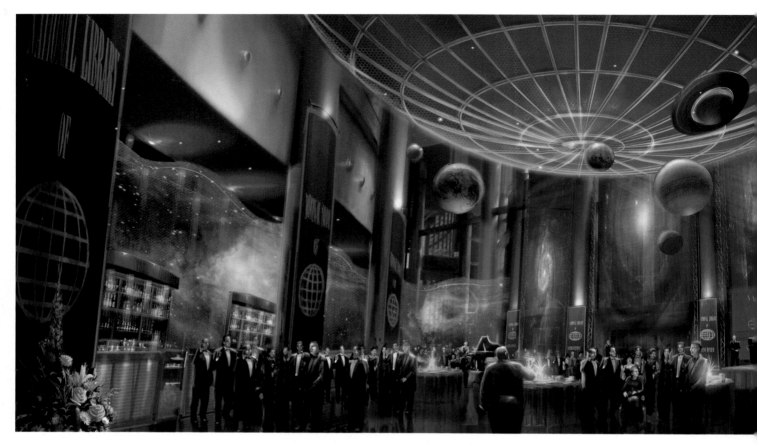

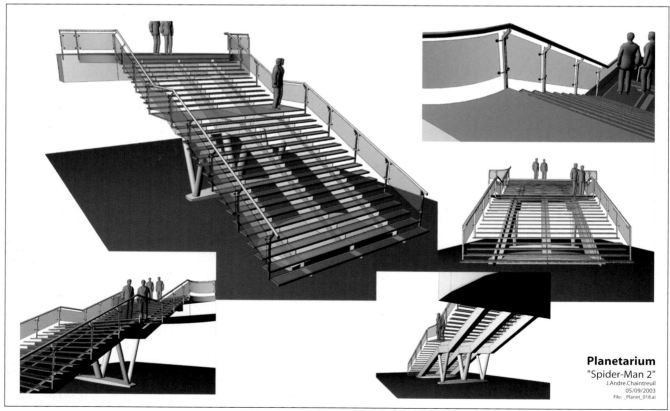

Planetarium
"Spider-Man 2"
J.Andre.Chaintreuil
05/09/2003
File: _Planet_018.ai

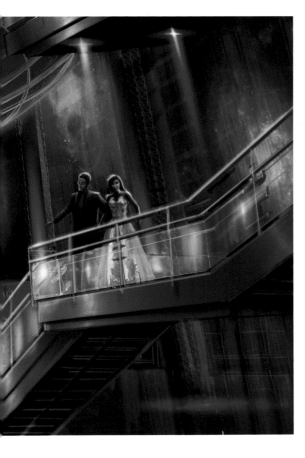

Opposite top: Planetarium party scene based on the Anaheim Convention Center location. Concept art by Wil Rees.

Below: The virtual geography of the planetarium set, by J. Andre Chaintreuil.

Opposite left: Virtual staircase designs by J. Andre Chaintreuil.

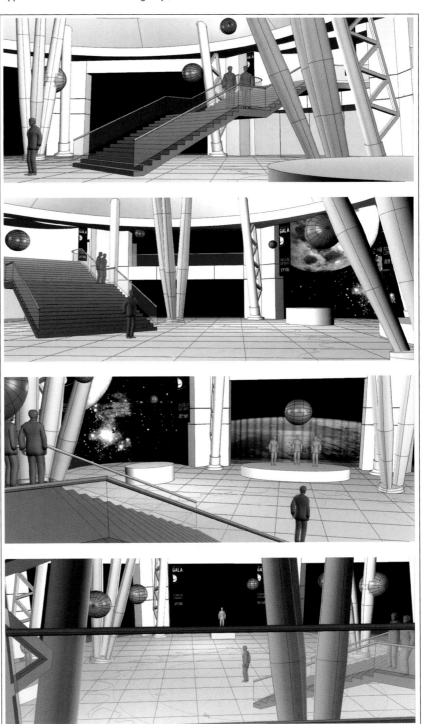

"The staircase was free-floating, sixteen feet wide and went up to twenty feet, and made of steel and Plexiglas. It was challenging to build, but had to be very dramatic for the impact of the scene and because this was a high-society party in New York."

—*TOM WILKINS, ART DIRECTOR*

THE VISION OF DR. OTTO OCTAVIUS

The Goblin had been picked for the first film, Laura Ziskin noted, because his "emotional resonance" as father of Peter's friend Harry Osborn provided plenty of possibilities for character development and dramatic conflicts. But Dr. Otto Octavius, while one of the most visually compelling villains, was something of a mystery, a character introduced in the comics as an inscrutable "atomic genius" obsessed with his experiments and held in awe by his colleagues, seemingly a loner without wife or family or significant other.

Still, it was inevitable that Doc Ock would appear in a *Spider-Man* movie—but Sam Raimi had a major concern.

Opposite: This Paul Catling image was one of the designs that "stuck," according to Neil Spisak.

Below: Seminal Doc Ock design by Catling was this back view with tentacles.

"Jim Acheson brought in this drawing of Doctor Octopus by Paul Catling, one of his conceptual artists. We looked at it and our reaction was, 'Wow—he got it!' It had majesty, it had violence, it showed the insertion of the device. There was the feeling that the tentacles controlled him, yet there was still some humanity there. The image melded man and machine in an amazing way."

—*Avi Arad, PRODUCER*

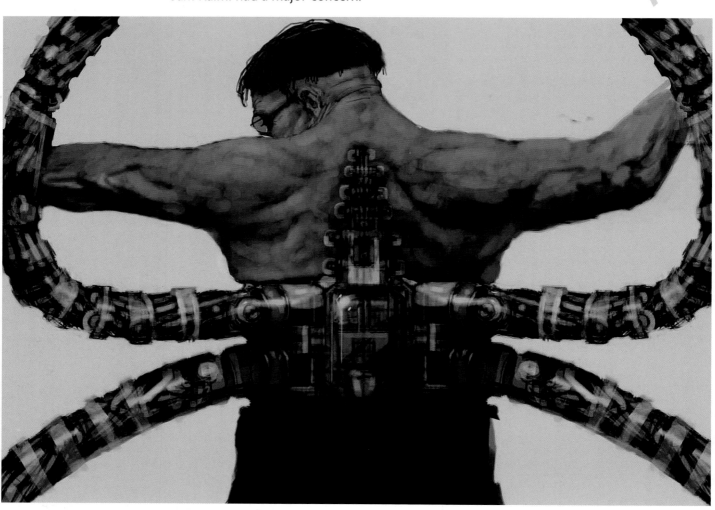

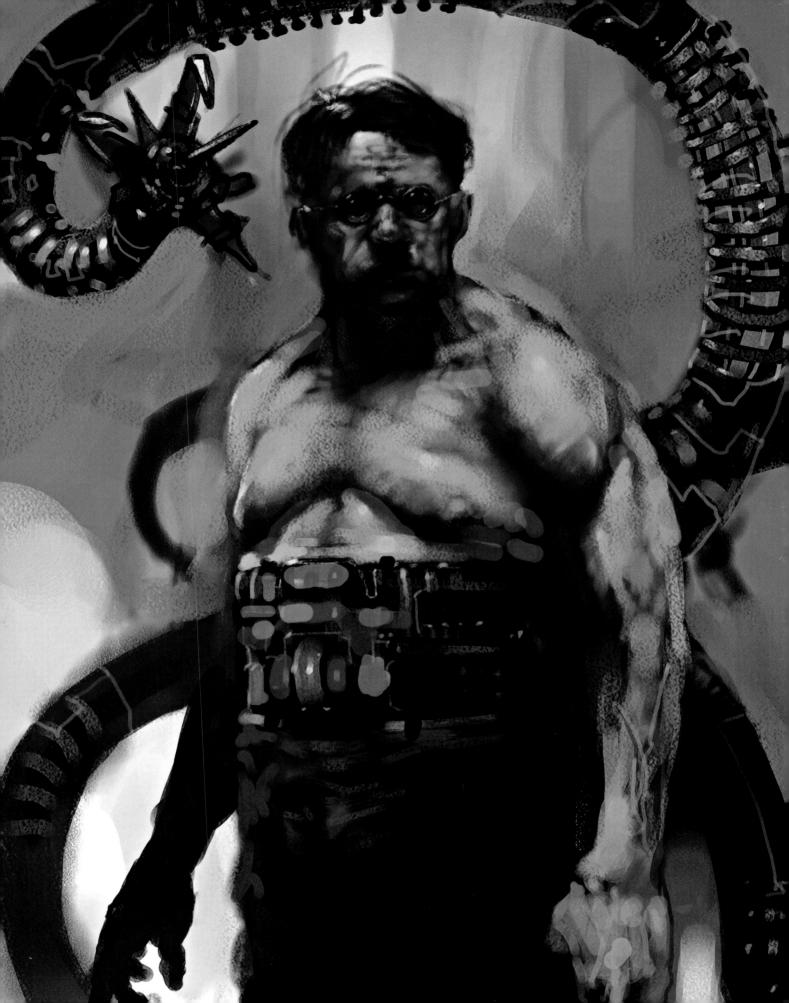

"The concern with Doc Ock was how would he play into Peter Parker's conflicts?" Raimi asked rhetorically. "He wasn't a slam dunk as a villain for this picture because Marvel has always had so many great villains to choose from. But Avi really wanted to go with Doc Ock and the character did offer a tremendous number of visual possibilities. The important thing for me was that it wasn't just about looking cool, but whether he was someone we could craft a narrative around, and whether his story would echo the theme 'With great power comes great responsibility.'

"We found a way to do that and he became the right villain."

In Sam Raimi's version, Otto is blissfully wed to Rosie, and their marriage is a lifelong love affair—the most precious thing in the world Otto Octavius could lose. "A character like Octavius was well rounded; we come to know him as an inventor and a good guy who Peter looks up to and then he has a little 'flip,' as we say, and becomes a villain," Spisak explained. "You don't have to literally say everything about a character, but the more information you impart and the more a character's personal story arc covers a greater range of emotion, the more invested the audience becomes in the character and the story.

"Something had to happen to Otto's wife, someone near and dear to him, to make the story work the way Sam wanted to tell it," Spisak continued. "Therefore, we needed to know that Peter Parker understood their relationship, and that what happens to the wife is a catalyst for what happens in the rest of the movie. I needed to visualize where they lived and in visiting their apartment we had to understand their back story, their good qualities, and the depth of their relationship."

A description of Octavius's apartment in a draft of the script by Alvin Sargent leapt off the page for Spisak and was the key to visually illustrating the love affair: "A well-worn apartment. People have come and gone for years. Good conversation, debate, wit, emotion, all have been left here.... There is a large round table where meals with friends have lasted hours."

"That inspired the look of their apartment," Spisak said. "Basically, the living space is in the same building as the lab, so they're architecturally related. It's a big, warm, open space with a big fireplace, old wooden furniture, thousands of books, and

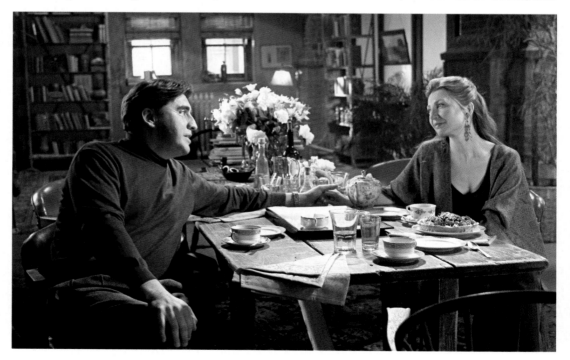

The great inspiration for genius scientist Dr. Otto Octavius (Alfred Molina) is his beloved wife, Rosie (Donna Murphy). Theirs is a lifelong love affair. Photo by Melissa Moseley.

great things collected from around the world. You've got like two minutes to tell the story of the place, so the idea was to jam as much as we could into a set that'd show the warmth and depth of the relationship between Otto and Rosie."

James Acheson recalled that the art department had been working for several months on designs for the look of Doc Ock when he got the call "to have a go at it" and assigned three artists he knew in England. "It was an audition, really," Acheson said of the artists who went to the task. "Paul Catling knew the *Spider-Man* comic book, and I also had a thick file of every Doc Ock image possible. What we were responding to was what the art department had done, they were leading the creation of the image of Doc Ock.

"One thing I felt was that [the tentacles] should have a slightly futuristic look. But, strangely enough, things like robotics or the space shuttles are *not* streamlined—all the wires are hanging out, they're a bit lumpy. We basically went back to form following function, including something substantial around the waist to act as a spinal brace for these mechanical arms.

"Paul's work was instantly staggering. He did hundreds of drawings for the character, but that first week of drawings set the look. He just captured the spirit of the character. In July of 2002 I came over [to Sony from England] with Paul's drawings and everybody went 'Wow'! It was a bit of an awkward time because the art department had been working on Doc Ock and I'd brought all this stuff into the equation. Suddenly the costume department was more intimately involved in the look of Doc Ock."

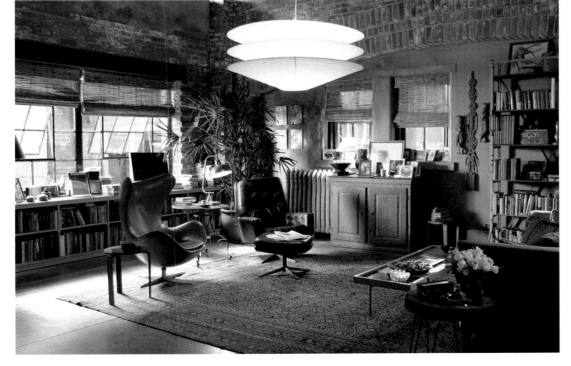

Final set of Otto Octavius's apartment. Note detail of Otto Octavius's desk. Photos by Melissa Moseley.

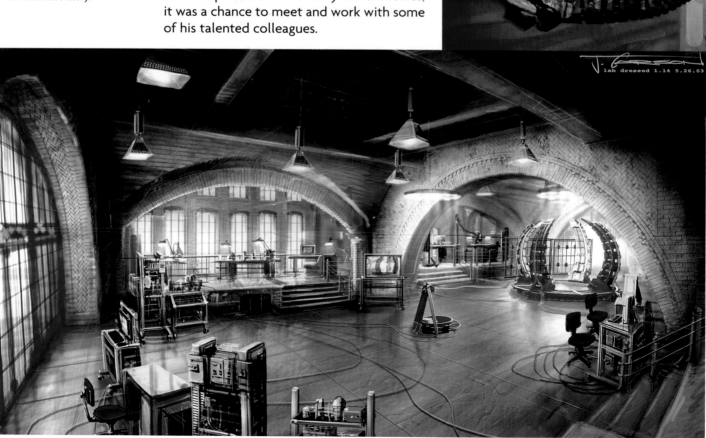

Top: Costume designer James Acheson.

Bottom: James Carson and J. Andre Chaintreuil worked together on this concept for Otto's midtown Manhattan laboratory.

Catling was flown over for a six-week period and quartered in the Barrymore Building, the second home for many of the art department staff. For Catling, whose credits ranged from being a sculptor on *Saving Private Ryan* to concept work for the *Harry Potter* movies, it was a chance to meet and work with some of his talented colleagues.

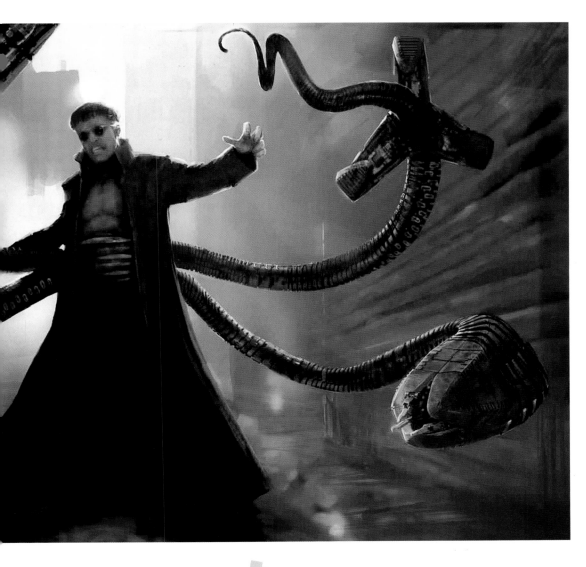

Paul Catling's final illustration of Doc Ock in full regalia reflects months of creative collaboration by the filmmakers.

"The polished, 'Lexus' version of the tentacles that Ock made in his lab become, after his accident, the heavily used 'Dodge' power wagon version. The accident has burned away that sparkle, and you end up with raw muscle.
The look of Doc Ock's tentacles, to a certain extent, defined the visual personality of the tentacles themselves. Scarred, charred, rusted, and corroded pieces of metal are kind of hard to hug. Instead of departing from the initial art and design look of the tentacles, we tried to reinforce that, making them an extension of both their look and Alfred's approach to his character."

—*John Dykstra, visual-effects designer*

Right: A very early insertion device concept by Alex Tavoularis. The art department went a different direction, focusing on an elaborate mechanical apparatus instead.

Bottom: Very first Doc Ock concept from the first *Spider-Man* film. Art by James Carson.

Opposite: Series of Doc Ock insertion devices by James Carson.

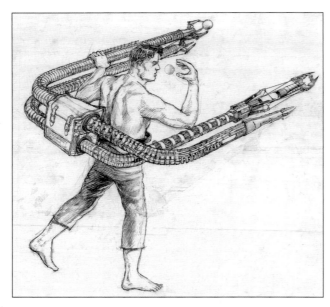

"Actually, the way we look at concept art is not unlike the reaction of the audience for this book, the way readers will look at this art and have a visceral response. But while our first response was to the aesthetic, we then had to filter that through our concerns: 'Is this image telling the story we want to tell?'"
—LAURA ZISKIN, PRODUCER

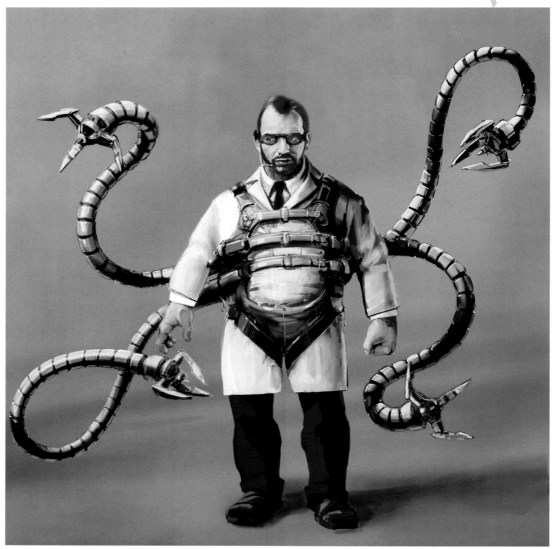

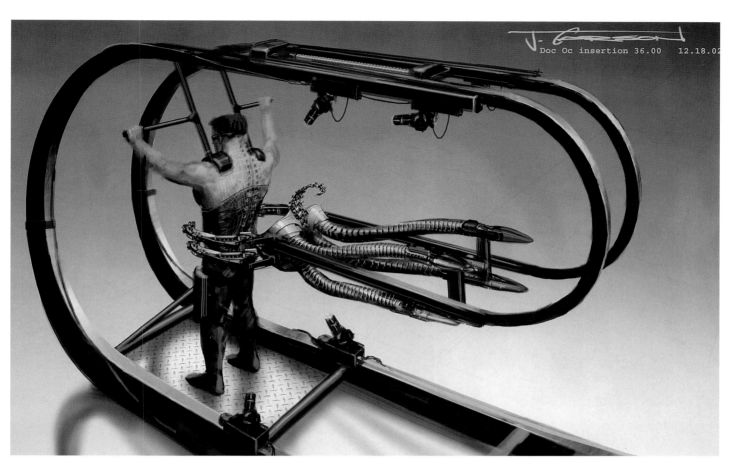

Doc Oc insertion 36.00 12.18.02

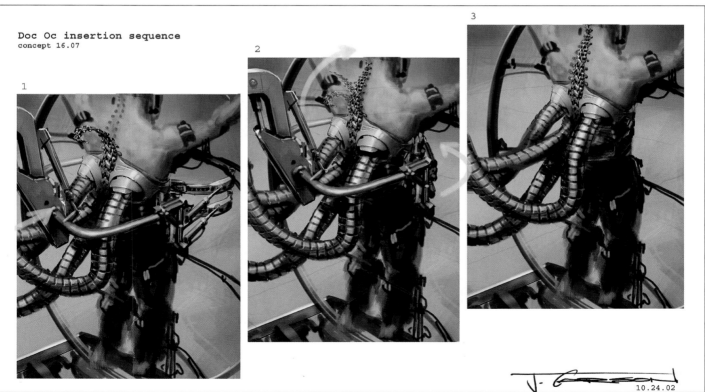

Doc Oc insertion sequence
concept 16.07

1

2

3

10.24.02

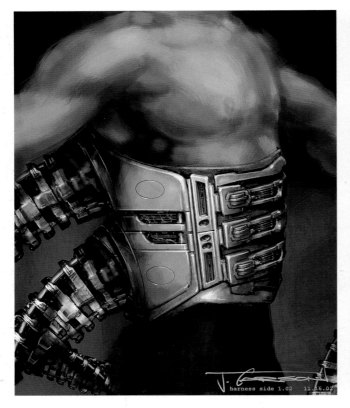

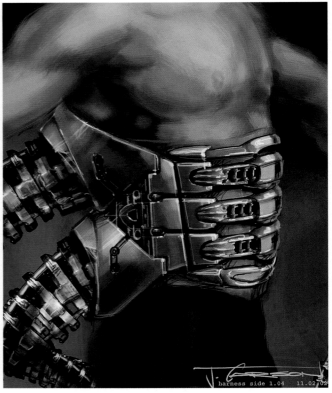

harness side 1.02 11.16.02

harness side 1.04 11.02.02

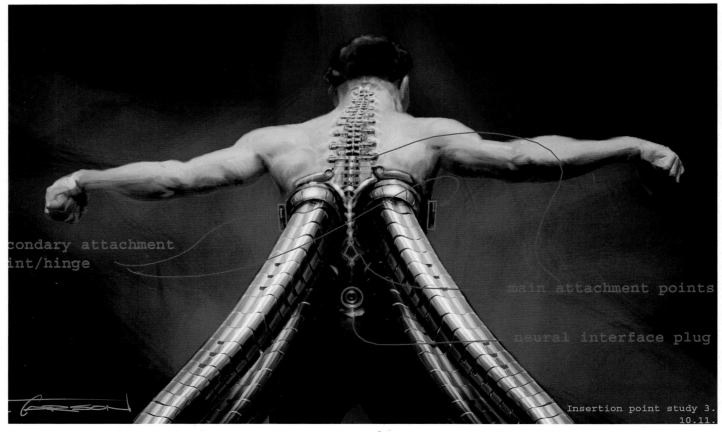

condary attachment
int/hinge

main attachment points

neural interface plug

Insertion point study 3.
10.11.

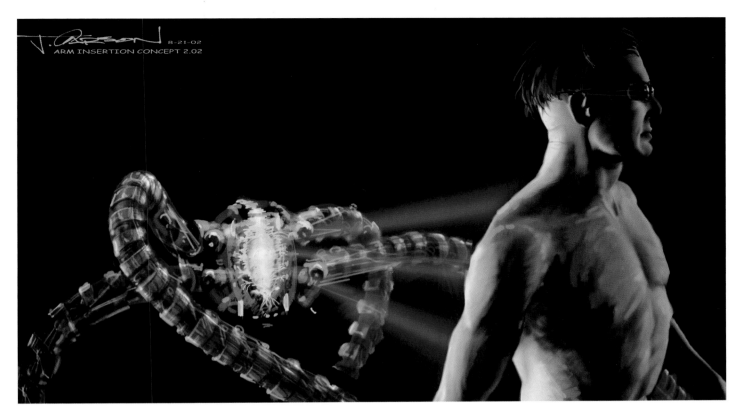

ARM INSERTION CONCEPT 2.02 8-21-02

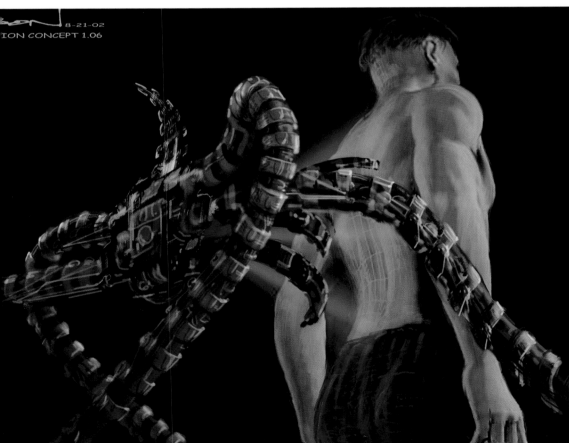

ION CONCEPT 1.06 8-21-02

"I created one image of the insertion device and arms that looked a bit like a crustacean," explained James Carson. "It's this feeling that the tentacles are almost like some parasitic alien creature, that there are two different intelligences—Dr. Octavius and the tentacles—coming together."

Insertion device art on this and previous two pages by James Carson.

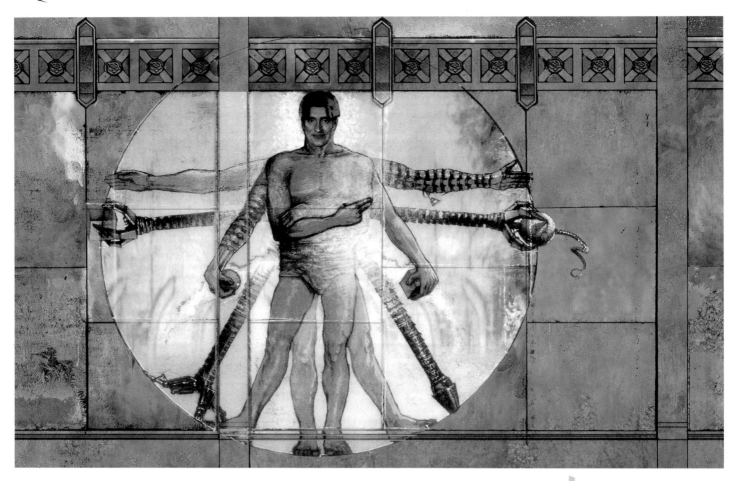

A mural in Dr. Otto Octavius's lab celebrates his ingenious mechanical arms (and also a bit of his egocentricity) in this concept illustration by Alex Tavoularis. The idea, based on the iconic design of Leonardo da Vinci's *Universal Man,* had itself been inspired by a concept for a circular contraption by which Octavius would affix his mechanical arms. Both ideas would ultimately be discarded during the conceptual process.

"Any awkward situation that might have arisen was completely buffered by Jim," Catling stated. "I was actually working in L.A. for the first time and a little unsure how the different departments interacted, but Neil and his department were enormously friendly and helpful. Alex Tavoularis and James Carson were among the amazing artists and it was great to meet people like that, whose work I'd long admired.

"I've been a massive comics fan since I was a little kid—I guess I actually learned how to draw by copying Marvel characters. It's difficult to say how I captured Doc Ock's spirit early on. I usually like to start with sketches that are loose and vague, but expressive. Most sketches I do have a dark and brooding feeling, with characters in pensive poses. I think my style somehow echoed the very character of Doc Ock, I think that's what people responded to. I spent a lot of time in my subsequent

"**Early on, Sam had this image in his head of a pier as a location for Doc Ock's lab. We worked backward from that. The pier is where he goes and hides after his accident, but we gave him a different environment at the beginning of the film. Neil's notion, which we all liked, was that Octavius lives and works in midtown Manhattan, that his living space and work space are in the same place.**"

—*LAURA ZISKIN, PRODUCER*

sketches trying to retain the spirit of my initial sketches."

The Catling artwork was an important influence over at Imageworks, as was the script itself. "The writing of the script had a

lot to do with how we started to conceive of the arms in terms of their physical design, their movements, and how they related to the character of Doc Ock," John Dykstra said. "In one version of our story the tentacles were Ock's creation, the end in themselves. In the final version the tentacles are the devices that allow Ock to work in an environment where you couldn't physically put your hands, and they become fused to his body in a fusion energy accident. The tentacles start out as benevolent supporters of his efforts and take on their own personality."

The "insertion device" by which Doc Ock's mechanical arms would be attached was itself a long conceptual journey. "There was a *ton* of art for Doc Ock's insertion device, that represents Sam and Neil trying to find their way," Tom Wilkins recalled. "There were designs that imagined the device as looking like a piece of exercise equipment, one time as a big circular platform inspired by Leonardo da Vinci's famous image of *Universal Man.* The idea for the mural of Ock in that da Vinci pose that Alex [Tavoularis] worked on spun off of this."

Illustrator James Carson recalled that one inspiration for the device was an early story scene in which Mary Jane actually visited Doc Ock's Manhattan lab. "The story changed, but there was an early idea that at one point, MJ sees the arm on the rig. The device is gleaming and powerful. Avi Arad also liked the idea that Doc Ock could get on the device, and that it was reminiscent of an exercise machine."

THE TENTACLES OF DOC OCK

The logistics and coordination required for bringing Doc Ock to life necessitated that the character have a personal art director. Neil Spisak hired Jeff Knipp to help supervise the overall research, development, and design. The entire process required the coordination of Spisak's art department, James Acheson's costume department, Edge FX—the Burbank-based effects company selected to build the physical arms actor Alfred Molina would wear— and John Dykstra's visual effects crew. They would have to build CG tentacles to composite onto shots of the live actor and also create a completely computer-generated Doc Ock.

"At the outset the logistical aspects were overwhelming. This was something that had never been done before, and how were we going to make it work?" Jeff Knipp recalled. "There were also the interests of all the department heads involved. Neil's was the overall design, Jim Acheson was interested in how the arms would look—both in texture and the design details—with Ock's wardrobe and the feel of the mechanics, John came at it from how to translate what was real into the speed and movements he'd need for the computer, and Edge FX was the construction department concerned with actually *building* it. The design concepts of the illustrators were the foundation of how we got started, and Paul Catling's illustrations were the ones that really grabbed everybody and provided us with a strong, clear direction."

One of the notions developed by Catling was the idea that a fearsome fusion accident would doubtless leave traces of corrosion, that the mechanical arms had suffered along with their physical host. "When I first talked with Jim he wanted something gritty and more realistic than the traditional Doc Ock look from the comics," Catling recalled. "The major concern was to make sure the tentacles did not look like chrome shower hoses and, secondly, how do we get all that stuff to fit elegantly under his long coat without having a bustle? Jim has an amazing sense of form and shape and an infinite eye for detail—and an enormous amount of ideas. It was my job to illustrate them."

Catling worked on developing his first designs, even as Edge FX started making prototype tentacles. Once the general look of

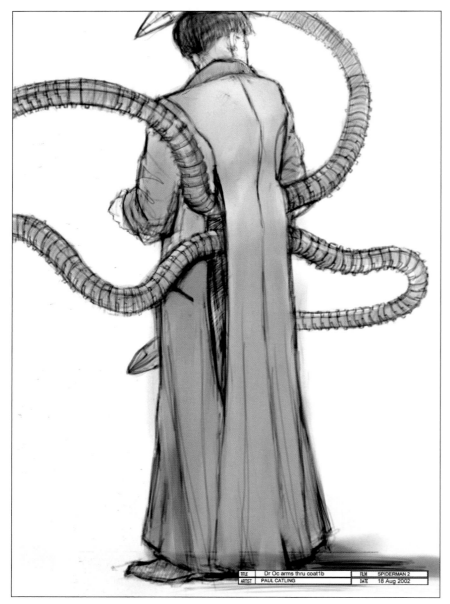

Paul Catling works out views of Ock's arms through his coat. "Paul Catling did some unbelievably beautiful work. His artwork was amazing," Neil Spisak noted.

| TITLE | Dr Oc arms thru coat1b | FILM | SPIDERMAN 2 |
| ARTIST | PAUL CATLING | DATE | 18 Aug 2002 |

"For the art department, some of the inspirations for Doc Ock were photographs of robots, mechanical equipment, wires, tubes—anything that applied helped inspire the direction. In the comic books you're basically talking about four mechanical arms coming out of his back, but how you actually make that happen mechanically is a whole other thing. Ock's arms were a whole journey."

—NEIL SPISAK, *PRODUCTION DESIGNER*

Very early study of Dr. Otto Octavius and his harness and tentacles, side view with arms at rest. Art by Paul Catling.

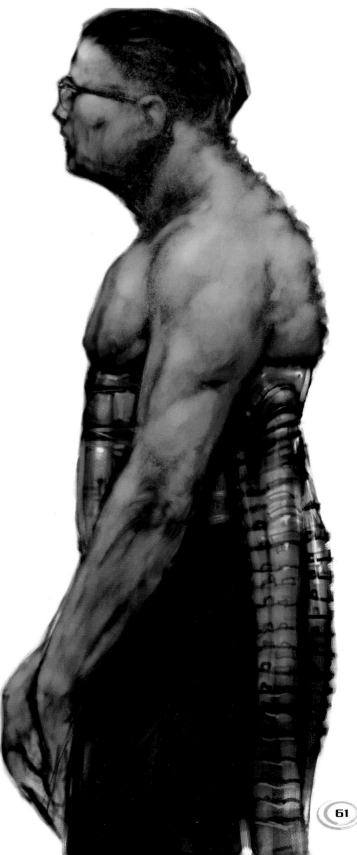

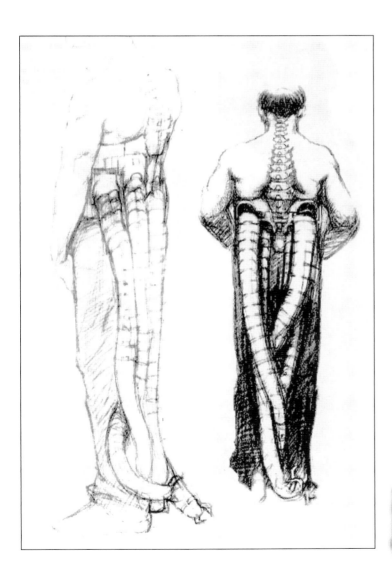

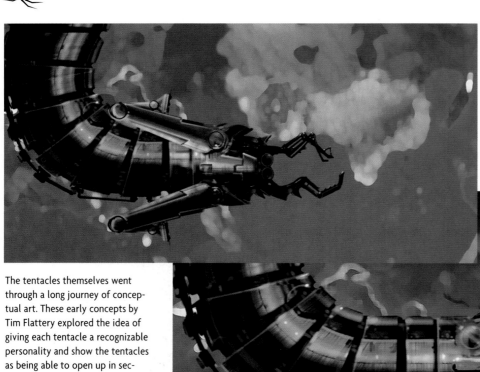

The tentacles themselves went through a long journey of conceptual art. These early concepts by Tim Flattery explored the idea of giving each tentacle a recognizable personality and show the tentacles as being able to open up in sections.

Below and opposite: Tentacle head concepts by Tim Flattery.

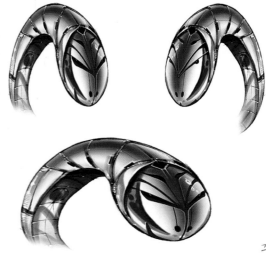

28

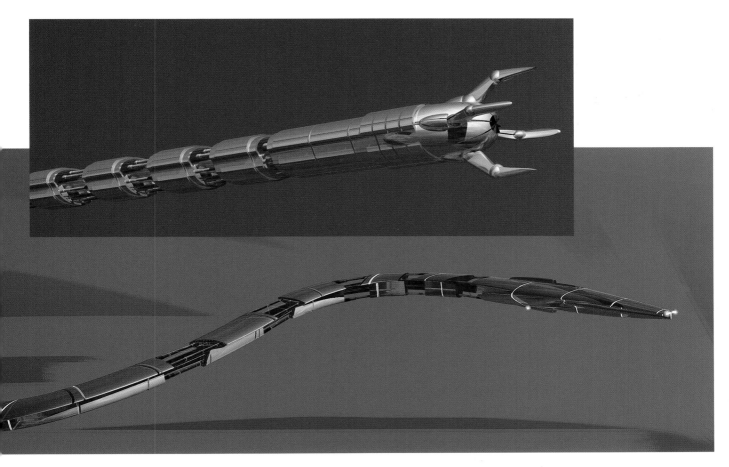

"There were a lot of tentacle drawings. We first tried to get an overall feel and experimented with jointed arms and spined tentacles in various materials: white and clear plastics, black polished steel with various nodules and spiky protuberances to give the tentacles a solid, muscled, and dangerous look. The design challenge was difficult because they needed to look tough enough to pick up heavy objects but light enough to retract. To add further menace, Jim (Acheson) suggested the tentacles should have little centipede grabbers that could spring out and bite into concrete to help Ock climb up walls; those ideas were ultimately abandoned."

—PAUL CATLING, *ILLUSTRATOR*

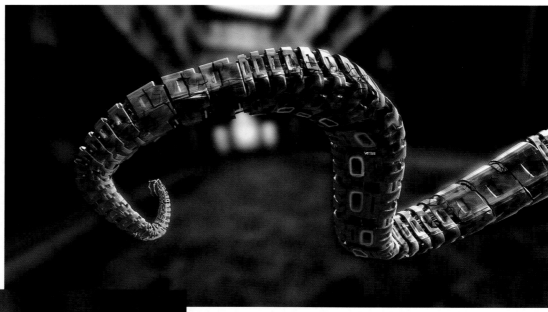

Tentacle concepts on this and facing page by Paul Catling.

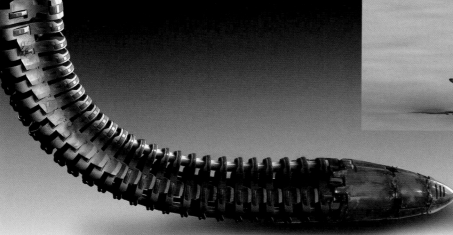

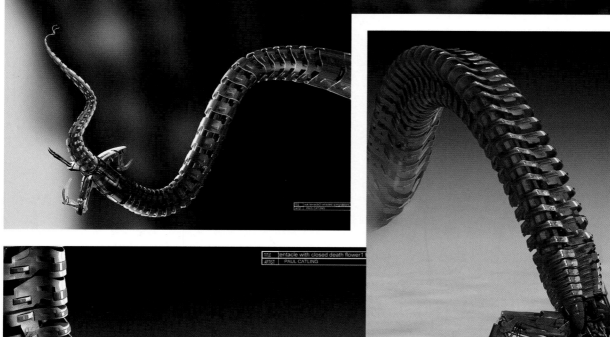

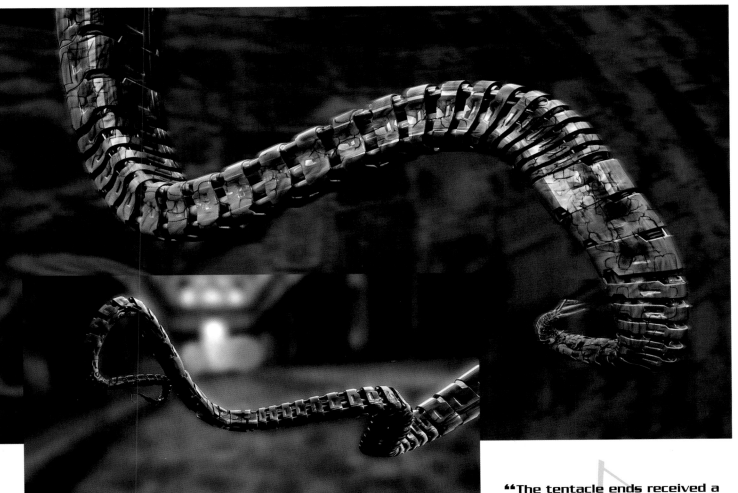

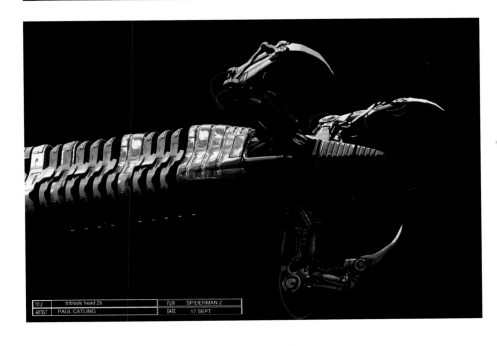

TITLE	triblade head 2b	FILM	SPIDERMAN 2
ARTIST	PAUL CATLING	DATE	17 SEPT

"The tentacle ends received a lot of attention because the grabbers had to pick up the smallest pin, but also punch through the thickest wall. Early on we experimented with a kind of flower bud shape that had three 'petals' that could open in three or four stages. This design stuck. Designs then went to Kent Jones, an amazing concept sculptor who would then adapt and realize the designs in 3-D clay.**"**

—*PAUL CATLING, ILLUSTRATOR*

Early tentacle concepts by
Paul Catling.

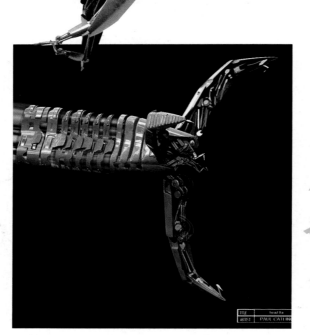

"I remember reading *Spider-Man* comics under my schoolbooks back in fourth grade. I revisited those comics at the start of both the last *Spider-Man* movie and this show. It was pretty clear in the comic books that Doc Ock is very capable and agile with those arms. We knew our CG version had to be able to do anything and be graceful doing it."
—*SCOTT STOKDYK,*
VISUAL-EFFECTS SUPERVISOR

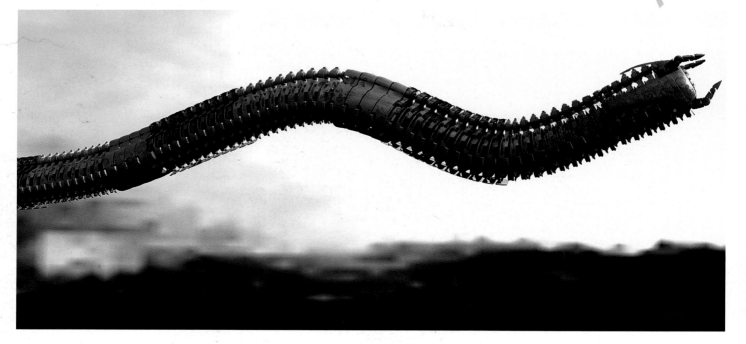

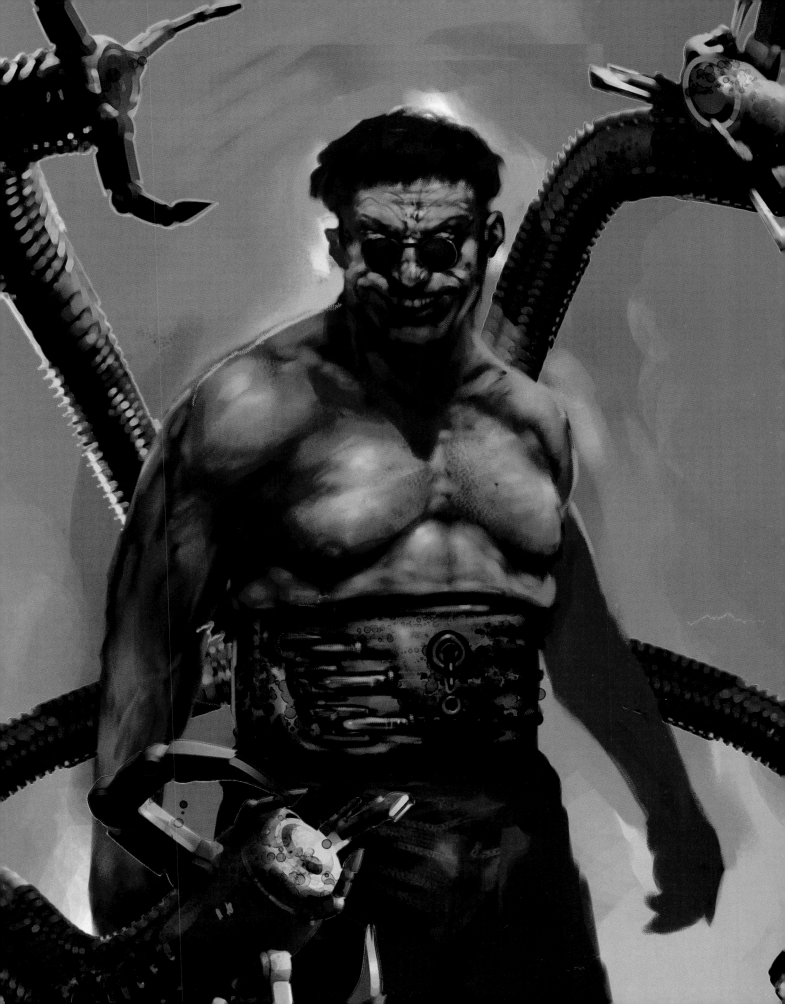

the four arms was established, the real designing began. "We had to go back to the specifics of how it would be made," Knipp explained. "Would it be metal or plastic, and what would the finish be, how heavy would the arms be, how intricate the manual manipulation of the hands and feet, do we call them 'hands' and 'feet' or 'tentacles,' do they do four different things or the same things? All these and more questions were approached over a six-week period."

"It was daunting," John Dykstra agreed, "but one of the great things about this business is that if it *isn't* daunting, you can figure the effect will be obsolete before the film is released. One of the difficult things

for Doc Ock was there was no paradigm for him. For example, we had a paradigm for the Green Goblin on his glider; we used the business of kick turns and extreme body language we've all seen from kids riding skateboards and snowboards or someone kicking off the lip of a big wave on a surfboard. But an octopus is too organic, and doesn't have the right strength to be the ultimate paradigm for this character, and Doc Ock isn't like any two-legged creature.

"He's unique, and that makes for a tough personality to create and a tough animation to achieve."

Spider-Man 2 co-producer Grant Curtis noted that the art department's work was

Opposite: Art by Paul Catling.

Below: Early drawing of back of tentacles, by Paul Catling.

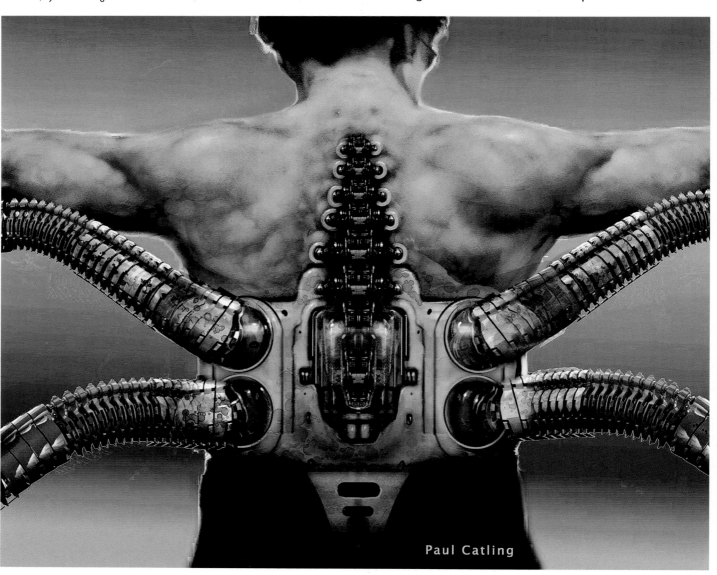

Paul Catling

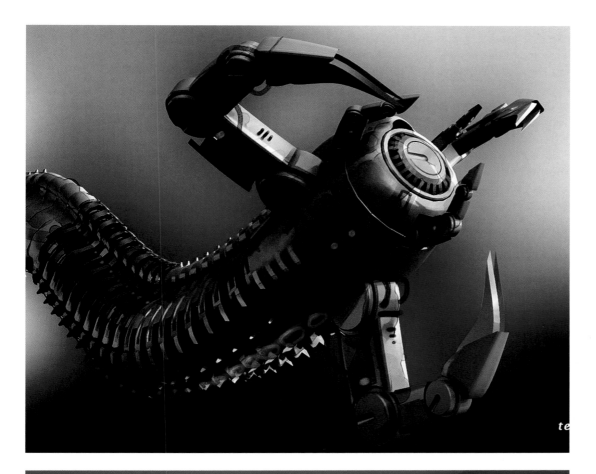

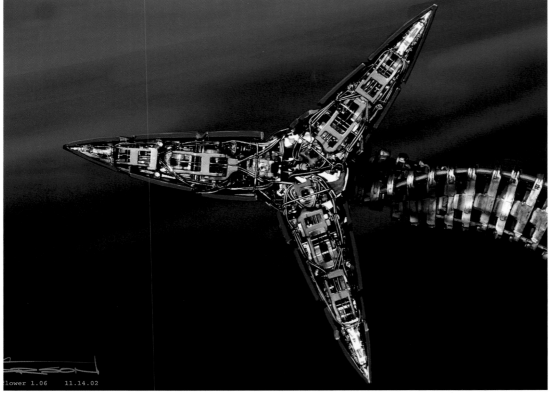

flower 1.06 11.14.02

Top: Another tentacle head design ultimately abandoned for the "death flower" design. Art by Paul Catling.

Below: This "death flower," as the deadly petal look was called, is a photograph from the physical Edge FX tentacle that James Carson scanned and in Photoshop experimented with different color looks, requested by Neil Spisak and James Acheson.

vital in visualizing how extreme the production could get with Ock's mechanical arms as they moved into actually producing them. Ultimately, the appendages were scaled back to an estimated four and a half feet at rest and thirteen feet when fully extended.

"You could make the tentacles four stories tall in the comics, but how do you explain that in the real world?" Curtis said. "When John Dykstra has to represent that in the pre-viz or CGI world, that's where the human eye starts to detect if an image starts to not make sense. Sam, Neil, John, and Jim Acheson kept coming back to this point that, yes, it's a comic book, so you can push the limits, but everything had to be grounded in the physics of the real world."

It was decided that the lower tentacles would be a base for power and capable of punching through a car or ripping apart a

fire hydrant. The lower "heads" were designed to work in scale when they were interacting with inanimate objects, giving them the massive feel of a piece of construction equipment. From there, the goal was to develop a final sleek form capable of speed and power.

Edge FX was ultimately given illustrations that inspired physical clay model carvings that finally worked out the conceptual issues in the real world, including the ability, gleaned from the comics, for Doc Ock to use his arms to climb buildings. "As those models were finished in the design process, we had meetings to tweak and add this or that," Knipp explained, "like suckers added to the bottom contours of the section pieces of the tentacles. That's where Jim Acheson introduced the octopus as a design concept."

"We had a lot of fun researching the

The clock tower scene shows the climbing abilities of Doc Ock's tentacles. Photo by Sony Pictures Imageworks.

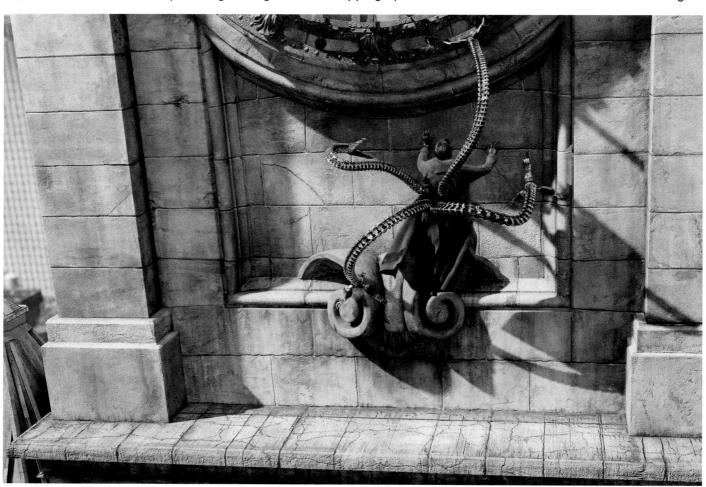

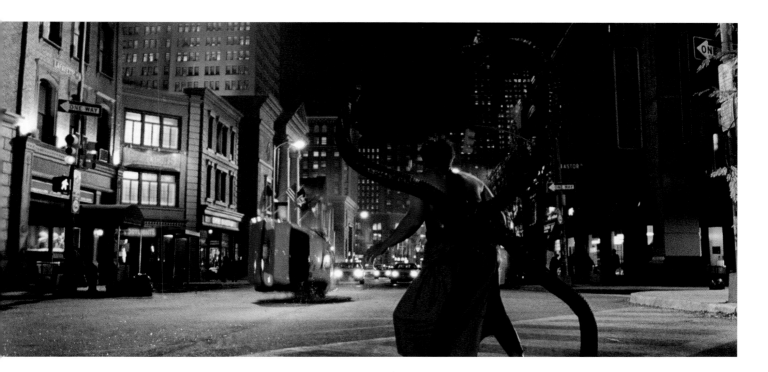

science and pseudoscience, but what remained was this concept of 'distributed processing,' " Dykstra recalled. "Researchers have discovered that octopuses have neural contact in their tentacles, the central core can decide to go somewhere and the tentacles pretty much find their way—essentially, they have a life of their own. That became part of the concept for the mechanical tentacles. As with all machines where emotion is not a component, they're very dispassionate about their task of handling fissionable material. Once things come apart with Ock's accident, they interpret their purpose on a new level, they take on a life of their own in their pursuit of fusion energy, as does Doc Ock, who becomes obsessed as any mad scientist must!"

Doc Ock, transformed by his fusion reactor accident into the powerful multi-tentacled villain, stalks the streets. The lower tentacles appear to be absorbing the energy as the upper tentacles toss a taxicab across the street. Photo by Sony Pictures Imageworks.

DR. OTTO'S FUSION DEVICE

The look and very nature of Otto's "fusion device" was one of James Carson's major assignments. "The starting point was, it needed to be big and wonderful and visual, and something that had to do with the next level of technology with potential for changing the life of all humankind," recalled Carson, who started his initial design phase with upward of thirty quick sketches.

In the big-screen version of Doc Ock, the scientist is no longer an atomic energy researcher. By 2004 energy production was a huge issue, so Dr. Octavius is now developing a potentially unlimited source of clean fusion energy, his experiments con-

ducted under the aegis of OsCorp, the company where Harry Osborn heads Special Projects after the death of his father. In fact, the future of the company is riding on Dr. Octavius's theories.

In the complex experiment, Octavius manipulates the fusion reaction with elaborate mechanical arms that form a metal spine along his spinal column. The "smart" arms themselves are wired to the scientist's brain and controlled via a neural link.

"Ock's energy fusion device evolved," Spisak noted. "We researched nuclear labs at UCLA and went to energy research places to get an idea before we came up with a movie science version of a fusion device.

Early concept for Otto's fusion device. Art by James Carson.

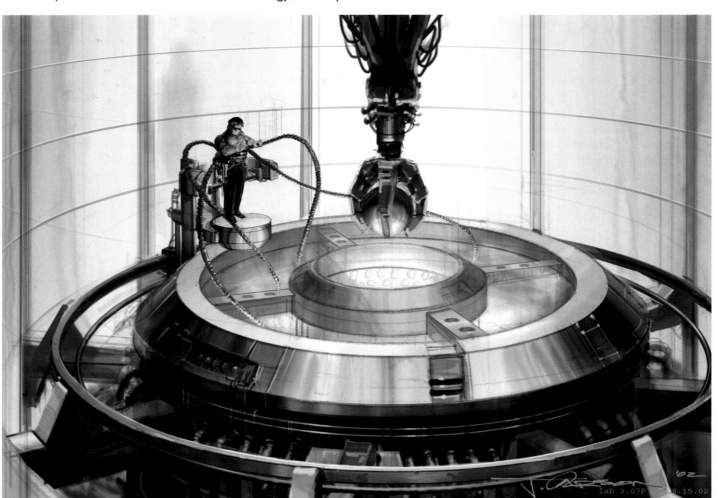

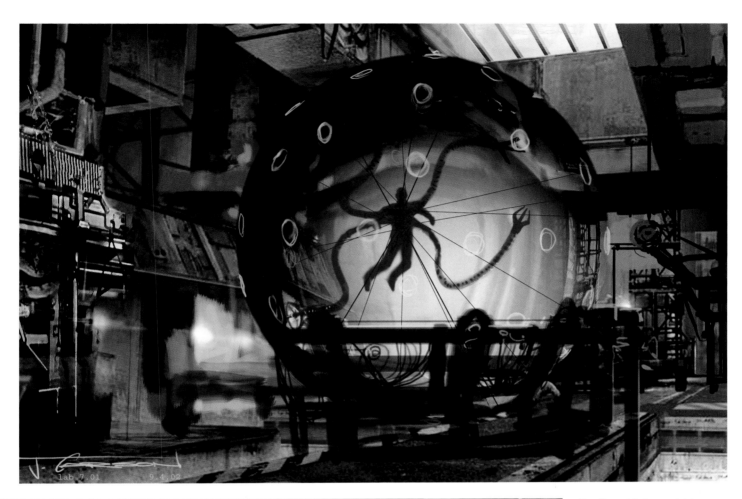

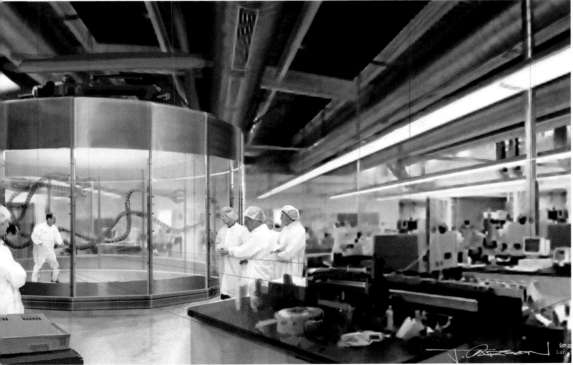

Top: "Actual fusion work takes place in a closed environment," James Carson noted, "so in this option I imagined him being encased in a translucent sphere which might contain the reaction."

Bottom: "This more traditional laboratory setting was an option for a less fantastic environment, something more generic and believable," James Carson explained. "As fantastic as *Spider-Man* is, Sam has always been concerned that the vibe be grounded in a believable environment."

Top and middle: Fusion device in open and closed positions, a notion for the experiment that was abandoned. Concepts by Robert Woodruff.

Bottom: Fusion device concept by James Carson.

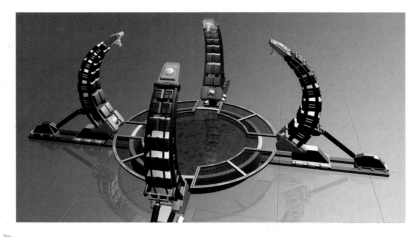

"To do pseudoscience you have to know real science, so there was a lot of discussion between Sam and Neil and John Dykstra about how the fusion device was going to work, what would be the cool way to make it happen. The producers had real scientists researching things so we could have real information to wildly veer away from."

—TOM WILKINS, ART DIRECTOR

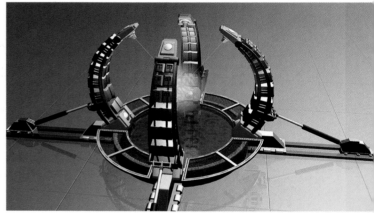

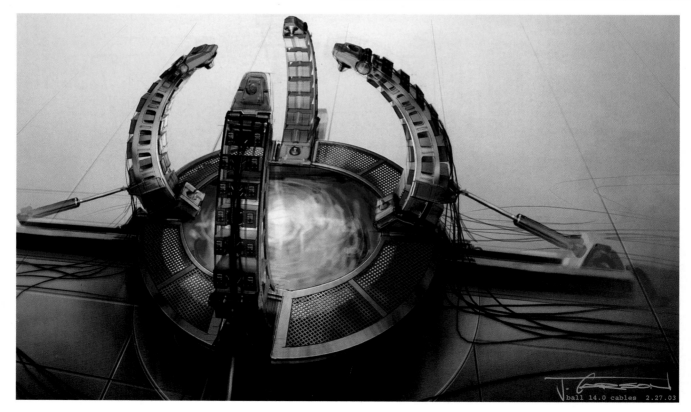

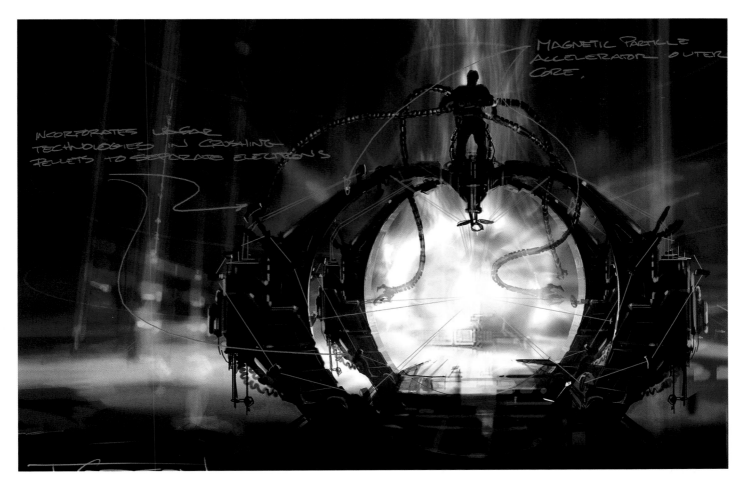

MAGNETIC PARTICLE ACCELERATOR OUTER CORE.

INCORPORATES LASER TECHNOLOGIES IN CRUSHING PELLETS TO SEPARATE ELECTRONS

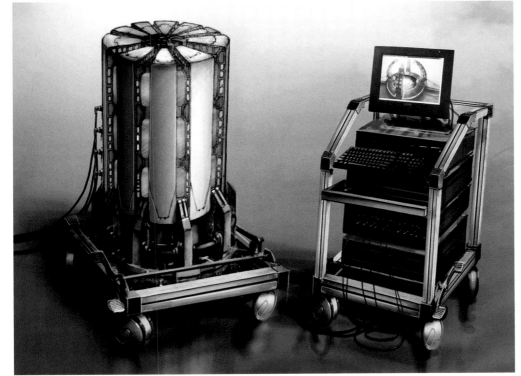

Top: Dr. Octavius's lab developed by James Carson.

Left: Final tritium storage device design by John Chichester and James Carson.

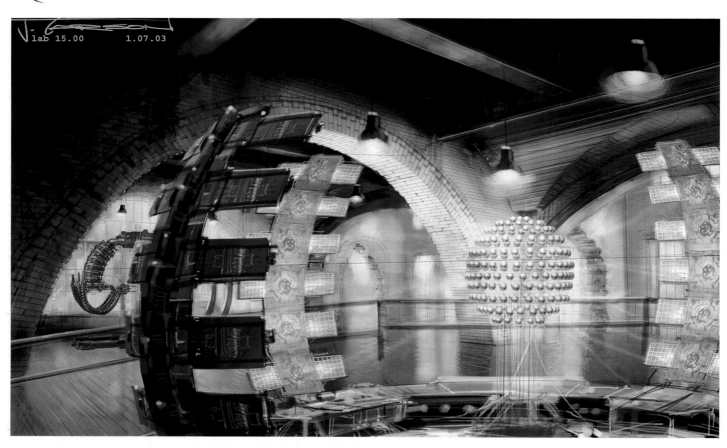

lab 15.00 1.07.03

Lab art with "revised crescents," by James Carson. Through the magic of computer software programs, digital designers can seamlessly manipulate a single image many times over.

Opposite: James Carson concept art for the circular contraption by which Ock could attach his arms (an idea that inspired the *Universal Man* mural in Ock's lab).

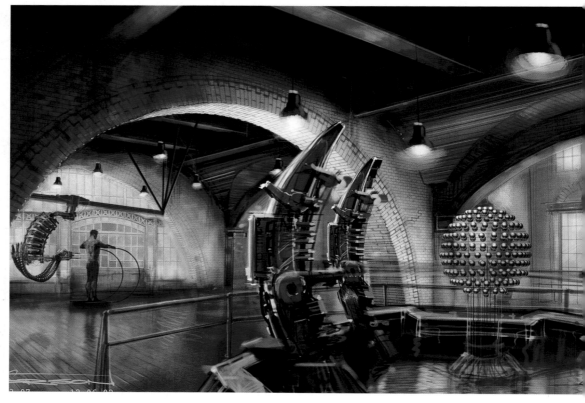

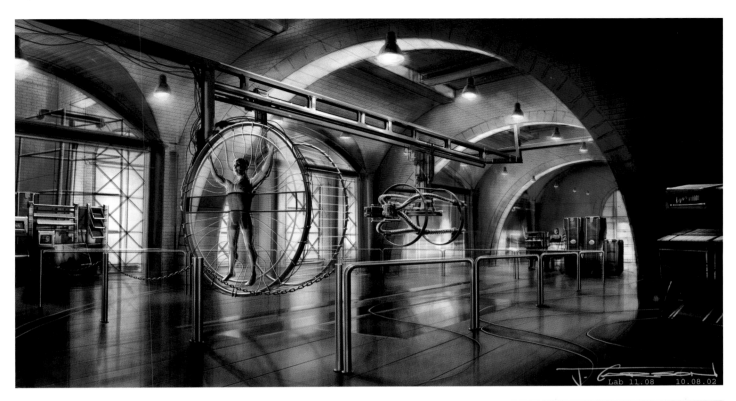

Lab 11.08 10.08.02

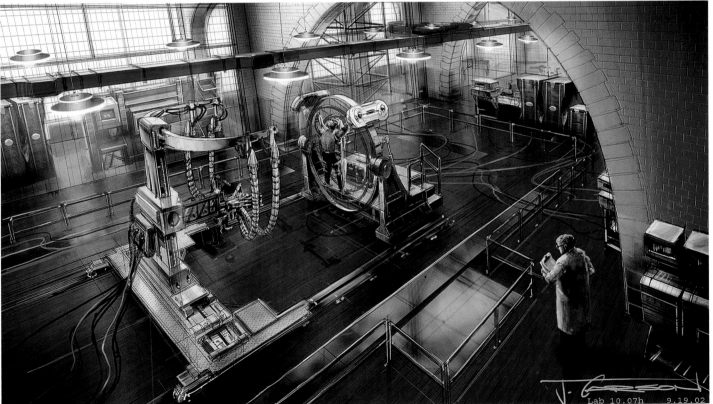

Lab 10.07h 9.19.02

Otto's lab. Series of digital designs by J. Andre Chaintreuil.

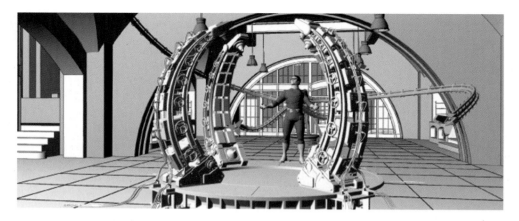

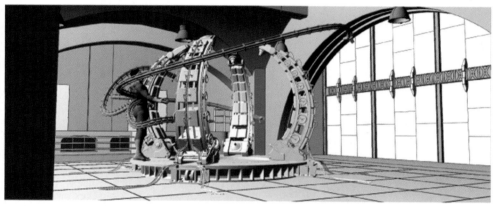

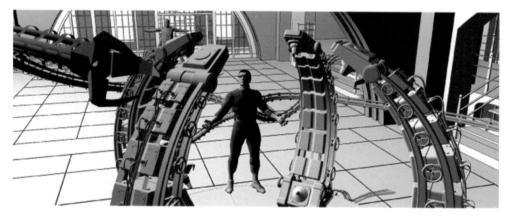

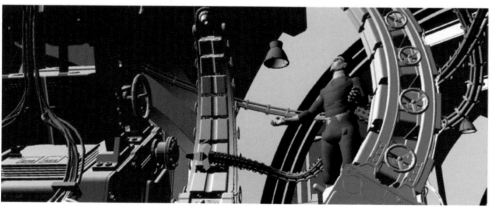

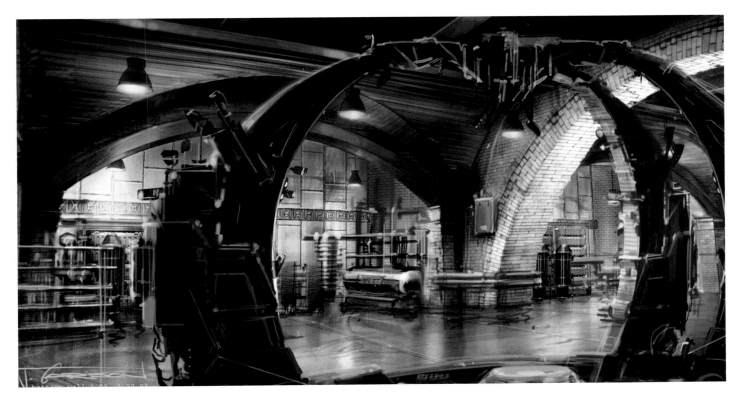

Top: "In this image we were trying to figure out the scale of the device in relation to the rest of Otto's lab," Neil Spisak noted. Art by James Carson.

Left: Otto's Lab—Arched Hallways. Digital design by J. Andre Chaintreuil.

"The vial of tritium, once acted upon, creates a burst of energy and a cycle of fusion. The crescent arms of the device create a magnetic field that contains the energy event itself, while Doc Ock uses his arms to manipulate, form, and 'sculpt' the energy."

—JAMES CARSON, ILLUSTRATOR

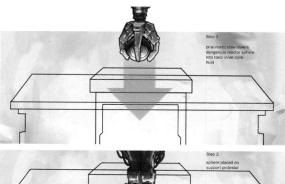

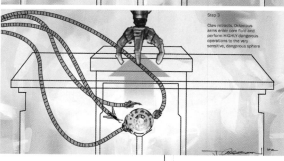

Step 1
pneumatic claw lowers dangerous reactor sphere into toxic inner core fluid

Step 2
sphere placed on support pedestal

Step 3
Claw retracts. Octopus arms enter core fluid and perform HIGHLY dangerous operations to the very sensitive, dangerous sphere

Top: Tritium power source canister designs by James Carson.

Middle left: Early concept for tritium delivery device by James Carson.

Middle right: Final tritium container design by Robert Woodruff.

Bottom: Tritium container device concept by James Carson.

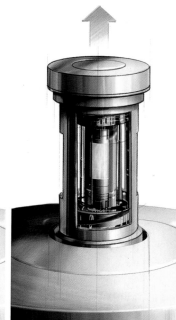
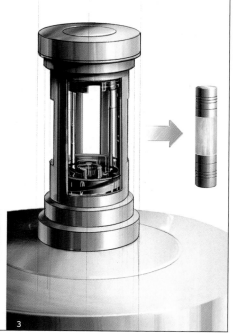

1

2

3

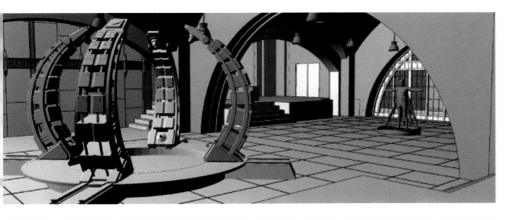

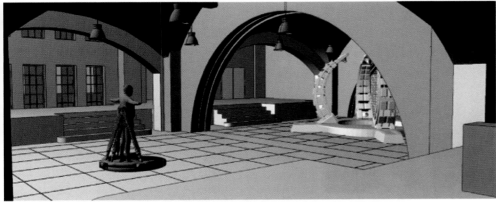

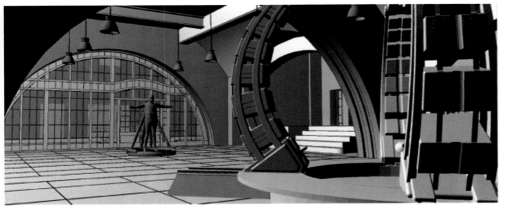

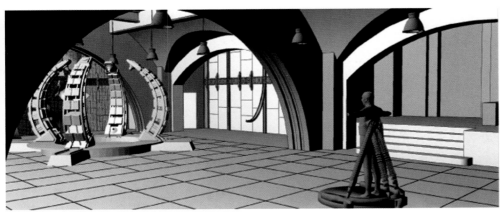

"We can take accurate measurements of the stage and model it in the computer, and then the production will know how a particular set might fit into the confines of that stage. I try to keep communication open with the construction department, and they can come do a walk through the computer model to further understand the set they are building. A computer walk-through helps you instantly understand the space—you get a feeling for what's important and what isn't in the set. I really enjoy being on a real set after working on the digital version for a long time. It's an incredible feeling because it's so familiar. You feel you could pace off a few steps and know exactly where you'll end up."

—*J. ANDRE CHAINTREUIL,*
DIGITAL SET DESIGNER

Left: "Other looks at Doc Ock's lab were about studying space and architecture, whereas this was more about how Ock would use his equipment and a little bit about framing the shot," Chaintreuil explained of his work on the sequence. "Rob Woodruff was progressing with his fusion device, and I'd take his digital model and see how the device would work within the overall set."

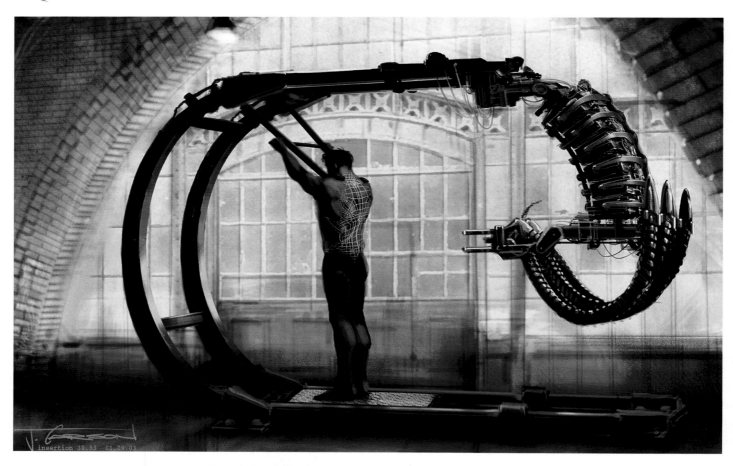

The insertion device continued to evolve in this series of concepts by James Carson. These designs followed up on Avi Arad's idea of an exercise device contraption.

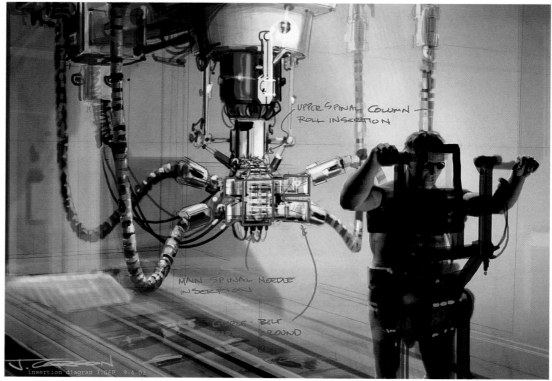

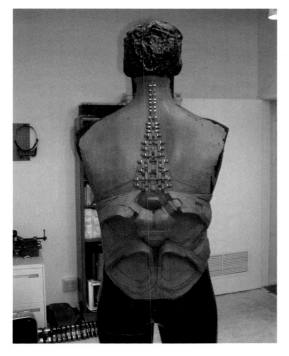

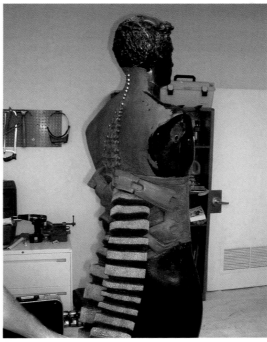

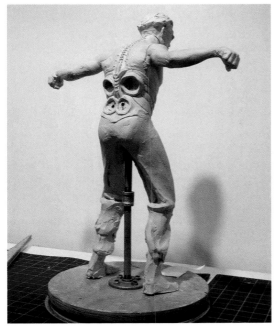

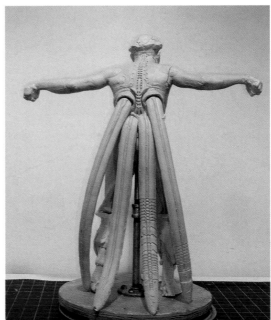

Physical sculptures by Kent Jones further developed the attachments and look of Doc Ock's tentacles.

But the concept needed to be fairly simple, because the movie is not about how this fusion device works. We were more interested in the visual look, and we applied the science to that."

In the final design, the mechanical arms were imagined as being mounted on a pedestal that Otto simply backed into. Costume designer James Acheson recalled that after months of work on the insertion device concept, they returned to a maquette produced by sculptor Kent Jones, who'd produced what Acheson called a "clay sketch" of standing tentacles. Raimi and Spisak agreed on that direction and all the ideas for a device that would attach the tentacles to Octavius—from the exercise equipment design to the circular contrap-

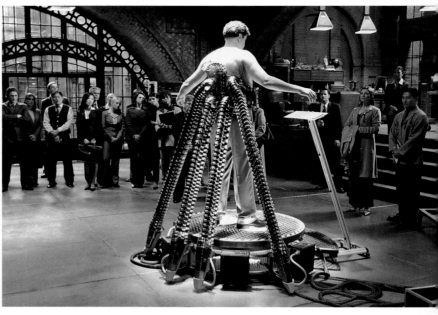

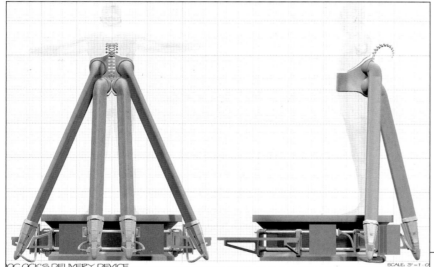

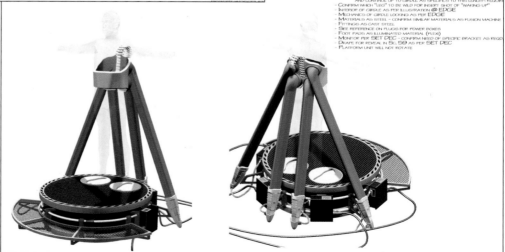

Top left, middle, and bottom: "Doc Ock's insertion device," by Robert Woodruff, developed the notion of a freestanding approach to the arms, discarding the earlier insertion device concept.

Top right: Final image of Dr. Otto Octavius in the insertion device. Photo by Melissa Moseley.

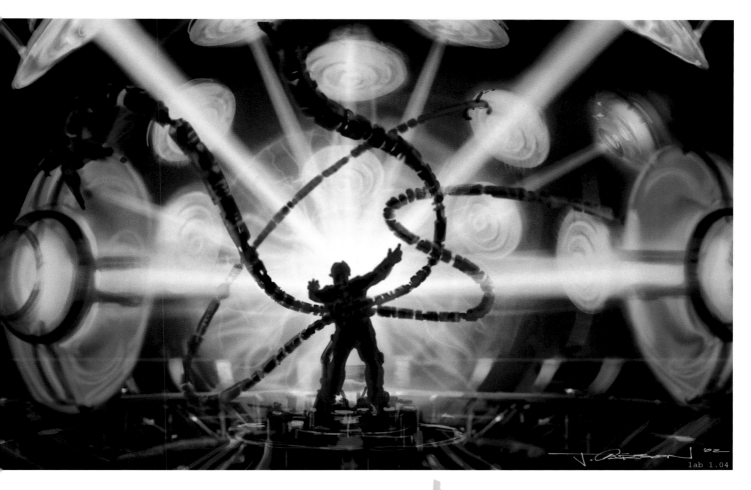

lab 1.04

tion that inspired Otto's heroic mural—were dropped.

"The important aspect was having Octavius attaching himself, forming a union with this harness and arms," James Carson noted. "The various contraptions for attaching the arms ended up adding extra steps without advancing the story. So [they were] dropped and we moved on. One of the things I respect about Sam is he's always thinking about how something moves the story and develops the characters."

"In that hub of the art department we all had initial discussions about how the arms would attach to Doc Ock and how his accident would occur. For his experiment, we took our cue from the comics in which Doc Ock is an atomic scientist. Having his experiment be this fusion device seemed to be within the same realm, but was also futuristic. Ultimately, the point is his hubris, that he's pushing the limits of something and goes too far. That seems to be a characteristic of Marvel villains."

—LAURA ZISKIN, *PRODUCER*

Fusion device concept by James Carson.

THE ACCIDENT

In his classic comics origin story, Dr. Otto Octavius's four mechanical arms are appendages extending from a metal contraption that, in the occasionally inexplicable logic of comics, becomes attached to his body "in some strange way," as one of the doctors attending to the injured Dr. Octavius notes, after a radiation accident.

In *Spider-Man 2* the tentacles become clearly *fused* to the doctor's flesh, a notion that tested the fragile balance between heightened reality and Super Hero fantasy,

as Neil Spisak observed. "The challenge with Ock was to make the fused tentacles look like 'that could have happened,' to provide some reality and credibility with these four arms sticking out his back and not go to some unbelievable comic book level that would take audiences out of the story. We wanted to be true to the comic book, and translating something from that genre to a movie always poses a dilemma, because something you can draw for a comic book becomes very difficult in live-action."

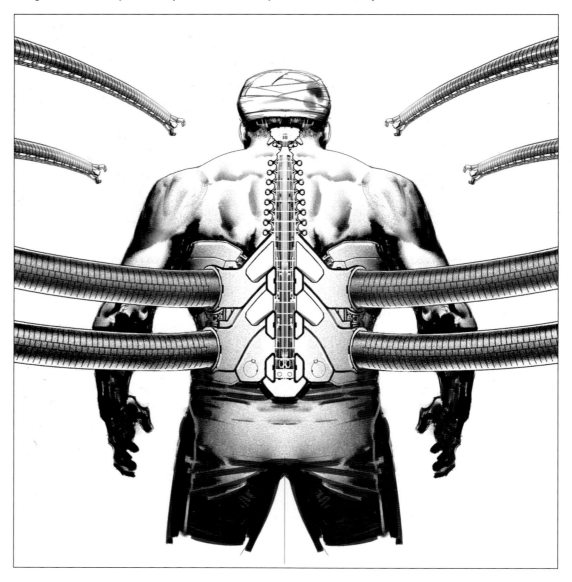

Doc Ock "post accident arms extended." Art by Adam Brockbank.

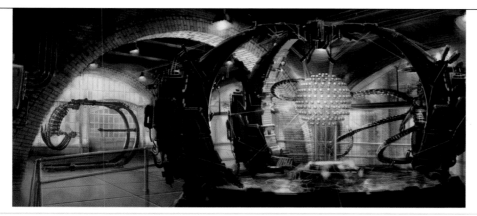

Art department research spells out in images and text the science and pseudoscience behind the fusion reactor. Art by James Carson.

ACTUAL (From "Physics in the 20th Century" by Suplee, Curt. pub 1999 Abrams Books, pg. 135):
Another way to encourage nuclear fusion is to squeeze a small ball of hydrogen so hard that the nuclei bump and fuse—a method called inertial confinement. This time exposure photograph, below, from the fusion facility at Sandia National Laboratory in New Mexico shows electrical arcs that result when the device is fired. Enormous currents heat a cage of thread-like wires the size of a pill bottle, producing X-rays. The radiation vaporizes the surface of a BB-sized ball of hydrogen inside the cage, compressing it.

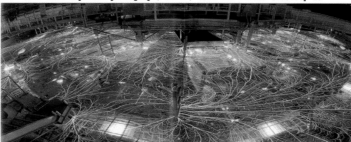

ACTUAL (From "Physics in the 20th Century" by Suplee, Curt. pub 1999 Abrams Books):
In order to accelerate charged particles to high energies, physicists give them repeated shoves with radio waves. Each perfectly timed shove boosts the particles' energy, just as pushing a child on a swing at the right moment will cause her to swing higher. The wave guides that direct the radio waves, such as this one from the Stanford Linear Accelerator Center, at left, often have the spare beauty of Native American art.

DR. OTTO OCTAVIUS' LAB:

A way Dr. Otto Octavius encourages nuclear fusion is to squeeze a small ball of hydrogen so hard that the nuclei bump and fuse—a method called inertial confinement. This diagram of his lab in New York shows electrical arcs (blue) that result when the device is fired. Enormous currents emanating from the conductive pool are routed up to the 3ft. diameter sphere, which heat cages of thread-like wires the size of tennis balls, producing X-rays. The radiation vaporizes the surface of BB-sized balls of hydrogen inside the cages, compressing them.

HYDROGEN PELLETS LASERS

In order to accelerate the charged particles to even higher energies, Dr. Octavius developed large ribbed-shaped structures that houses focused lasers(Red), giving the arcs and hydrogen pellets repeated shoves. Each perfectly timed shove boosts the particles' energy, just as pushing a child on a swing at the right moment will cause her to swing higher.

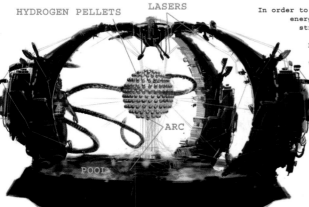

ARC

POOL

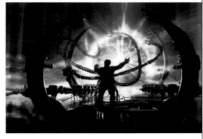

The main problem with this system is the potential volatility of the arcs and fusion. Due to innate particles that are in the air, the arcs and laser beams are invariably thrown off-course, resulting in a non-direct hit to the heat cages of the hydrogen pellets. Dr. Octavius developed his neural-interfaced mechanical arms to provide near instantaneous adjustment and redirection to facilitate fusion. Although a human beings processing and reaction time are too slow to achieve this alone, if neurally connected to sensors through the brain, which is infinitely more powerful than any computer, the redirection and ultimate fusion is possible.

J. CARSON
lab 13.09 explanation 1-10-03

"When we first meet Dr. Octavius he's a noble yet self-absorbed man who's built these mechanical arms to create an energy source that will benefit mankind. But during the explosion the tentacles take over his brain and he becomes the personality of what the tentacles are. It's like he was once human and had a heart but the machine has taken over. He's lost his heart and becomes driven beyond any human compassion."

—JEFF KNIPP, ART DIRECTOR

The accident. Concept art by James Carson.

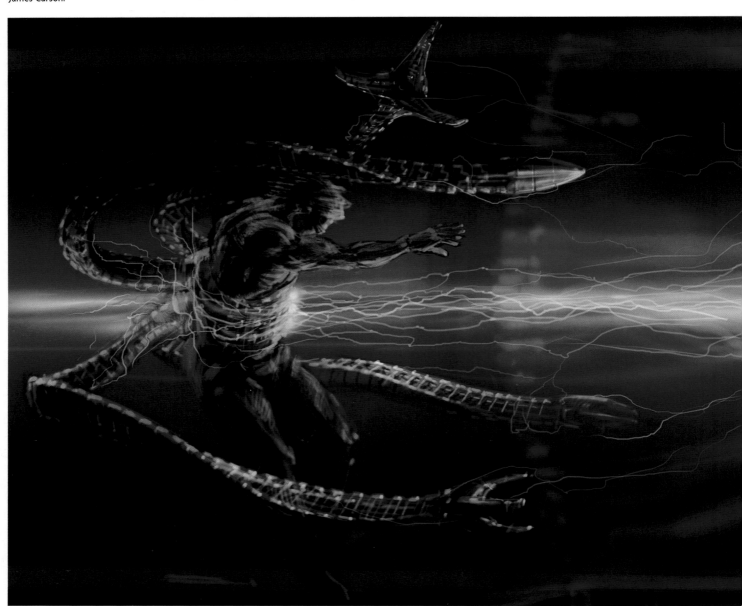

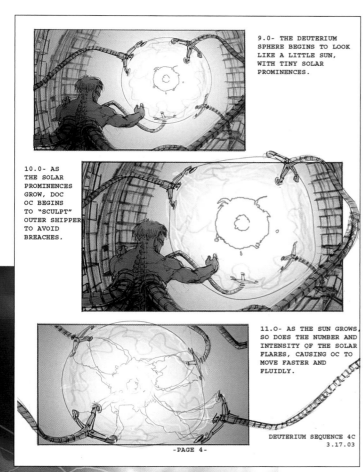

9.0- THE DEUTERIUM SPHERE BEGINS TO LOOK LIKE A LITTLE SUN, WITH TINY SOLAR PROMINENCES.

10.0- AS THE SOLAR PROMINENCES GROW, DOC OC BEGINS TO "SCULPT" OUTER SHIPPER TO AVOID BREACHES.

11.0- AS THE SUN GROWS, SO DOES THE NUMBER AND INTENSITY OF THE SOLAR FLARES, CAUSING OC TO MOVE FASTER AND FLUIDLY.

DEUTERIUM SEQUENCE 4C
3.17.03

-PAGE 4-

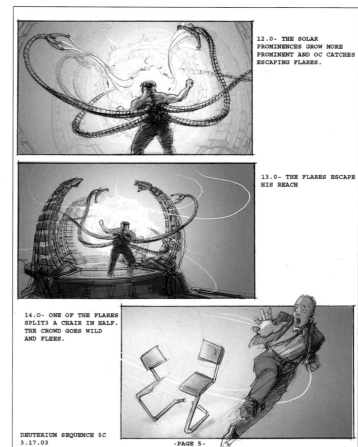

12.0- THE SOLAR PROMINENCES GROW MORE PROMINENT AND OC CATCHES ESCAPING FLARES.

13.0- THE FLARES ESCAPE HIS REACH

14.0- ONE OF THE FLARES SPLIT3 A CHAIR IN HALF. THE CROWD GOES WILD AND FLEES.

DEUTERIUM SEQUENCE 5C
3.17.03

-PAGE 5-

This storyboard-style sequence by James Carson details the fusion reaction event and was a precursor to the final approved "light sequence."

"All the metal in this room is supposed to be sucked toward one point in space, the center of the fusion event. The walls are far enough away so the metal was pulled out, ripping the mural."

—JAMES CARSON, ILLUSTATOR

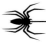

lab 16.09 boom 03.18.03

Right: "Boom!" Concept art by James Carson.

Bottom: The final light sequence approved by Sam Raimi for the actual fusion reaction that Sony Pictures Imageworks would emulate in CG. Concept art by James Carson.

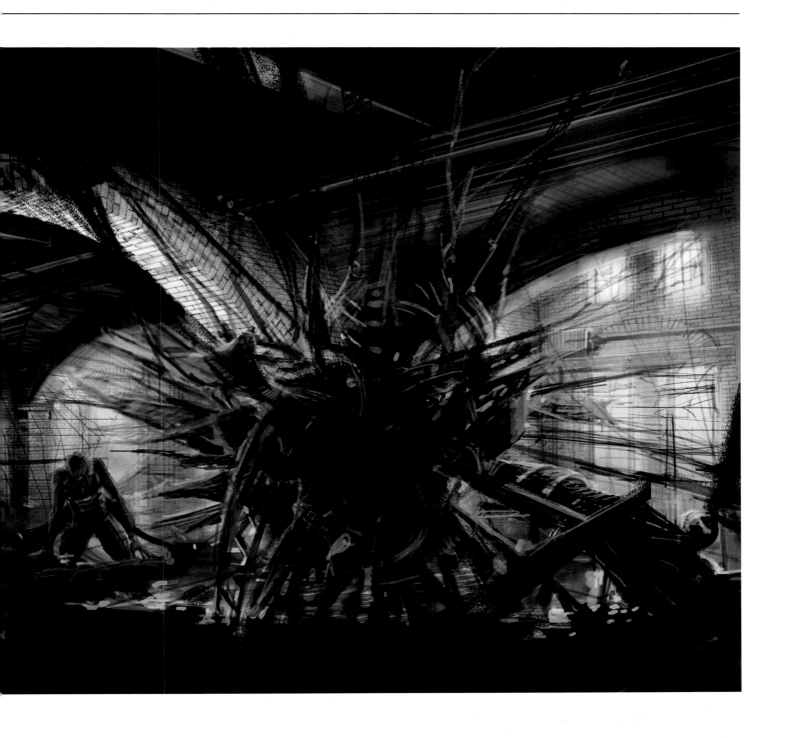

DOC OCK IS BORN

When Dr. Otto Octavius awakes in the hospital after the disastrous fusion energy accident, he's reborn—he's truly become Doc Ock, and in his horrifying reaction, the living tentacles lash out at the doctors and hospital staff.

Sam Raimi and his team of storyboard and animatic artists spent months designing the "hospital attack sequence," which marked the official start of principal photography in March 2003. As DP Bill Pope recalled, "It was Alfred's first shooting day and we went in to shoot this elaborate fight sequence just to get our feet wet, something we could pass off as a test.

"But this 'test' sequence is what's in the final film. And from there, and as the script got closer and closer to finalization, our learning curve went up steeply. For Sam and Neil and everybody it was about having a palette we all were working from, an idea of what our view of Manhattan should look like, how to improve on things while also allowing it to fit into the first movie."

The mural in Doc Ock's ruined lab was originally to have been featured in a poignant sequence in which the dazed Octavius realizes his horrible fate—but, as noted earlier, the dramatic sequence was another dream and design that never materialized before the cameras.

"The original idea was that after Ock broke out of the hospital he'd come back to the ruined lab where this twisted metal from the accident would reveal this freakish, fun-house reflection of himself," Tom

In this moody concept Doc Ock returns to his ruined lab, now the site of his greatest failure, where he sees the ruined heroic mural of himself. Both the return and the mural itself were discarded during the conceptual process. Art by James Carson.

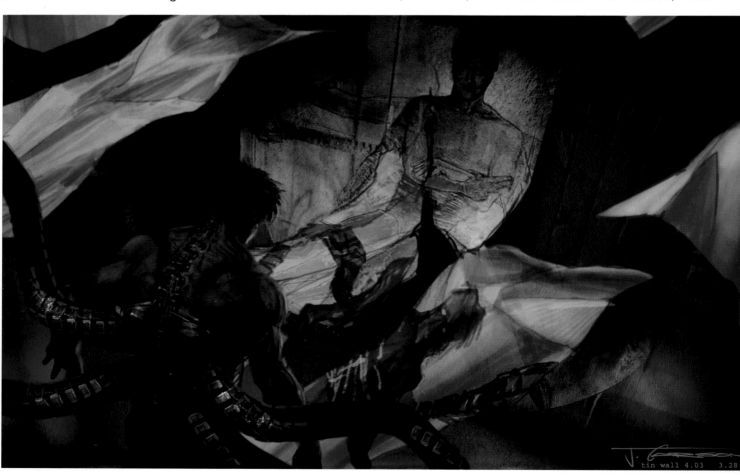

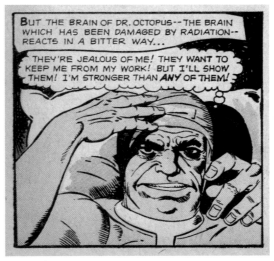

Wilkins recalled. "We had this big plan for the 'post-destruction' scene where it's raining and the lab windows are all blown out and the tentacles are talking to him while he's talking to himself and his tentacles, wondering how he became this madman. He was supposed to have this big soliloquy and then Peter Parker would come in and he'd throw him out the window.

"I remember the meeting where we were pre-vizing how the fusion device would work and Sam and Laura and Avi and Neil and Dykstra and everybody was there and they decided *not* to do the scene, that they'd do it in the pier instead. It was like, 'Wow! Okay . . .' That whole sequence was moved to the pier, where Doc Ock rebuilds his fusion device."

Middle: In the classic comics, Doctor Octopus's inherent ego gets pumped up to megalomaniacal heights by his radiation exposure. In *Spider-Man 2,* the doctor is a dedicated scientist transformed into the powerful, multi-tentacled Doc Ock after a demonstration of his latest creation goes horribly wrong. *The Amazing Spider-Man* #3, July 1963, "Spider-Man versus Doctor Octopus," select panel. Artist: Steve Ditko.

Top left: In *Ultimate Spider-Man,* writer Brian Michael Bendis and artist Mark Bagley (with Art Thibert inks) update Doctor Octopus, showing the deadly arms fused to his flesh. *Ultimate Spider-Man* #14, December 2001.

Top right: Live-action still shows the menacing reach of the physical tentacles created by Edge FX. Photo by Melissa Moseley.

"Our story starts with tentacles initially designed for laboratory use, so they're more sterile and functional. And then there's the accident where Doc Ock is born and those tentacles are no longer clean and chrome, they're now charred. It's almost like they've matured, like a soldier who's gone through basic training and has come back from the war. It's a different world, the battle scars are there."

—AVI ARAD, *PRODUCER*

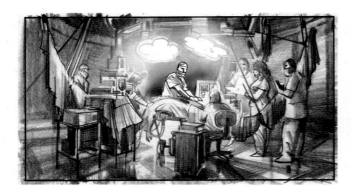

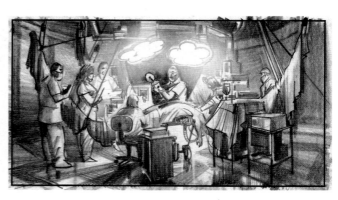

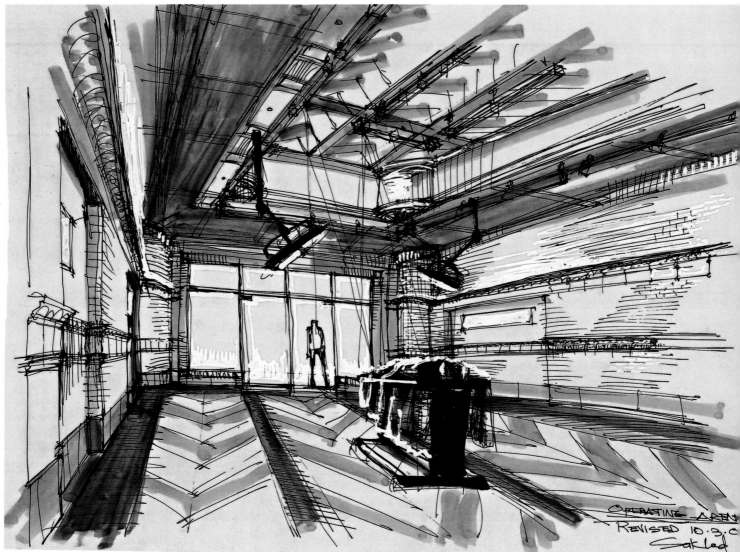

OPERATING AREA
REVISED 10.3.C
Saklad

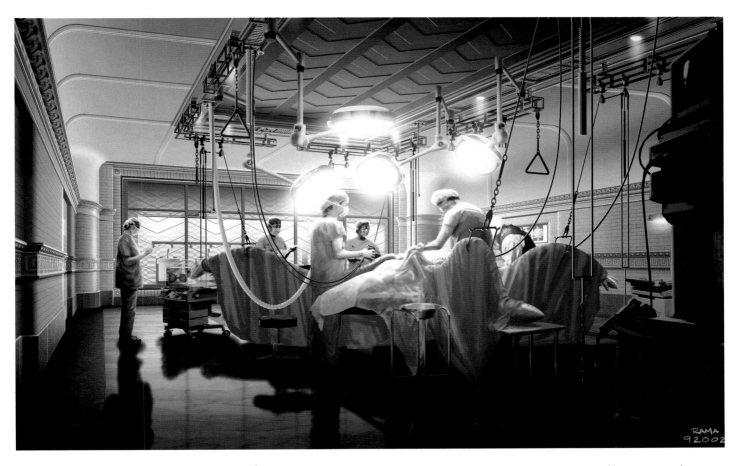

Top and bottom: Hospital operating room. Concept art by Jamie Rama.

Opposite top: Doc Ock operating room sequence by storyboard artist David Lowery.

Opposite bottom: Hospital operating room concept art by Steve Saklad.

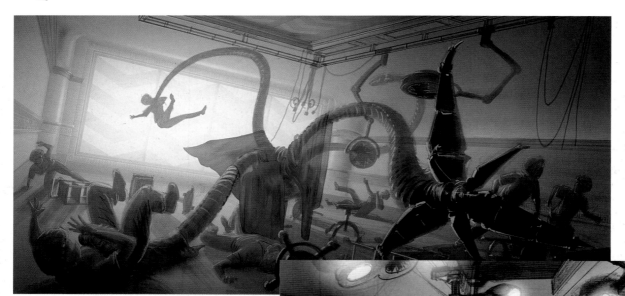

Top: Hospital attack. Art by Jamie Rama.

Middle right: Hospital attack aftermath. Art by animatic artist Anthony Zierhut.

Bottom: Final hospital attack as seen in the film. Photo by Sony Pictures Imageworks.

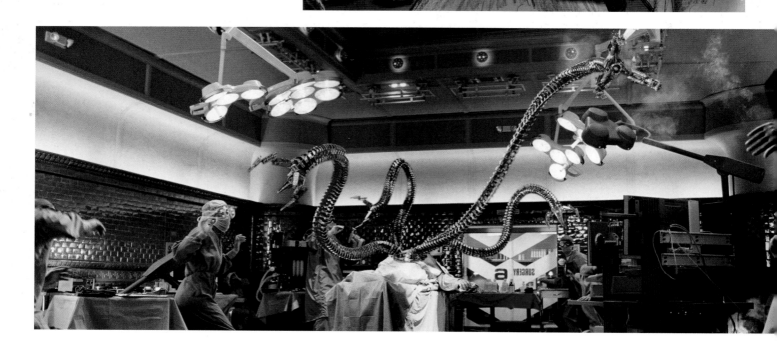

"I originally had an idea of having Doc Ock, naked from the operating table, come crashing into a dry cleaner and attack this conveyor belt where the clothes are wrapped in plastic bagging, and find some clothes for himself. In one filmed version he finds a vintage clothing shop and smashes a display window and plucks a trench coat, boots, and trousers off a mannequin that conveniently fit our boy! I was actually grateful when Doc Ock fell off the perch in the first *Spider-Man* and we went with the Green Goblin. For me, the character is one of those unresolved comic images—how *does* he put his clothes on? In the end we just see him conveniently clothed.**"**

—*JAMES ACHESON, COSTUME DESIGNER*

"There are many long coats worn in movies now, in films like *The Matrix*," costume designer James Acheson observed. "But for Doc Ock we had to have a long coat for practical reasons, to hide his tentacles. Although his trench coat was designed, we tried to make it look more like regular clothing."

The production's first consideration of Doc Ock in the flesh, as noted earlier, was outfitting and photographing an apprentice editor, with hoses representing the "arms," hung from the ceiling of the art department. "That was our first real glimpse of how big, and *long*, these tentacles would be," Spisak recalled. "You can learn a lot from something as incredibly simple as that [leading] to what it became, which was a sophisticated piece of machinery with wires and cables and servos, as well as John Dykstra's computer-generated version."

The physical device worn by actor Alfred Molina featured the mechanical arms puppeteered by Edge FX, which became the model for the digital version built by the visual-effects crew. As the puppeteers became conversant with the tentacles and experimented with movement concepts, so did the Imageworks CG animators working under supervisor Anthony LaMolinara.

"We moved forward in parallel," Dykstra explained. "Although the practical and CG applications could be used interchangeably, it turned out that the best application of the puppet tentacles was local stuff: seeing the arms coming out of his back and moving in and out of frame, picking up a flower, tak-

Opposite page and below: Early concept drawings by Temple Clark.

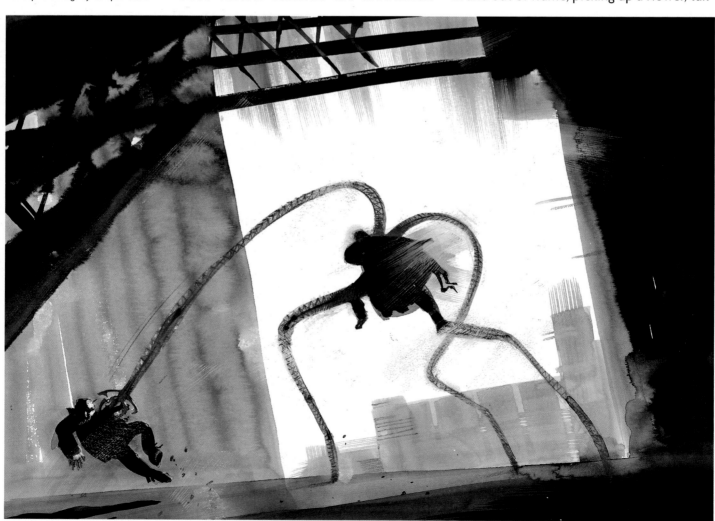

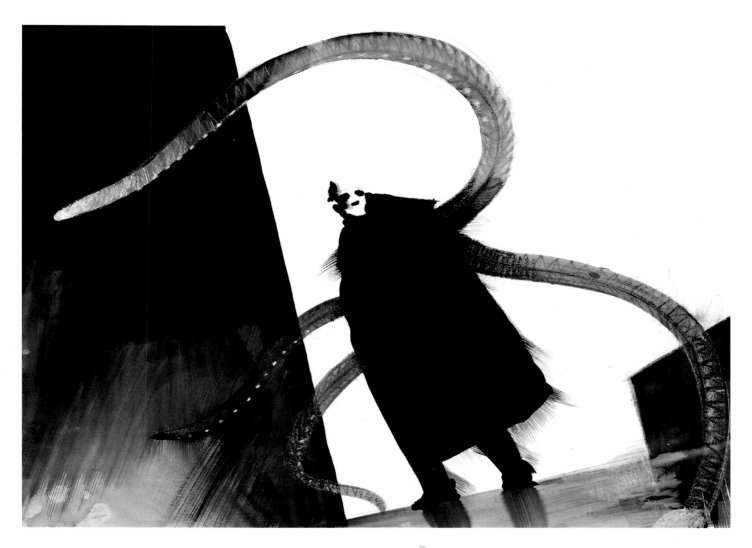

ing off his hat. The CG tentacles were used more for wider shots and more of the broad performances, where we'd see Doc Ock moving up the side of a building or lifting something heavy.

"The making of a movie is a collaboration, it's one of the few arts that really can only be done that way," Dykstra added. "The creation of a film is a living document; there's a lot of innovation, and epiphanies happening along the way. As we worked with CG characters new personality traits came up, such as the personality Alfred defined for the villain in this film, and how that related to the look of his character."

It's always difficult for computer graphics to create realistic organic material—things like water, human flesh, hair—but the machinelike tentacles were no cinch in CG,

"What was so compelling about Doc Ock, why he became the adversary in the second film, is this image of a man with four mechanical arms that become part of him—he's a prisoner of those arms, in a way. But Ock can also operate in Spider-Man's world; he can climb buildings with those arms. The only thing we played a little fast and loose with was in the comics he's kind of this mad scientist, and for the movie we enlarged on his life story."

—LAURA ZISKIN, PRODUCER

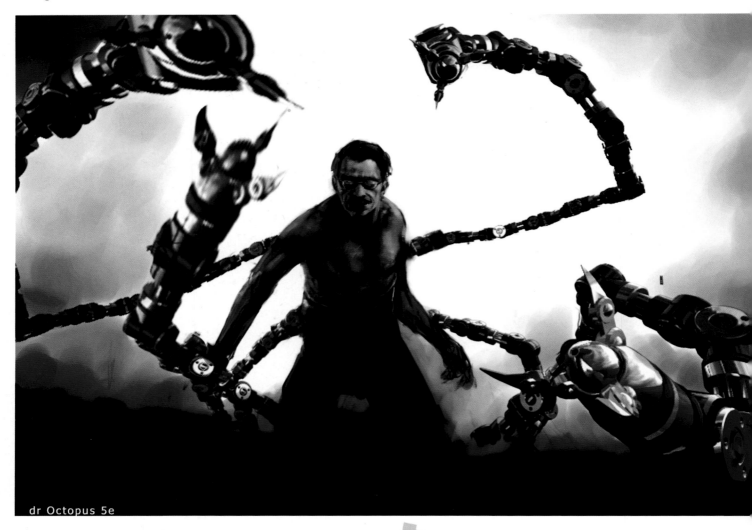

dr Octopus 5e

Doc Ock unleashed. Art by Paul Catling.

"The toughest thing about the CG tentacles was the animation—it was hard to give them the fluidity and strength the script called for, and still make them mechanical. One problem was, even in their compressed state they're nearly six feet long. If they were bolted to a wall it wouldn't be so bad, but they're on a guy who's walking around, so the arms had to respond to his movements. They had to move in precision but not look too precise, they had to look mechanical yet be organic. It was a tough middle ground to hit. The critical thing was those tentacles had to be a foil for the character of Doc Ock, so a critical component was when Alfred Molina was cast. Once he started portraying the character and began working with the puppeteers, that really helped us because he imparted his own personality and physicality to the character. That's what gave us a good paradigm for what we wanted to do with our CG character, having Alfred at the center and the tentacles after the fact."

—JOHN DYKSTRA, *VISUAL-EFFECTS DESIGNER*

Above left: This seemingly fanciful Alex Tavoularis image of Ock handling a hot dog is actually designed to illustrate the precision and dexterity of his powerful arms.

Above right: Doc Ock takes a smoke in this classic comics image. *Amazing Spider-Man* #11, April 1963, "Turning Point," select panel. Artist: Steve Ditko.

The precise methodology of Dr. Octavius is seen in these before-and-after photos of the scientist in happier days and in his Doc Ock incarnation. Photos by Melissa Moseley.

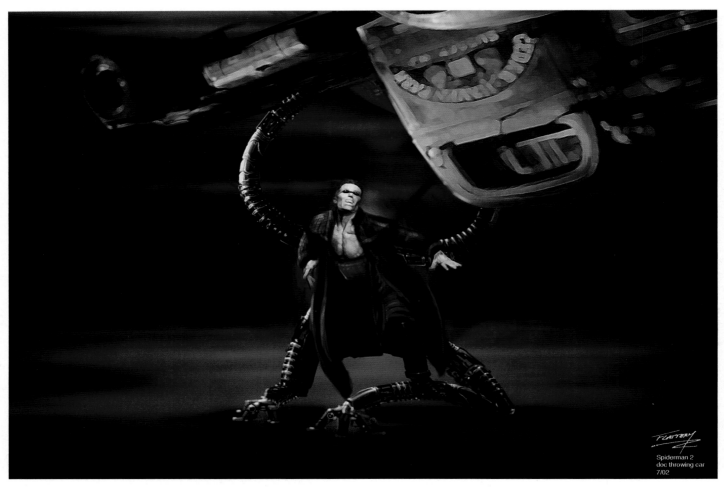

Spiderman 2
doc throwing car
7/02

Tim Flattery imagines Doc Ock lifting a car, one of the illustrations designed to determine a believable scale for such a feat.

either, particularly since Imageworks had to perfectly replicate the corrosion and destructive patterns inspired by the conceptual art.

"Having to make the CG version of these metallic tentacles both helped and hurt us," visual-effects supervisor Scott Stokdyk noted. "It helped us in that there were shinier parts and more finished parts which allowed us to catch light in different ways and create an interesting look. The downside was, we had to paint more textures and build more geometry and they took longer to animate. We also had to perfectly match the specific textures of the puppet arms so that they could cut together, but in that case we were able to scan the physical pieces themselves and match them exactly at the point Imageworks got involved in the modeling process."

Scott Stokdyk noted the CG Doc Ock started with motion-study tests and setups for the CG tentacles around July of 2002, only a month after Imageworks' first *Spider-Man 2* meetings. By May of 2003, the effects house delivered its first shots, which were based on plates shot for the hospital sequence in which Doc Ock awakes, shots that incorporated both CG tentacles and wire removals for the puppetry of the physical arm effects. By September of 2003, after the brunt of the summer's principal photography, and even as the pier set was in construction on Stage 30, Imageworks' animators were into the heavy post-production period of visual-effects work.

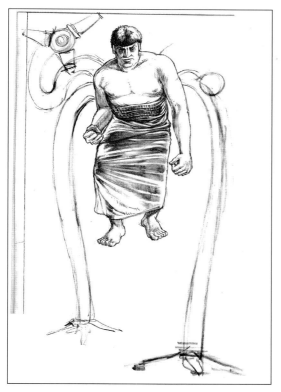

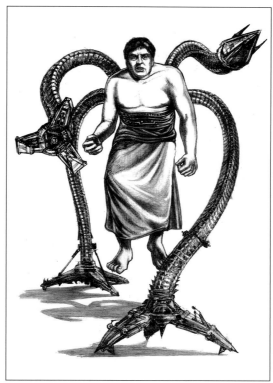

Doc Ock concept art by Alex Tavoularis.

Spider-Man 2 propmaster Douglas Harlocker commissioned graphic artist Francois Audouy to create *Daily Bugle* covers for the sequel. Alex Tavoularis's art was used as an artist's composite of Ock for this "Doc Ock Still at Large" *Daily Bugle* cover.

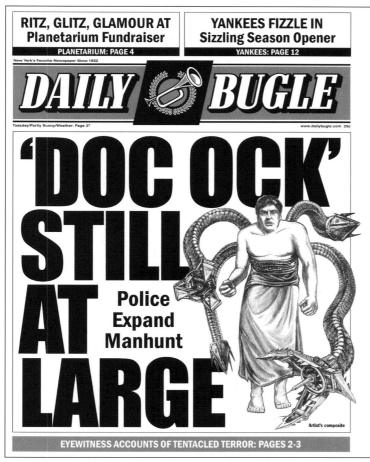

RITZ, GLITZ, GLAMOUR AT Planetarium Fundraiser

PLANETARIUM: PAGE 4

YANKEES FIZZLE IN Sizzling Season Opener

YANKEES: PAGE 12

New York's Favorite Newspaper Since 1932

DAILY BUGLE

Tuesday/Partly Sunny/Weather: Page 37

www.dailybugle.com 25c

'DOC OCK' STILL AT LARGE

Police Expand Manhunt

Artist's composite

EYEWITNESS ACCOUNTS OF TENTACLED TERROR: PAGES 2-3

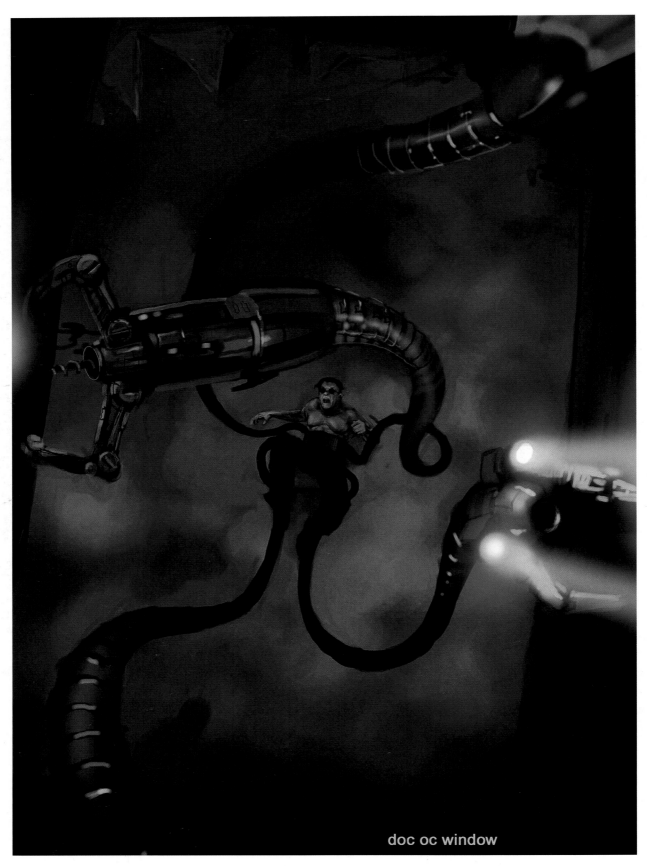

doc oc window

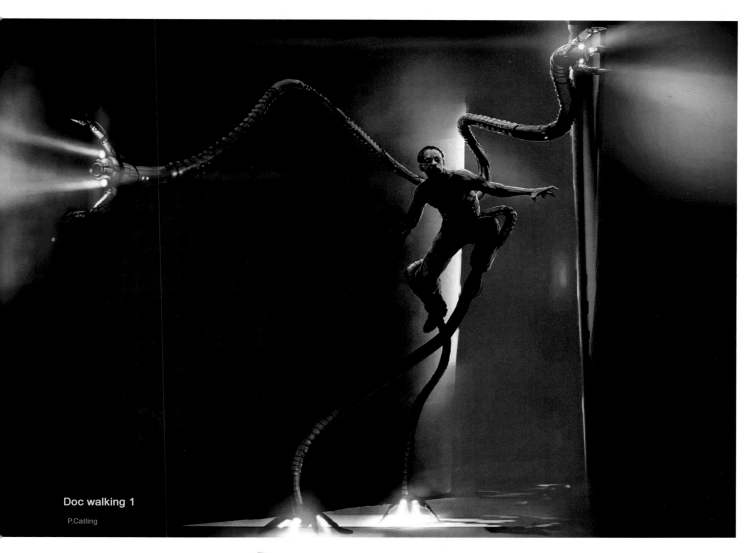

Doc walking 1

P.Catling

"Everything we do in effects is rooted in the physics of the real world, like the weight of Ock's tentacles and how fast he could move up and down a building. In 2-D there are so many ways you can cheat that, whether you're talking about the comic books or concept art. Once you get the [live-action photography] plate and the CG elements and have to go into the real world, you can cheat things while still being rooted in reality. For example, when we're animating our CG tentacles in 'real' 3-D space we can scale them for a better composition, which is something you can't do in the real world, or when our CG Spider-Man is falling we can have him falling faster or slower than he would drop from real gravity. But you cheat just a little, because too much will obviously deviate from reality. It's basically about artistic license."

—*Scott Stokdyk, VISUAL-EFFECTS SUPERVISOR*

The concept artists all had a go at working out the look of Doc Ock in action. It was key to the final look of the character, particularly in the scale and believability of Sony Pictures Imageworks' CG incarnation.

Opposite and above: Art by Paul Catling.

The clock tower was one of the most dramatic battlegrounds for Spider-Man and Doc Ock, as well as one of the major sets. Set designer Andrea Dopaso estimated the clock face at twenty-two feet in diameter, echoing Big Ben in London. Dopaso compared the clock tower, which would be enlarged upon in CG, to the first film's Times Square balcony set, which was built on a soundstage and the rest of the building digitally extended by Imageworks.

"At the beginning the clock tower was designed with lots of elaborate, overscale pieces, which Neil loved to have in the film," Dopaso said. "When Spider-Man flies to the top of a building he is supposed to appear very small in comparison with the enormous architectural pieces that adorn the building's exterior. Those pieces are enormous because they are meant to be observed from street level. However, to create these architectural pieces requires a lot of work. Each has to be designed, fabricated, and/or sculpted to appear real and fit the needs of the scene."

The major challenge for the clock tower, according to Dopaso, was that the production schedule allowed only six weeks from concept to drafting to completion. "It was insane," Dopaso said, laughing. "I remember looking at construction coordinator Jim Ondrejko and saying, 'I don't know how we'll come out with this one.' There is so much involved with a set like that. We needed to provide an architectural element that could later be incorporated into a CG building. In addition, all the requirements of the fight choreographer and the stunt coordinator had to be addressed before the design and construction could begin."

"Because of actor reasons or script and time-line reasons things sometimes get moved up on the schedule," explained art department coordinator Jan O'Connell. "A beautiful thing like the clock tower takes a long time to design and suddenly you have to have it tomorrow. I remember the designs started out looking so amazing, but the reality was, it'd have taken six to eight weeks to build and they only had about three weeks [for construction]. So certain design elements had to be cut back to make the set happen in the new timeline.

"But I loved what still came out of it, the simplicity and elegance."

The great comic-book Super Heroes always seemed so *eager* to don cape and cowl, particularly ordinary civilians who are suddenly transformed into super beings after being zapped by lightning, splattered with exotic chemicals, or bathed in radia-

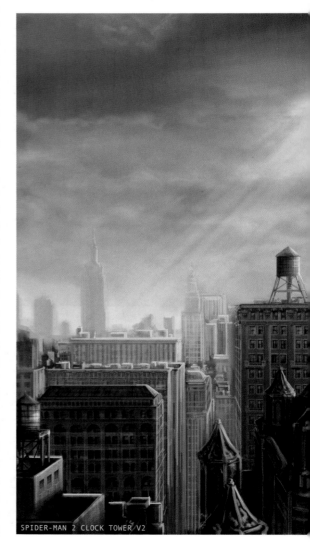

SPIDER-MAN 2 CLOCK TOWER V2

tion. There was never any doubt or terror and the cosmic dust had barely settled before they were making vows to use their superpowers for truth and justice.

Peter Parker stands apart, one of the few who accepted that great responsibility, but also recognized that Fate had delivered a great burden.

In one particularly dramatic clash Spider-Man and Doc Ock meet atop an elevated train, with Ock damaging the train's controls. Only by pushing his superstrength to the limit does Spider-Man keep the train from hurtling off the tracks into the shipping yard below.

The train sequence entailed the very first official photography of the production, starting when the crew went to Chicago in

"We wanted to dramatize the features of Spider-Man and Doc Ock and find a place where they could best fight, where their powers would be pushed to the limit. So you consider locations that are both stunning and challenging—such as the clock tower. That location was amazing because it afforded the chance to create a total awareness of vertigo, which is one of the improvements we made for this second movie."

—*AVI ARAD, PRODUCER*

Below: "The point of this image was the architecture of the clock tower and how the city around the building would look, with these 'God's fingers' of light streaming down," explained artist Wil Rees.

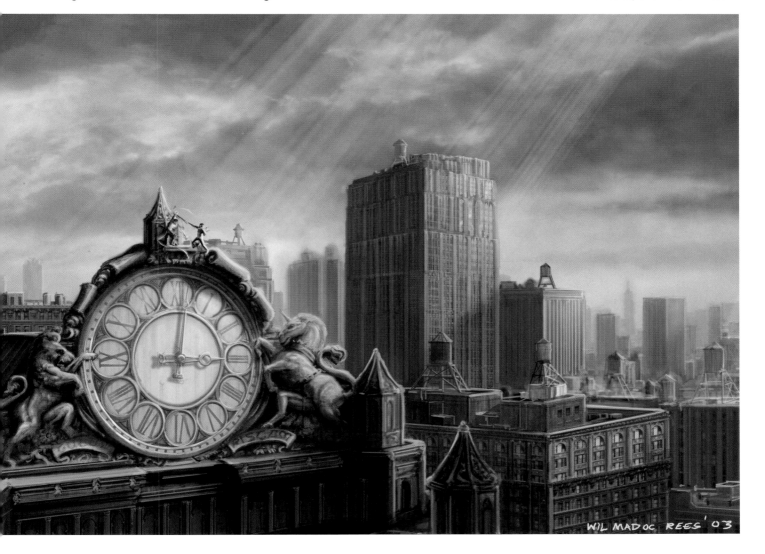

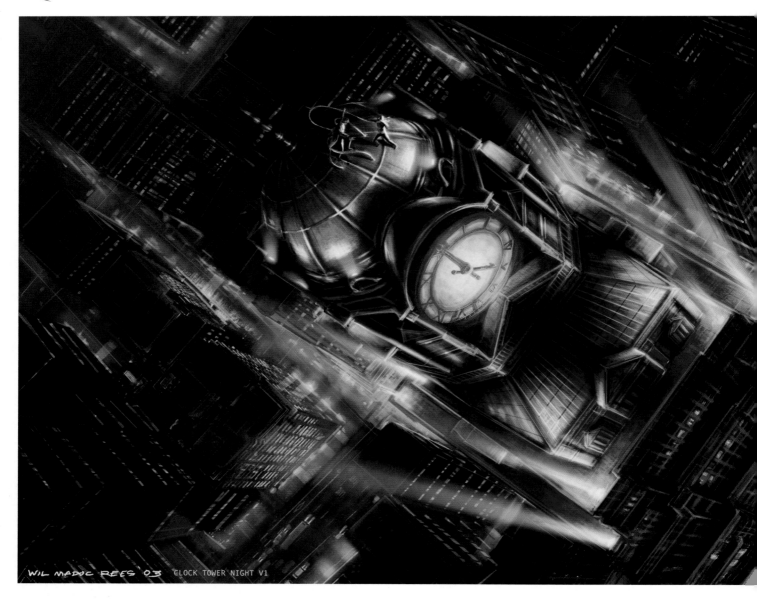

WIL MADOC REES '03 CLOCK TOWER NIGHT V1

Above: This nighttime view of the clock tower battle by artist Wil Rees had to be redone when the scene was changed to a day shot. In Photoshop, it's easier to turn a day shot to night than it is to deal with the lighting details required for transforming night into day (see opposite). So, to get a daytime version, Rees copied the original illustration and digitally repainted it. Note how he was able to cut and paste the two characters, positioning them in different places.

November of 2002 to shoot the background plates. "It actually snowed while we were there," co-producer Grant Curtis recounted. "The heavens just opened up. But it's not in the film; we waited for the snow to melt. It was just a weird thing to be shooting *Spider-Man* while it was snowing.

"We shot in Chicago because elevated trains no longer exist in Manhattan. We used the elevated trains in the same manner as Sam and Neil taking existing elements, and heightening them to create their idealized look of New York."

The original plan of having the trains fly off the end of the tracks and explode when they hit propane tanks was to have been done with a huge miniature set and precise pyrotechnics. But then, in the rush of the accelerated schedule, things changed. "There were months of work on this sequence and they were thinking of doing the crash as a miniature," noted Tom Wilkins. "That was a big change—the train *doesn't* go over the edge, and it's CG instead of a big miniature. Set-wise it was one of the big changes in the movie, along with the *Bugle* rooftop sequence going away."

"Instead of the train wreck, we moved right into drafting up plans for Doc Ock's ruined pier," Tom Valentine recalled.

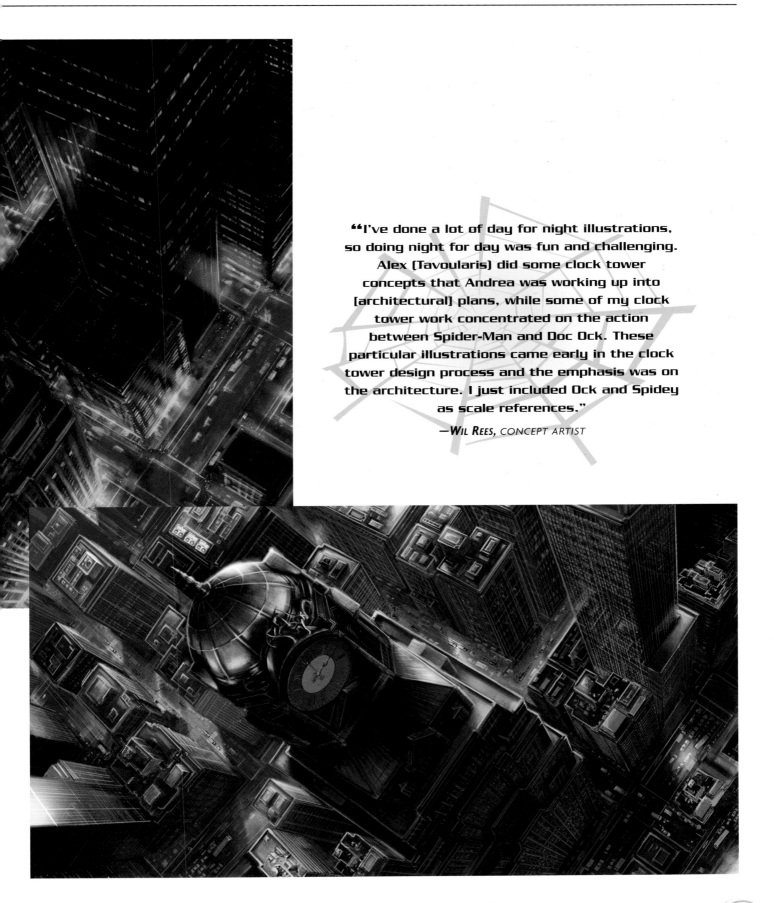

"I've done a lot of day for night illustrations, so doing night for day was fun and challenging. Alex (Tavoularis) did some clock tower concepts that Andrea was working up into [architectural] plans, while some of my clock tower work concentrated on the action between Spider-Man and Doc Ock. These particular illustrations came early in the clock tower design process and the emphasis was on the architecture. I just included Ock and Spidey as scale references."

—WIL REES, *CONCEPT ARTIST*

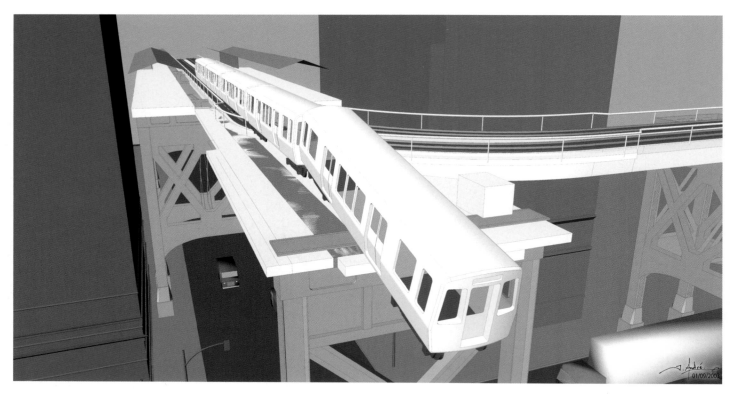

Top: This image of the train was created by digital set designer J. Andre Chaintreuil, based on the storyboards by Steve Markowski (right). They were key in helping Sam Raimi envision the runaway train scene.

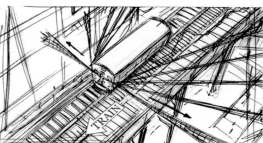

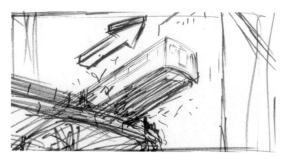

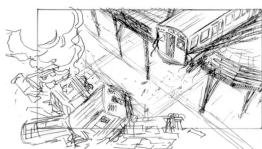

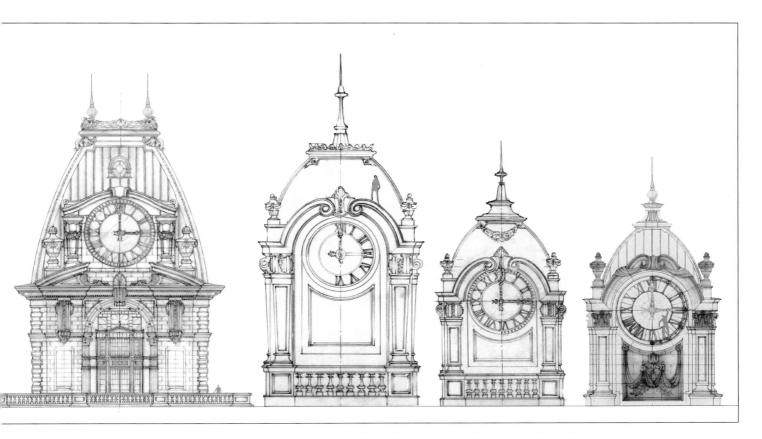

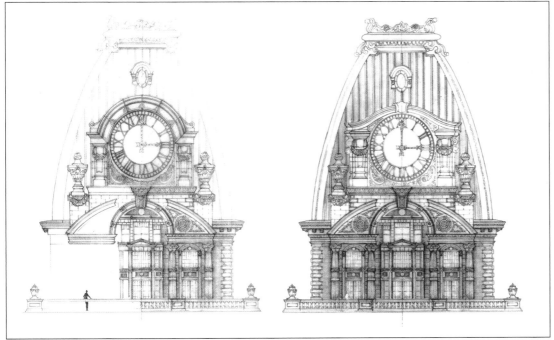

Clock tower architectural elevations by Andrea Dopaso.

Top: Animatics helped plot out the effects-heavy clashes between Ock and Spider-Man. Wireframe "Battle Building" animatic-in-progress by Anthony Zierhut using Blender 3D software.

Center: Clock tower storyboard art by Dan Sweetman.

Bottom: Spider-Man and Doc Ock prepare to face off on the final clock tower set.

Left: In this 3-D animatic for the battle-building sequence, Brad Morris used NewTek LightWave 3D to show Spider-Man escaping the lash of Doc Ock's deadly tentacles.

In *Spider-Man 2,* the dramatic settings for the battles between Spider-Man and Doc Ock emulated the tradition of the comic book. Here the two foes clash atop a speeding boat on open water (bottom left: *The Amazing Spider-Man #11,* April 1963, "Turning Point." Artist: Steve Ditko) and in the close quarters of a sculptor's studio (middle left: *The Amazing Spider-Man #12,* May 1963, "Unmasked by Doctor Octopus!" select panels. Artist: Steve Ditko).

Below: This live-action shot put Spider-Man and those awesome tentacles in complete perspective. Photo by Melissa Moseley.

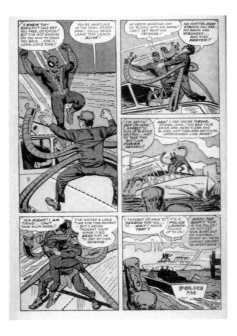

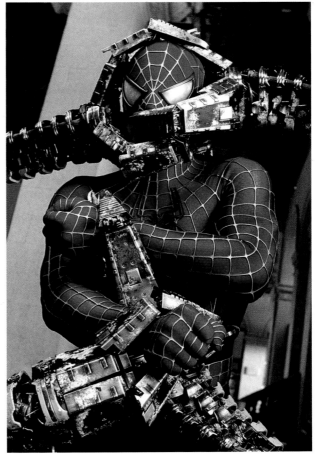

THE GIFT AND THE CURSE

In the comics, Peter Parker often has struggled with that Spider-Man part of himself. He's suffered defeats, had his internal dialogue buzzing with doubts, has visited

Bottom right: In *Spider-Man* comics, being a Super Hero didn't mean you're immortal, as in one classic story where Peter was laid low by a virus. Due to his weakened state, Doc Ock unmasks him in front of Betty Brant and J. Jonah Jameson. No worries—Peter puts up such a pathetic struggle that everyone thinks he's impersonating Spider-Man.

Bottom left: But in his fevered state he finds no rest, haunted by the hallucinatory image of his Spider-Man persona.

Both from *The Amazing Spider-Man* #12, May 1964, "Unmasked by Doctor Octopus!" select panels. Artist: Steve Ditko.

Middle: Peter Parker struggles with the inexplicable loss of his superpowers in the classic comics story "Unmasked at Last!" *The Amazing Spider-Man* #87, August 1970. Artists: John Romita and Jim Mooney.

"The first movie had these broad strokes of this young boy who's had potential greatness thrust upon him. By the end of the first film Peter Parker has decided to embark on a journey of responsibility and, in the second film, we're on the journey itself. Things get more complex; we're not seeing general concepts but the specifics of that life he tries to lead and what it costs him emotionally. There are moments when he considers this great gift a curse and decides to deny his sense of personal responsibility for personal happiness. But that causes him a moral uneasiness. That's never been an option for Peter Parker, to fulfill himself at the expense of others and ignore this great gift."

—SAM RAIMI, DIRECTOR

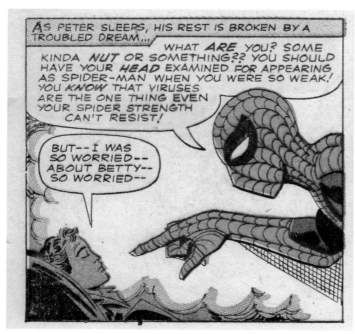

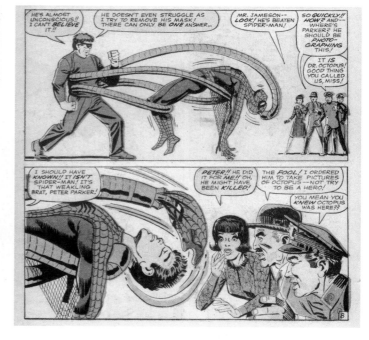

a psychiatrist. He's even considered shucking the Super Hero gig—and did so in "Spider-Man No More" (*The Amazing Spider-Man* #50, July 1967), the famous story in which he discarded his costume, like a mythic Atlas who finally throws off the weight of the world.

Despite the temptation to quit, the lesson Uncle Ben taught Peter—about responsibility—has always inspired him to slip back into his Spider-Man suit. In *Spider-Man 2* Doc Ock is on the loose and wreaking havoc in New York.

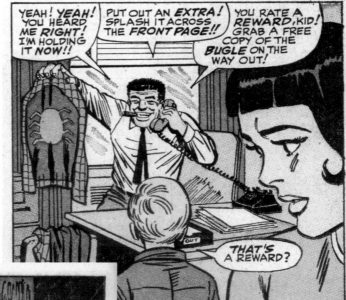

"**One of the things that interested us was the 'Spider-Man No More' comic. That seemed like something that could be integrated, this moment where Peter Parker feels that being Spider-Man is keeping him from what he really wants. That image of him throwing his costume into the trash can seemed a touchstone. A lot of people were also saying the movie should be about him losing his powers; a lot of people were interested in that.**"

—*Laura Ziskin*, PRODUCER

Left and above: Peter Parker turns his back on his Spider-Man persona—to the delight of J. Jonah Jameson. *The Amazing Spider-Man* #50, July 1967, "Spider-Man No More!" select panels. Artist: John Romita (Mickey Dimeo, inks).

CONTINUED AFTER NEXT PAGE

Below and opposite: Peter Parker rushes to help a trapped child in the burning building sequence. Concept art by Wil Rees.

Above right: Storyboard composition of Peter running up the burning stairway. Burning building storyboards by Jack Hsu.

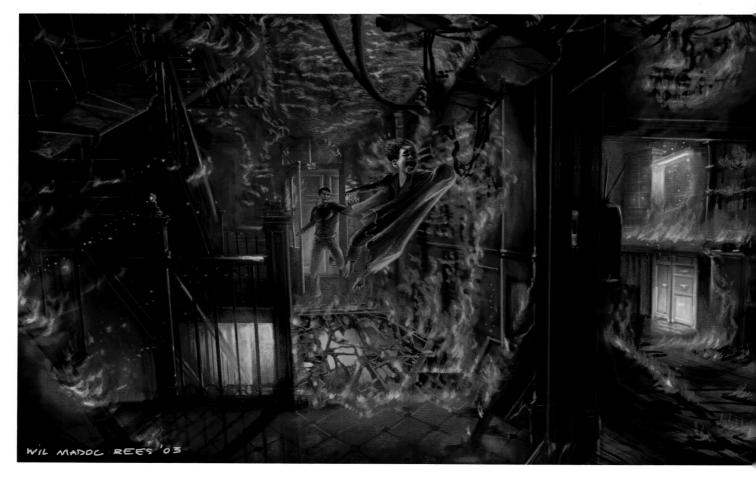

WIL MADOC REES '03

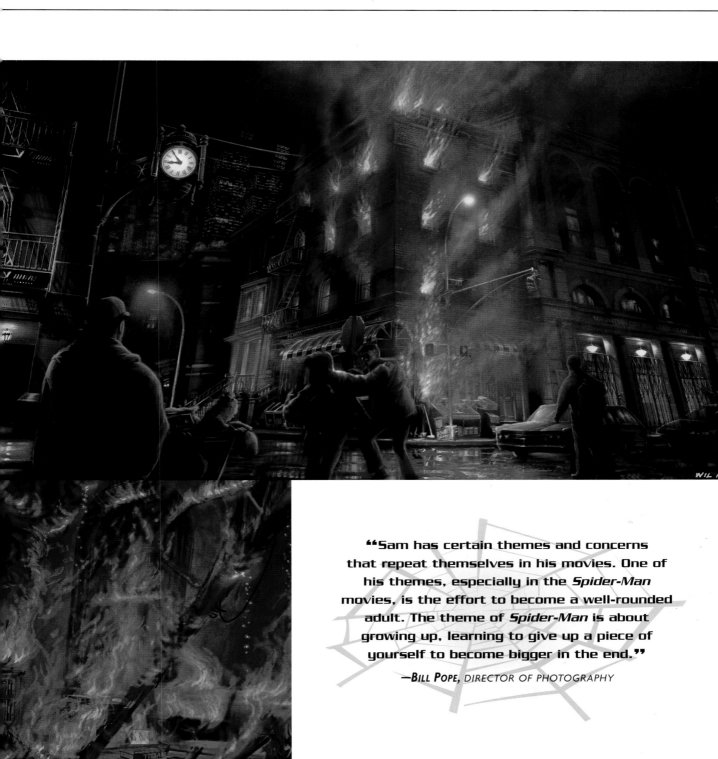

"Sam has certain themes and concerns that repeat themselves in his movies. One of his themes, especially in the *Spider-Man* movies, is the effort to become a well-rounded adult. The theme of *Spider-Man* is about growing up, learning to give up a piece of yourself to become bigger in the end."

—BILL POPE, *DIRECTOR OF PHOTOGRAPHY*

DIABOLICAL LAB

The inspiration for Doc Ock's ruined pier lair, according to Sam Raimi, was the gloomy, decaying waterfront building from the first film, where Peter Parker cornered his uncle's murderer. "I asked Neil for a dilapidated, multilevel structure on the water, but then Neil took that so much further and it became a wonderfully different creature," Raimi recalled. "Neil loved the idea that the whole thing is half-sunken into the river and it was his idea to construct it like that—he's a genius. It was a unique setting for Ock's fusion machine and the final confrontation between Spider-Man and Doc Ock, a great playground for them to encounter each other."

The pier itself evolved from months and months of art department research, from photographs of ruined buildings to images of old New York piers from the glory days of shipping and boat travel. Tom Wilkins noted that research for the pier filled a black folder more than an inch and a half thick with location and archival photo references. "We also went out to salvage yards to get physical material the craftsmen working on the set could use as reference," Wilkins explained. "We all think we know what these things look like, but there's nothing like having an actual piece of rusted metal or rotted piece of wood to really achieve that look.

"We took interesting details, like the cast-iron look we'd been exploring on the

Interior of Doc Ock's pier lair. Art by Alex Tavoularis.

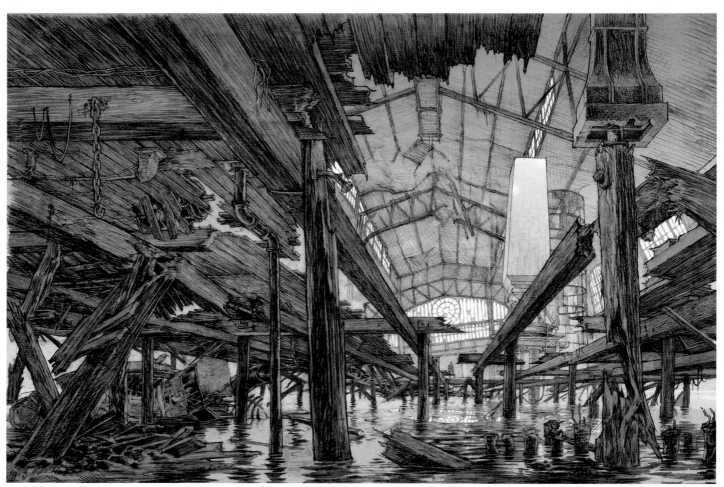

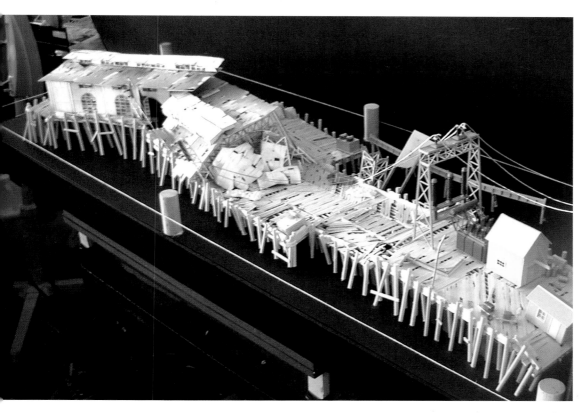

Left: Art department scale model by Tom Frohling showing the full establishing view of the ruined dock and sinking pier that becomes the lair of Doc Ock. Photograph by Tom Frohling.

Bottom: Waterfront tour by Alex Tavoularis.

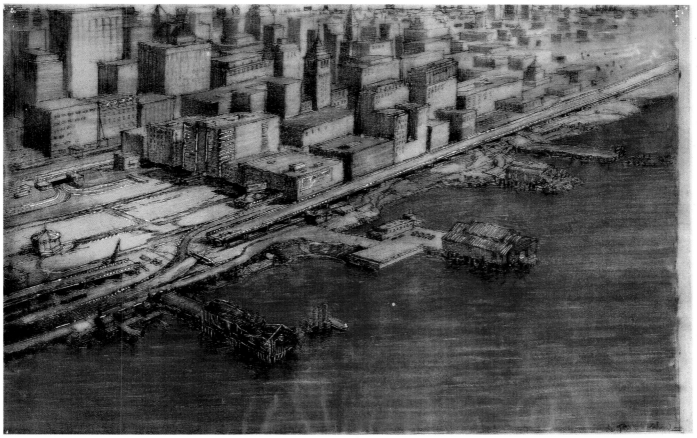

"I think any movie is an organic process, but that's especially true for the way Sam works. An idea evolves as Sam searches out everybody's ideas and finds the closest thing to his vision and develops it from there. And that vision is constantly shifting. Even after it's shot it's still shifting, because visual effects will change it, what editing leaves in or out will affect the whole thing. The moviemaking process is very organic in that way. Things change every day."

—NEIL SPISAK, *PRODUCTION DESIGNER*

Bugle building, which bled over into the pier. Just the windows alone required research for the style of window and how much light would come in, there were ideas of catwalks and potential places Spider-Man could fly down from—those are some of the things you think about going in. It was a pier, which meant big gantries and columns, shackles, and a big heavy floor. We shot the Brooklyn side of the pier, the land-fall side, down in San Pedro [California] as a location with lots of big cranes, the plates where a miniature set was tied into that location in San Pedro. It's always exciting to do a set like that because with Spider-Man flying all around there was going to be a lot of wide shots that'd really show off the art direction."

"Designing the pier was a huge undertaking," art department coordinator Jan O'Connell noted of the process that emerged after the earlier conceptual work led by Alex Tavoularis. "It started with set

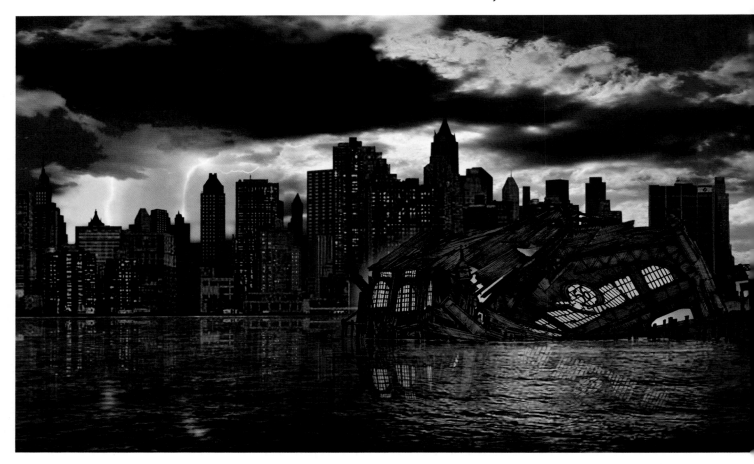

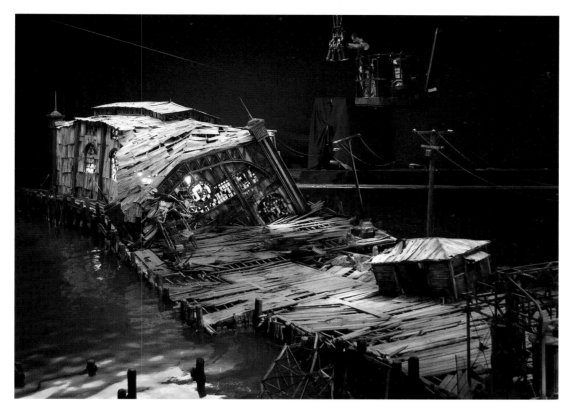

Left: Miniature pier set constructed by Grant McCune. Photo by Melissa Moseley.

Bottom left and opposite: Pier 56 concept art by Alex Tavoularis.

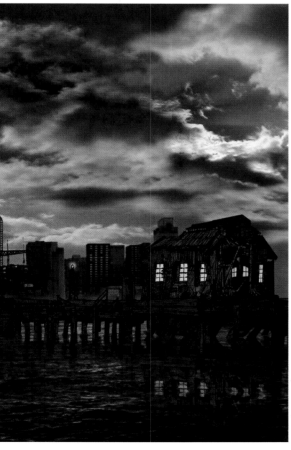

designer Kevin Ishioka, then Patte Strong-Lord, and went over to Andrea Dopaso and then to Mick Cukurs and Dan Jennings and Jim Truesdale, then model maker Tom Frohling, and art directors Tom Wilkins and Tom Valentine. That's a lot of different styles. Andrea has very flowing lines, Mick is meticulous with his heavier lines, and Tom Valentine has a little lighter line. It's interesting to see everyone's personality come through the drawings."

"The art department was really good about checking with me and the grip department about what would be workable on the final set, things like how tilted and nutty we could make the floor of the pier," Bill Pope said. "I'd constantly be giving them specifics as to what the load bearing needed to be, how extreme an angle, what piece of the set would need to be movable so we could get gear in, how high the set could be so we could get lights above it. Neil's five art directors all had their own turf and were really good about checking things. They were all practical people and total filmmakers who didn't

make a move unless they'd coordinated it with everybody."

So it was that in early September of 2003, as the pier set came to life, the art department still hummed with life. But the energy that once had the place spinning had been dissipating since the production's peak in June and a creative force of twenty-five to thirty artists, art directors, model makers, and department staff were quartered at the Heidelberg Building. Principal photography was scheduled to be completed by the end of October, and O'Connell was already transitioning to what she called "wrap mode" and seeing to the archiving of a thousand individual pieces of conceptual art produced for the film, returning any rented equipment, and performing the tasks that marked the poignant end of the "little company."

Most of the artists who'd worked here had flown away to other films. Even art director Steve Saklad had departed for a well-deserved vacation.

The art department's focus in the final stage of principal photography was the "pier set," Doc Ock's desolate and dilapidated waterfront lair. The last big *Spider-Man 2* illusion left on the shooting schedule was well into construction just around the corner from the Heidelberg Building at Stage 30.

The historic soundstage was the usual cavernous, square space one would expect, but it included something special: the studio's famed water tank—on the lot it's sometimes called the "Esther Williams stage" in honor of the actress and freestyle swimming champion who filmed many watery sequences there. The stage was dry during construction, but after the huge crew—headed by construction coordinator Jim Ondrejko—finished building the set, the tank would be filled with up to four feet of water meant to simulate the view of New York Harbor as seen through the lair's broken and rotted floorboards.

The pier, like other sets in the film, was

Pier. Concept art by Alex Tavoularis.

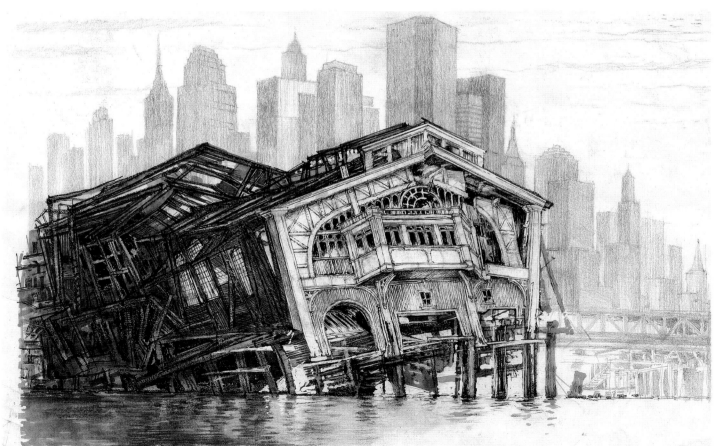

dreamed up by the art department's conceptual artists, imagined in physical scale models, and rendered in architectural blueprints by the department's set designers. But the work of the art department continued as the set construction began. Both Spisak and his remaining art directors were overseeing the particulars, making certain the director's vision—communicated through Spisak and worked out through months of concept art—had been perfectly realized.

This particular September day there was a constant back and forth between the art department and Stage 30. Neil Spisak appeared, walking up the Heidelberg stairs to his office for a moment, only to head out again to supervise some detail of the construction. Tom Wilkins had art department assistant Theresa Greene working the phones to track down a salvage yard where they might get ruined wood and other physical references for use by the craftsmen on the construction crew. They would be charged with making props and set pieces look aged and weathered. Visual-effects art director Tom Valentine was also up and down the stairs, with rolls of blueprints tucked under his arm, his concerns including the logistics of erecting the "backings," gigantic photographic images of New York that would be seen outside the windows of the set. Another regular visitor to the rising set was lead model maker Tom Frohling, who had created a key scale model reference of Doc Ock's ruined lair.

This day Alex Tavoularis, a key player in the pier's design, had also returned for a visit, and sat at the conference table that had been the power center for many a *Spider-Man 2* concept discussion, sifting through long sheets of the drafting paper he preferred for his pencil or charcoal drawings. There was a rustle of the thin paper as he pulled out drawings produced during months of concept work: a sketch of Spider-Man using his superstrength to put the brakes on the runaway train ... an early concept of Doc Ock and his mechanical arm attachment ... a seductive scene of Mary Jane caught in a spiderweb ... an architec-

turally precise rendering of the clock tower that was to be another of the battlegrounds for Spider-Man and Doc Ock.

Tavoularis broke into the film business on Francis Coppola's *The Conversation* through the intercession of his brother Dean (whose credits include production designer for Coppola's *Godfather* films and *Apocalypse Now*), and as a storyboard artist for the first *Star Wars* film. Alex had come full circle, back to pure illustration on *Spider-Man 2*, after serving many films as a production designer or art director.

"I like illustrating, there's a lot less pressure." Tavoularis smiled. "Basically, Neil would give me an idea and I'd try to create an image that fulfilled what he wanted. Working on this show was a pleasure because Neil and Tom [Wilkins] worked with me creatively. The goal is always to nurture the artistic spirit, not stifle it, and those guys did that. When I was doing production design that's what I tried to do with people. You have to go right up to the threshold of telling an artist enough of what they need to know without telling them too much [so] that they lose their spirit."

In his tactile approach of putting pencil point to paper, Tavoularis was an anachronism in the *Spider-Man 2* art department. The other illustrators, including Wil Rees and James Carson, used the computer as their favored artistic tool. While the digital set designers on staff, J. Andre Chaintreuil and Robert Woodruff, created 3-D representations of proposed sets, allowing the filmmakers to fly the virtual camera around digital environments and decide issues of design, scale, and shot placement—the kind of conceptual work once accomplished with physical models and a miniature "lipstick" camera.

"Back when I was working on the first *Star Wars,* Coppola or George Lucas, I can't remember who, told me the computer would become a tool for artists," Tavoularis recalled. "I *never* imagined that. Never."

Tavoularis laughed and confessed that the notion of conjuring an image out of nothing in the computer was "frightening."

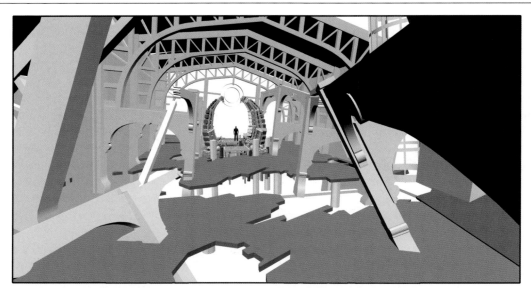

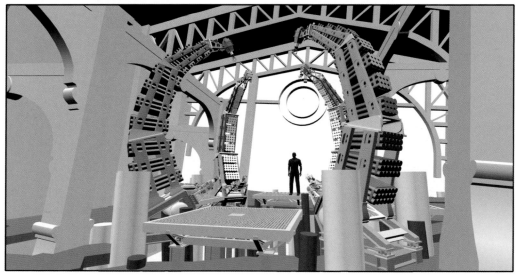

"**A digital model can show the direction in which light is coming to an object, but I don't need a digital file to tell me that. But with a physical model I could easily move around lights and get a ballpark idea of where I wanted the lights to be.**"

—*ROBERT WOODRUFF, DIGITAL SET DESIGNER*

Yet to meet deadlines and present art in full-color form, he'd scan his sketches and utilize Photoshop software to quickly produce a final color image. "I still want to be tactile, it's just an emotional decision," he said, shrugging.

Despite the increasing use of digital drawings and precise 3-D renderings, one aspect of conceptual work never changes: its organic nature. A creative quest, the search to illustrate an idea, is always in flux. It's a journey full of wild tangents, serendipitous discoveries, and concepts that get drastically revised or sometimes go nowhere. Tavoularis shared an old story

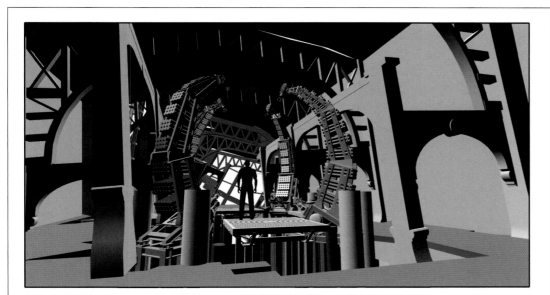

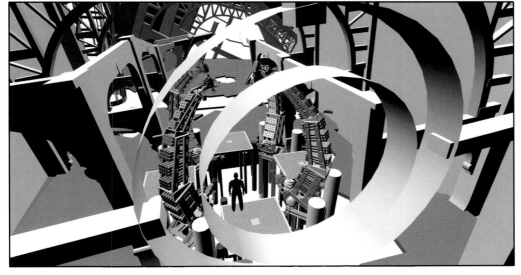

about an idea that never made it to the screen, on the first *Star Wars,* as he was storyboarding the famous opening sequence when an Imperial Star Destroyer overcomes the Rebel Blockade Runner, and ruthless Darth Vader first appears.

"At the time, the [working] music for the movie was Gustav Holst's *The Planets,* so for inspiration I'd listen to the selection 'Mars: The Bringer of War,' and that was like the background music for Darth Vader. I had Darth Vader appear, and then in the next frame I drew Vader ripping somebody's arm off. I don't think that was even shot."

For *Spider-Man 2,* Tavoularis developed the mural that was to go in Dr. Otto Octavius's Manhattan laboratory, inspired by Leonardo da Vinci's *Universal Man* standing figure, that iconic representation of a naked man within a circle whose outstretched arms and legs are symbolically depicted in both neutral and action poses, making for eight appendages, the same number as Otto would possess when he strapped on his four mechanical arms. But though the mural concept never made it to the shooting stage, Tavoularis's sketches of the magnificent clock tower *did* make it into the movie, but budget and deadline

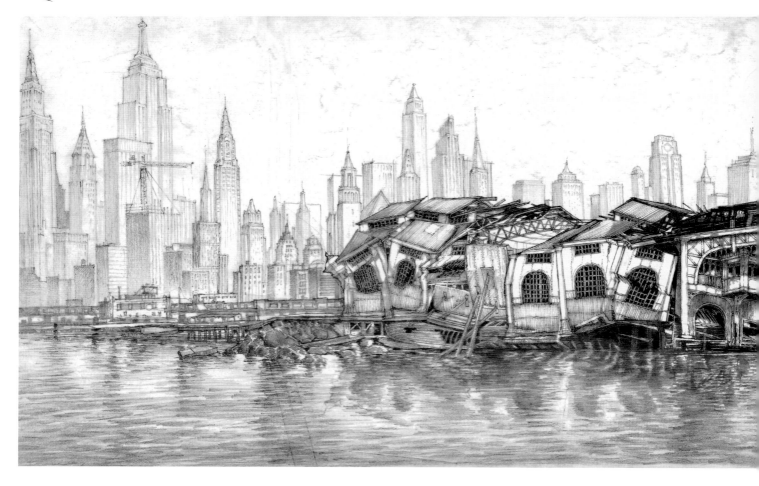

Above and opposite: Pier and waterfront concept art by Alex Tavoularis.

pressures stripped the final structure of layers of conceptual detail.

One of Tavoularis's greatest achievements would be Doc Ock's mood-drenched lair at Pier 56, which Neil Spisak had imagined as being located on the East River opposite Roosevelt Island (the site of the first movie's final battle between Spider-Man and the Green Goblin). In one dramatic establishing view, Tavoularis depicted Doc Ock on the dock as he first gazed upon the place. This is where he would escape to after the disastrous accident in his midtown Manhattan lab, which left the mechanical arms fused to his body. The sprawling image was first prepared by Tavoularis, as a black-and-white rendering, with color and photographic cut-and-paste images of real clouds and water added in Photoshop.

But concept artists like Tavoularis don't start and stop with a single image—they might explore an idea in dozens of individual pieces of artwork. A series of black-and-white drawings covered the length of this waterfront of dreams, pencil images moving like snapshots across the water and along the imagined dock and sinking pier. From the exterior view, Pier 56 was in serious decay, its rotting wood and rusted metal framework buckling, the whole structure imploding from the weight of time and neglect. Inside this dark place the doctor would establish a true mad scientist's lab, where he would seek to rebuild the failed fusion device he's convinced will unlock a limitless energy source.

Tavoularis pointed to a drawing exploring the interior of the imaginary space. A rosette window hinted of faded glory. The building was a meticulously detailed danger zone of exposed pipes and pilings and rotted floorboards fallen away to reveal the water.

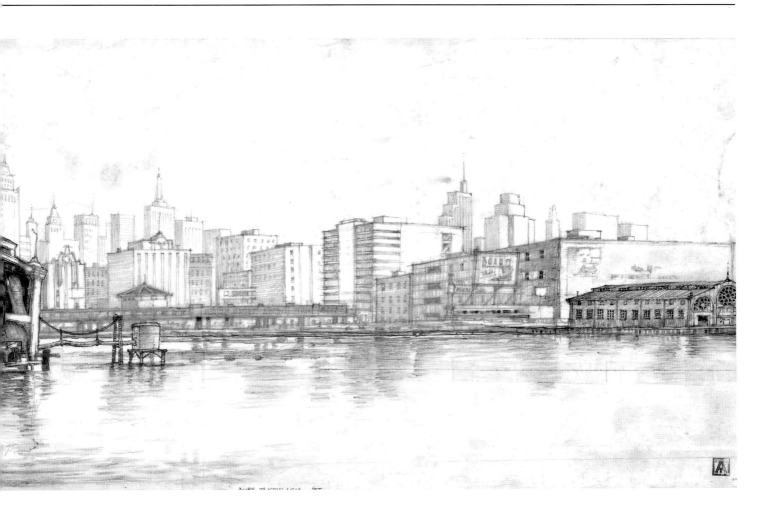

"When you're dealing with electronics and machinery, the furthest thing in your mind is getting near water, right?" Tavoularis said, grinning slyly. "A damp, cold environment is *anti*-electronics. But they came up with the justification that water was needed to cool down Doc Ock's device.

"The bottom line is to get to this cool-looking, broken-down pier to shoot the scene," Tavoularis chuckled.

There's a notion of L.A. as Lotus Land, an oasis of swimming pools and movie stars. But this sunny September day the dream factory looked like any construction site seen through the gigantic "elephant doors" of Stage 30. Workers moved around with leather belts strapped to their hips slung with hammers and other tools; there was the hum of motors and forklifts; an acetylene torch was sparking and glowing at the bottom of the dry tank. From above, one blue-collar daredevil strapped into a harness dramatically dropped down from the stage ceiling, or "permanents."

Outside, where Main Street narrowed between the soundstages, stood major props that would dress the set, including a little boat inspired by an Alex Tavoularis drawing and a row of barnacle-crusted pylons, each little barnacle a molded and cast piece painstakingly put into place.

Pier 56 was taking form as a 110-by-60-foot piece of comic book surrealism, the construction itself the culmination of a creative journey that had begun when the pier set was first conceptualized in August of 2002.

"We went through a process of determining how big the pier would be and once we were close to that, we decided it'd be a ruined, cast-iron, turn-of-the-century-style structure with a lot of brackets and columns to make it look interesting," explained Tom Wilkins, who with Tom Valentine and Neil Spisak comprised the art direction team for the pier.

The set itself was built of wood with steel window frames and constructed in sections that would be lifted into place and hung from the permanents with quarter-inch cable. The grand illusion was first prepared with spray guns that covered the wood sections with drywall compound,

Doc Ock and pier fusion reaction.
Art by James Carson.

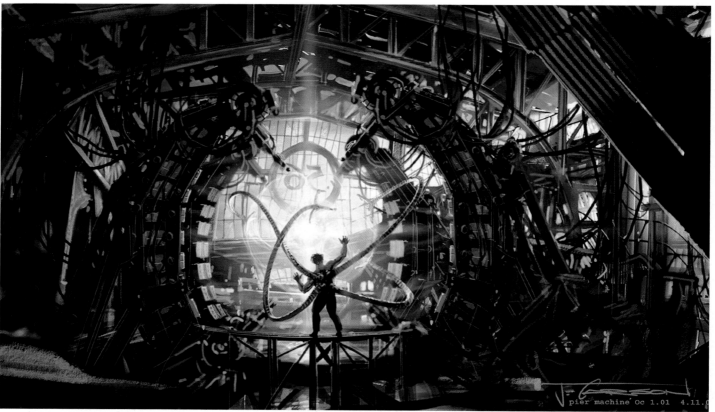

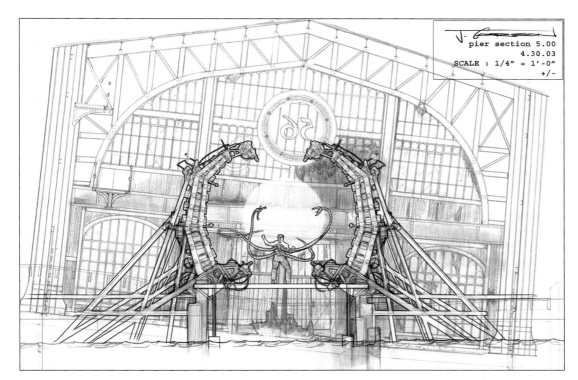

Pier section art by James Carson.

then added painting and texturing—making the "wood" look like tarnished metal.

"The major sections of the structure were first assembled straight, but then intentionally misaligned, creating skewed angles to the walls," said Valentine. "Essentially, the whole building is made of pieces that have been repositioned. All of the rotted timbers and floorboards were hacked and damaged by hand. For the construction crew, this is the opposite way they're used to working. They're used to being precise. *This* set had to be strong and safe for the crew but appear treacherous."

The set wall sections themselves were "wild" and could be removed to allow a crane to bring in the full-scale fusion device. The removable walls also allowed for camera freedom when filming began.

Down in the dry tank, on another side of the set and looking around at faux cast-iron structures, stood Neil Spisak, paint supervisor John Snow, and paint foreman Ken Jones, discussing that alchemical process in which wood and plaster would be made to look like rusted metal. Jones himself had twenty-three years' experience painting sets and represented a lineage of knowledge stretch-

"I remember looking at our first little eighth-inch model of the intact pier and thinking it'd have to represent a 60-by-110-foot-long set and that it had to literally be a wreck! It's easy to crush in the side of a cardboard model, but knowing you have to build something like that as a huge set caused a lot of anxiety. But when we latched on to the idea of designing it as an intact thing and then modeling it in pieces and using the model to develop what we wanted, little by little we got to doing the final three-quarter model. It also meant that when the actual set was being built on Stage 30 I didn't have to be there every second of the day to answer questions. The model was there on the stage so the carpenters and construction crew could just look at something and have their questions answered as to how a piece should hang or be broken."

—TOM WILKINS, *ART DIRECTOR*

ing back to the "old-timers," who'd revealed to him the secrets of mixing paint colors and creating illusions of surface aging and texturing.

Also down in the tank, plasterer Nick Fuchs was spreading plaster on a wooden

piece designed to look like an aged support beam. Fuchs's hands and T-shirt were stained with the wet plaster he had to carve and detail before it dried. A bead of sweat trickled down the side of his face—this was truly art *work*. He paused, put his hands on his hips, and gave a weary smile. "This is the last big hurrah here." He nodded at the production's last major set.

Wilkins estimated that a team of set designers that included Patte Strong-Lord, Mick Cukurs, and lead set designer Andrea Dopaso had produced some fifty pages of drafting for the constructed set pieces that made up this massive puzzle. "The work of a set designer has to have both imagination and architectural reality," explained Dopaso.

"The difference between concept art and what set designers do is, our drawings have all the details for actual construction. Everything basically starts with concept illustrations, but concept art is often more about the visual look of something than about a concrete space.

"So a set designer will take concept illustrations and develop that with sketches and floor plans, trying to *shape* a set. We'll sometimes develop sets in tandem with model makers. In the case of the pier, it was supposed to be half broken and demolished and sinking into the water. That's a very hard thing to draw architecturally. So we drew the set as if it were one *intact* piece and Tom [Frohling] did a model in pieces, showing the decay."

This Alex Tavoularis art was composited over a background to give the filmmakers an idea of how much city would be seen in the background.

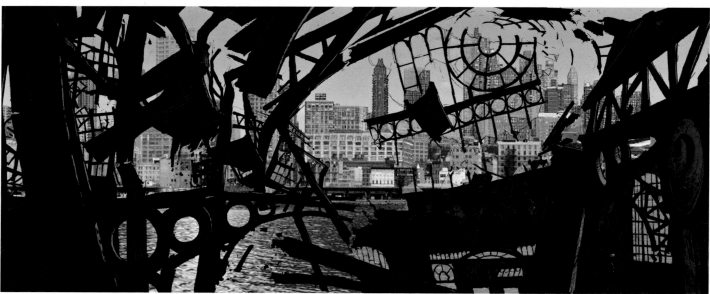

The pier model construction also began with an intact version. "The ruin was such a complicated set, with so many things that weren't sitting straight to each other, that we decided a larger-scale model would be a lot easier to work with for storyboarding scenes, directorial discussions, and construction," Wilkins added.

From a sixteenth-inch-scale model, Frohling's department graduated to a quarter-inch foam model that developed the general shape of the ruined structure. "We realized we still weren't getting enough detail at that scale," Wilkins recalled. "It was Tom Valentine's idea to do a three-quarter-inch model detailing the heaving of the floor, the cracks, and all the decay. At that point [executive producer] Joe Caracciolo added more weeks of model making because he realized what a valuable tool it'd be for meetings and discussions. It turned out to be an excellent tool, and an interesting process with a lot of communication between Neil, Tom Valentine, and myself."

Valentine had been called onto the pier project because he'd had experience building a ruined set for the 2002 thriller *Murder by Numbers.* "For that film we needed an aban-

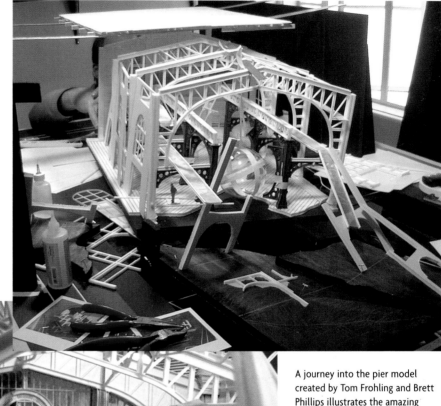

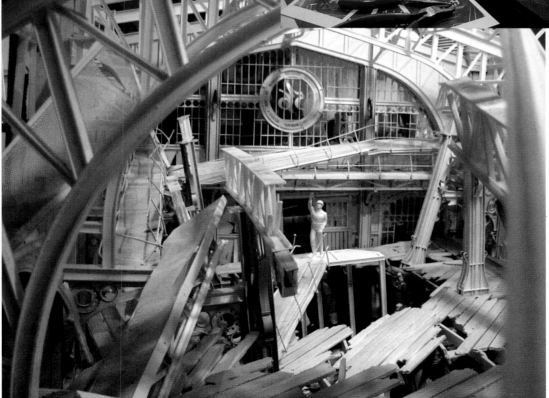

A journey into the pier model created by Tom Frohling and Brett Phillips illustrates the amazing details of ruin and decay that served as a 3-D "blueprint" for the production principles and construction crew. (Note the toy figure, scaled to some six feet, adding further perspective reference.) Director of photography Bill Pope in particular appreciated the pier model, which he used to imagine his lighting setups and camera movements for the final Stage 30 set. Photos by Tom Frohling.

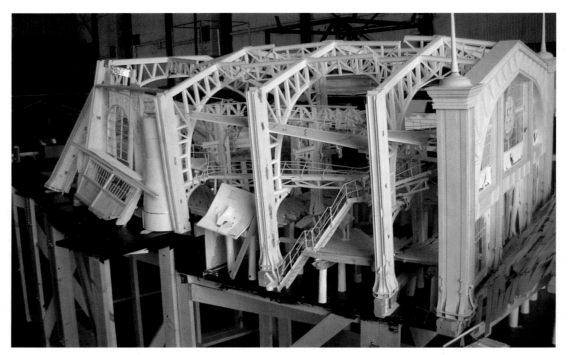

doned lodge on an ocean cliff with the seaward wall and floor ripped away," he recalled. To communicate the damaged areas to the construction crew, we built a three-quarter-inch-to-the-foot model. Our ruined pier design shared similar construction problems of breakage and decay but on a much grander scale. I felt that with so few straight lines to guide the carpenters, a large three-quarter-inch model was an absolute must."

At that scale the Pier 56 model would be a hard-to-miss eleven feet in length. Knowing that the model would be used as a reference there on the construction site, it was also made to take punishment, and constructed of durable styrene plastic and wood timbers with molded and cast details like columns and railings.

"Everything was exact," noted Frohling, whose key model crew included Brett Phillips, with Rob Sissman and Glenn Williams for shorter periods. "It started with concept art from Neil and Alex Tavoularis to get the shape and form, and from there we had fun. We could add a lot of creativity to this model, working out the actual breaks that'd be hard to draw, creating the way things were broken, the way columns leaned, the heaving of the floorboards. It's hard to

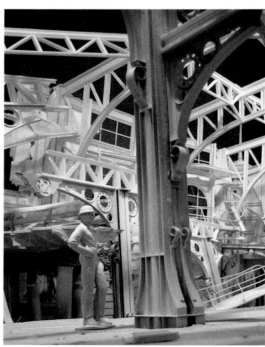

get the sense of the relationship of those things unless you actually see it."

The final three-quarter-inch model was a key "blueprint" for Ondrejko's crew and the entire production. The unpainted model showed every detail of ruin—down to individual strips of wood indicating the rotted floorboards—and sat on a table against a

wall of Stage 30, next to a drafting table stacked with unrolled blueprints. A lipstick camera hooked up to an adjacent monitor allowed for intimate explorations of the scale structure. Like the final set itself, the model was constructed in pieces so it could be taken apart and put back together.

Members of the construction crew would wander over from the massive, imploding structure that began filling the soundstage, to eyeball some particular aspect of the model, sizing up how a certain detail related to their own work. The model was used by members of other departments, including director of photography Bill Pope, who briefly borrowed it while pier construction was still ongoing, to take it to another stage to be lit and filmed, working out shooting ideas for the real camera action that was coming down on the production calendar like an express train.

Although concept art is archived after a show, these kinds of models usually get thrown away, observed Wilkins. Sure, they can be saved, but then you're left with an old model taking up shelf space and gathering dust. These working-class models weren't "stars," like the scaled miniatures designed for camera that always had to be beautifully detailed and painted. Superbly crafted and detailed as they might be, working models aren't designed to be objects of art and usually aren't even painted, with potentially distracting details kept to a bare minimum.

"We've done models on this show that are just chunks of Styrofoam board that get hacked apart to get at the basic idea of a shape," Frohling explained, "and we've made models that require precise proportions and molding little details. But it's not worth it if you create something that's too cute. It's all about the design, so you should be able to tear the whole model apart and put it back together if needed.

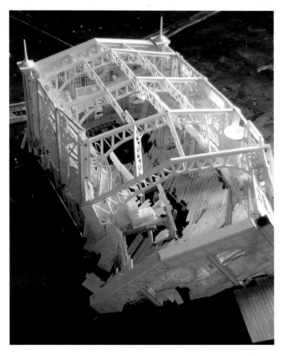

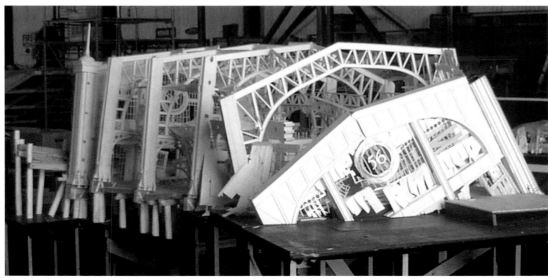

Opposite and this page: Sections of the pier model exterior and interior. Photos by Tom Frohling.

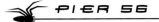

"The point of the design of the pier was we had to have an environment the character could live in, and Doc Ock just wouldn't fit into something like a modern skyscraper. The environment reflected back on the character, so the pier was disjointed, it was tangled, sharp, and dangerous. It was all the things that come into play with Doc Ock."

Shooting the pier set was a huge challenge for Pope, who planned his shots in advance with the art department's three-quarter-inch-scale model. "Once you're on a soundstage that's crammed with a huge set it's hard to move around," Pope said. "Even though the set walls were wild, it's not like you press a button. I try not to move anything unless I can help it. But sometimes I have to move a big crane in and out and I have to fly a wall. But all of that has to be figured into the calendar. If it's going to take three hours you move the wall at night. If it's going to take twenty minutes you do it now and shoot another shot in another direction while it's being moved."

The logistics of lighting the pier set were immense, with Pope anticipating more than

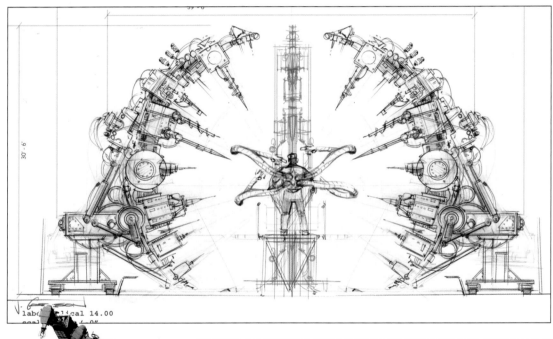

Bottom left: Digital pier fusion machine design by Robert Woodruff.

Right and bottom right: Pier fusion machine designs by James Carson.

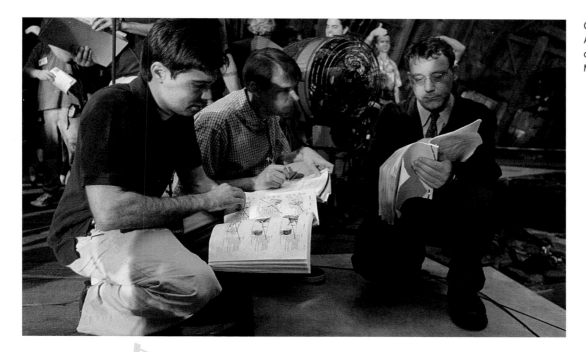

Ozzy Inguanzo, animatic artist Anthony Zierhut, and Sam Raimi discussing storyboards. Photo by Melissa Moseley.

> **"Drama is about deciding what the audience can see and can't see, what the scope of vision will be. Filmmaking is all a matter of control. Neil's control of color and texture and space and my control of how the camera sees that all goes hand in hand."**
>
> —*BILL POPE, DIRECTOR OF PHOTOGRAPHY*

a hundred space lights in the lighting grid up in the stage perms. Each light, as Pope described them, was basically a fifty-five-gallon drum-shaped instrument with white silk and up to a dozen individual 1K lights. "They light a big general area and provide the feeling of a seamless light source," Pope noted. "Lighting a set like this is not something you haphazardly throw up—I'm talking 40 to 50,000 amps of power being funneled in from three other soundstages, with cables running out of the other stages and into ours, going from floor to ceiling. They call these cables that run up the stage wall to the perms a 'waterfall,' and the crew for the pier set said this was the biggest waterfall they'd seen."

"It was important to Sam and Avi Arad to have two variations of the fusion device, that the first one in the lab and the one in the pier be very different in size and scale," James Carson explained. "The fusion device in the pier looks huge and mean, with a feeling of more potential destruction. To make the difference obvious, the size of the original device kept getting scaled back as the pier device was scaled up. In the movie we've already seen the damage and havoc wreaked by the little device. When you see the larger fusion reactor you know bad things are going to happen."

"The crescents that created the electromagnetic induction field in Otto's original lab were about nine feet, but in the pier set they're sixteen feet high," added art director Wilkins.

The pier, as with all the movie's sets and environments, evolved from that first spark of Sam Raimi's imagination and had been developed in the production's art department, in digital animatics, drawn storyboards, and physical sculptures. It had all come to the point when the camera eye would take it all in, the filming itself the ultimate reflection of all the many months of dreams and designs.

PART THREE

DREAMS AND DESIGNS

"THERE'S ALWAYS TOMORROW..."

In the art department office in the Heidelberg Building, Jan O'Connell had flopped down on the couch facing the conference table crowded with set blueprints spread out and rolled up like sacred scrolls. Several stacks of folders had within them the artwork she'd gathered for consideration for this book. On the facing wall was a production calendar marking off October and the final weeks of shooting, the downhill coast from the filming peak of June 2003.

O'Connell reflected on the life of "the little company," recalling the fun of the first three months when everything was blue sky. Back then she was focused on gathering the research required for production designer Spisak and his art directors and illustrators. The result was organized in a row of thick black folders, with additional research material from *Spider-Man* and *Spider-Man 2*, notably location photography, filling the six filing cabinets and sixty boxes that lined a far wall of the Heidelberg Building.

But that early cushion of time quickly ran out and sets began rising on soundstages even as new sets were being dreamed up or in various states of creation. There were crisis points when the evolving script was in flux, when design ideas were developed and dropped, when concepts were finalized and headed for construction but had to be redesigned because of the vagaries of time and budget. Along the way, there was the art department's camaraderie, from Friday-night parties to the time a nasty flu bug briefly put the entire department out of commission.

O'Connell was asked to sum up the experience. She had one word for it: "Tired." She grinned. "I'm beyond tired. Twelve hours is a minimum day for us, which is no big thing. But you don't get breaks in this business. There's always something happening, especially in the thick of things. You could be here twenty-four hours a day, seven days a week and you still wouldn't be caught up, that's the reality of a huge show like this. But my thought process was 'There's always tomorrow.' That's what I'd always say to the guys in the art department. 'Don't worry, you can only do so much each day, the work will still be here tomorrow, there's always tomorrow.'

"But looking back, we're always amazed: '*How did we do that?*' But that's the way it is on every show, you always wonder how you're going to do something. But it gets done. I think that comes with experience."

Lead set designer Andrea Dopaso echoed the sentiment. The blueprints produced by the set designers each had to be copied and circulated throughout key production departments—a staggering one thousand total blueprint copies a month, almost nine thousand for the entire show. But no matter how daunting the deadline, the entire production somehow always made it. "That is *always* the case! In this type of movie things keep getting bigger and bigger and more elaborate but somehow we always pull it off. The drawings get done, and the construction gets completed on time. I guess we all get accustomed to that. So we just get more ambitious and want more and more and more."

"We were lucky on this show because there were so many great people and personalities, and Sam is a very sweet and easy guy," O'Connell added. "I think back to where we started, when every week there were two or three major meetings here and it was always a full house: Sam and Avi and Laura and John Dykstra and everybody, an average of twenty people, sitting around this table, kicking conceptual ideas around. All the conceptual things happened in this room. I was lucky to be a part of that.

"But it's always sad to wind down from a production. You become so close so quickly with everybody, sometimes a little too close. It's sad when people leave because you work so many hours together. It's not a normal job where you say good-bye at five."

Tom Wilkins recalled the beginning, when the art department established itself in the Heidelberg Building as production designer Neil Spisak's office and the hub for the dreams and designs that conjured *Spider-Man 2*. "If you had a time-lapse shot of these office walls, you'd see all the artwork that went up on the walls probably changed five or six times since we set up for our first production meeting. Digital renderings, pictures of backings, location maps, concept sketches, set drawings—all kinds of things came and went from these walls that really tells the story of how you create the visuals for a movie of this size."

At this point in time, the last weeks of principal photography with the big pier set yet to shoot, there was a strange flux of comings and goings. Even as the production was gearing up for the final shoot, other aspects of the huge enterprise were winding down, from archiving the conceptual art to taking down the façade of a water tower set that had been built for the show and not used and putting it into storage in anticipation of *Spider-Man 3*—"It's called 'fold and hold,'" Laura Ziskin explained, smiling.

Already there was the inevitable buzz of questions about the third film in the series. "There are thoughts," Ziskin mused, "but no conclusions."

When Sam Raimi was asked if he'd be back to direct a third *Spider-Man*, he replied without hesitation: "Absolutely. I love Spider-Man. Sony is talking about the third

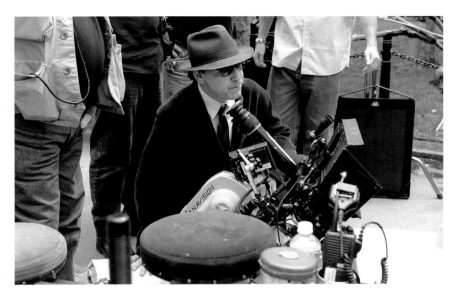

Director Sam Raimi. Photo by Melissa Moseley.

picture and they've approached my brother and me about writing the story, the first draft, and we might do that. The only thing that might get in the way is I really need a break. I haven't really taken a break in years. But I've been on a tremendous ride."

Cinematographer Bill Pope put his finger on the thrill of it all when he noted that, despite all the daunting logistics involved in mounting a production, it was always a kick to put on a show. "The kid's fantasy aspect of moviemaking is still there for us, it's the reason we're in this business. I love walking around a stage and knowing that here was the stage where Esther Williams did all her swimming, that this stage was the Munchkinland of Oz, that in that stage the flying monkeys picked up Dorothy in the forest.

"That just floors me," said Bill Pope.

LIGHTS...
CAMERA...ACTION!

When filming begins, the gigantic elephant doors and side entrances are shut and the soundstage becomes a self-contained world. The night of October 23, 2003, the *Spider-Man 2* production was into its third week of filming on the pier set. Guards posted outside the side entrances checked badges to make certain only production principals and approved guests would enter the top-secret set. And *no one* could enter when the bright red light posted by the side doors flashed like a beacon in the night, indicating that cameras were rolling inside.

Inside the soundstage, behind the folds of a great black curtain, stood the pier in all its ruined glory: high walls and the roof of a Machine Age icon ravaged by time, pieces of stairway fallen onto half-broken columns, busted windowpanes and rotted floorboards, floor sections fallen away to reveal the murky water below. A shelf of rock and such detritus as a battered piece of the hull

of a boat on the landward side and, at the opposite end of the pier, the gleaming fusion device, a high-tech vision amid the ruined structure. The far stage wall, past the seemingly buckling wall of the pier, held the massive photographic backing of the glittering skyscrapers of nocturnal New York.

Swarming across the set were crew members involved in everything from lighting setups to the work of special-effects supervisor John Frazier's crew, who were wiring key prop pieces that would be propelled across the set, to emulate the centrifugal pull of the activated fusion device. Co-producer Grant Curtis was making the rounds, and he noted that everyone was happy that this marked the finale of principal photography.

"I think this set does justice to the scope of this film and the past two years of hammering out the story and working with the actors to further define where their characters have come. We've been preparing for

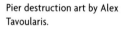

Pier destruction art by Alex Tavoularis.

the pier scene on and off for the whole film, but intensely during the past two months, with Sam meeting with his storyboard artists every day. It's truly a fitting climax."

Heide Waldbaum, the Doc Ock animatronics producer from Edge FX, stood off to the side on a shelf of rocks, killing time before her puppeteers would set to work animating Ock's tentacles. She walked over to a pool of brackish water by the broken shell of the boat, which was already wired as one of the prop pieces that would be pulled into the fusion reactor. She pointed at a broken section of beam above the water that had already been rigged with two pulleys from which they'd affix cables to puppeteer tentacles for a big scene the next day when Doc Ock would have an eerie "conversation" with his artificial arms.

Waldbaum recalled the long journey Doc Ock had taken ever since the conceptual art had been created back in August of 2002. Over those many months, that art had inspired a series of foam sculpture prototypes the effects house made during the tricky transition to final physical tentacles. The final tentacles themselves featured vertebrae constructed of a hard resin nickel-plated to look like metal, then wrapped around a foam core reinforced with a fiberglass rod. The two feet on the lower tentacles were dubbed "pneumatic shovels" by lead puppeteer Eric Hayden, while the two heads on the upper tentacles were called the "death flowers"—as each head opened into three petals.

"The hardest part in the beginning was, there was no script or storyboards—just a vision in Sam and the designers' minds," Waldbaum recalled. "Maybe the tentacles could pick up a car, and light a cigar—it was a big guessing game at the start."

Waldbaum remembered how it all began for real, back during the hospital sequence at the start of production, the moment when Doc Ock awakened on the operating table after his accident and lashed out at the doctors with his now malevolent arms. Alfred Molina himself had been hired only two weeks before, and it was truly Edge FX's

baptism of fire—"a nerve-wracking guessing game," Waldbaum recalled—a rush job just getting a life cast done of the actor for the "girdle" device that would conform to his body and out of which the tentacles ostensibly sprouted.

"We went into the hospital sequence very determined," Waldbaum explained. "It was a new thing for everybody, with a ton of action involving the tentacles. In one shot a tentacle had to grab a surgeon around his hand while holding a surgical blade and thrust him up into the surgical light above, thirteen feet up in the air, and it had to be timed with a stunt person who was being simultaneously pulled up on wires off-camera. The puppeteers supporting the tentacle didn't want to make the tentacle look limp; the tentacles had to show strength. And it *worked*! That was a great moment.

"At that point I think the production felt comfortable with the practical tentacles. We'd only made a third of what we needed for the movie; at the end of the production we have almost 180 pieces and over 210 feet worth of tentacles.

"Now it all seems so easy. . . ."

Today Waldbaum walked over to the focal point of the pier setup, an area below the fusion reactor where actor Alfred Molina stood facing the camera, dressed in the long coat. Below him were Edge FX lead

puppeteer Eric Hayden, engineer Bob Mano, and puppeteer Christian Beckman, who was holding a tentacle by a rod. Many shots required Molina to wear the fiberglass girdle with tentacles attached, the whole outfit weighing a cumbersome seventy-five pounds, but "Fred," as Molina was affectionately known, was spared the extra weight this night, with the puppeteers animating tentacles to *appear* to be coming out of the actor's body. "Fred is one of the nicest and most cooperative people in this business as far as actors," Waldbaum noted. "He rarely complains about anything, and he understands the look is what sells the shot. He really made our job a lot easier."

There were glimpses of down time between the complex setups: Spider-Man himself appearing and posing for pictures with a thrilled little boy visiting the set, dolly grip Dan Pershing finding a moment to prep for the chess matches that occupied the crew during breaks, by consulting a copy of *Winning Chess Openings*.

Off and on during the night Sam Raimi would go from the set to "Video Village," an

area of monitors that would allow him to play back camera footage. This area was located behind the black curtain and set against the stage wall, not far from where the drafting tables and the miniature scale model of the pier had been set up during the pier's construction.

At one point, as Raimi watched a playback of a scene, visual-effects effects supervisor Scott Stokdyk stood behind the director's chair, mentally checking off all the details from the upcoming shot. After the shoot, Imageworks would have to take the footage and remove the wires from the mechani-cally rigged debris that would be flying across the set, and add CG tentacles that would block an attack as Mary Jane took a swing at Ock with a length of wood during a dramatic confrontation.

"The wood is held by a wire, so it'll stop in the middle of space and we'll put our CG tentacle in there," Stokdyk explained. "There's a lot of timing cues in this shot. He [Molina] has to throw his shoulder back to show that he's leading the tentacle and directing it back to hit the wood and grab it and throw it away. Then he has to do another shoulder move for [another CG tentacle] that'll swipe MJ away."

Stokdyk explained that, to facilitate the integration of the computer-generated tentacle within the live-action photography, a member of the Imageworks crew would step in and photograph the environment without actors, using a high-end digital camera outfitted with a fish-eye lens, bracketing the scene in two shots of 180 degrees each. The resulting 360-degree record would account for all light sources and reflections that would help to believably integrate the tentacles into the scene.

But for now, the focus of all the energy on the set always returned to the area where the lights and camera were trained. The shot Stokdyk described began in earnest with rehearsals in preparation for the real camera action. Under the glow of a yellowish light Bill Pope and his crew watched from behind the camera as Sam Raimi explained the timing of the elaborate dance during which Kirsten Dunst would

"For me, I don't know if there was any one point where I saw the visual look of the film come together. But during the course of a production you appreciate the artistry that surrounds a film. The tone and color palette that Sam, Neil, and Bill Pope decided upon affected every other artist—this small artistic community that is evident in a film. Every swath of color Jim Acheson might use corresponds to this color palette, every prop that [prop master] Doug Harlocker picks, every set that [set director] Jay Hart decorates. It's an incredible weaving of one vision that takes shape and grows exponentially through every artist. It all really hit me once when I was down in the pier set for a meeting when it was still under construction. There was a plasterer called 'Big Nick' who was putting plaster over this wooden support beam and making it look weathered, adding these cracks and aging it. He wasn't just splashing plaster around, he was bringing an artistry to it."

—*GRANT CURTIS, CO-PRODUCER*

attack Molina, summing up the choreography with the mantra "Swing, stop, throw, and hit."

The actors took the cue. Dunst swung the piece of wood, the wires pulled it out of her hands as Molina shrugged his shoulders to emulate the lashing tentacles, and the startled actress was pulled off-camera by a wire. Spider-Man wasn't in the shot, but Molina stared into the camera eye as if he were gazing into the eyes of the web-slinger himself, and puppeteer Christian Beckman, a buff young man in a T-shirt, sat below and held the rod puppet tentacle that would end the shot with a strike toward the camera, his biceps bulging as he thrust it forward.

Between takes and rehearsals Edge FX engineer Bob Mano attended to the tentacle while crew members came up with bottles of spray water to mist down Molina and Dunst, giving them the wet look to match the scene.

During one such break Beckman explained that he was actually puppeteering an "extrusion" rig tentacle, one of many arms they'd built for various shots, this one able to accommodate a hidden "death blade" knife that would shoot out from the open death flower. "It's the only head and tentacle we have that's hollow and some-

"What was great about this production was having the first movie as a foundation to build upon. We knew all these characters and where they lived. We also knew what we'd done well visually in the first film and what we wanted to improve upon. You'll usually work on a movie and look back and wonder whether there was something you could have done differently, so it was very exciting to have this foundation and go to the next step. I don't think you get that chance very often."

—Neil Spisak, PRODUCTION DESIGNER

thing can come out of, it wasn't meant to do what I was doing with it in this shot." Beckman smiled. "We should have had a device to lock it off, but I was actually trying to puppeteer it as I would a normal tentacle and it was very heavy with a steel core. It was made with a hollow steel center to extrude the secondary tentacle and then the infamous death blade."

Waldbaum explained that a week earlier, Raimi had, "on a whim," asked Edge FX, along with the art department to come up with a tentacle that would shoot out a knife, even though there hadn't yet been a formal use for it. It was easily done, with their existing hollow extrusion tentacle, which was originally made to extrude a "snakelike" secondary tentacle. Ultimately the secondary tentacle was never used, but the hollow extrusion tentacle found another purpose when Sam came up with the idea of the death blade. "Sam calls it the 'Penetrator 6000,' but back when we first tried the death blade, it didn't go as well, and he called it the 'Penetrator 200.' " Waldbaum laughed.

"For the tentacles the function was dictated by the form," explained Eric Hayden, who acted as liaison between the director and the puppeteers. "We built the monster based on the concept drawings and when

Co-Producer Grant Curtis consults the production schedule during the pier lair shoot. Photo by Melissa Moseley.

A tremendous amount of the pier pre-visualization and concept art Sam Raimi credits to Steve Markowski, who did a brilliant job in the design stage.

This Steve Markowski storyboard sequence develops the final Spider-Man/Doc Ock confrontation. At the bottom, Spider-Man watches as the out-of-control fusion reaction begins shaking the pier. (Note the camera instruction: "Adjust up with Spidey.")

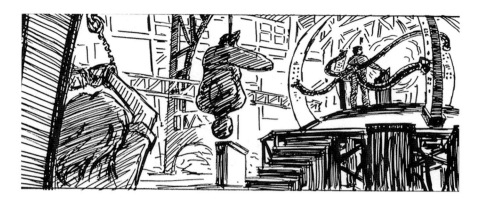

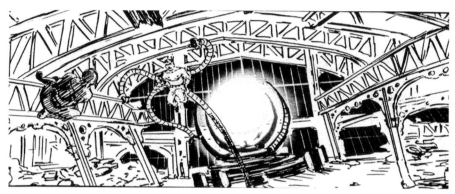

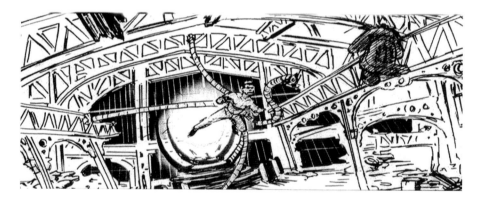

we physically realized those designs, their weight and structure dictated the way in which the puppeteer artists added life. One of the first things we discovered was, the actual parts looked like a snake's skeleton. It was very serpentine. We ended up trying to make them as serpentine as possible, because a snake is threatening and menacing and driven by its head."

At one point, during the many takes shot for the sequence, a call went out for the "shaker motors" to emulate the force of the reactor unleashing its energy. The special-effects device had the pier walls rattling in a fearsome sound effect. "It's shaking the camera, Sam," Pope said.

"It'll get us in the mood," Raimi said, smiling.

Once, between takes, Raimi was sipping a paper cup of coffee through a lid, when the top inexplicably blew off. "What th—?" he muttered, and then he milked it for laughs. He had gently been squeezing the cup, and this caused the lid to fly off before he could take a sip, cracking up Molina in the process. It was one of those lighter moments that typically break up the tedium and pressure of a long shoot.

The pier set was a unique and expensive creation and the plotted shots had to be set up and filmed in a race against the time that was running out for principal photography. Grant Curtis was tracking the visual-effects shots, watching the budget, seeing what could be done to cut or trim and save time. He had a formula that calculated the average shots completed per day, the shot count that was left, and the days remaining in the production.

"The shooting in the pier has gone as expected," Curtis noted. "It's an uneven floor or there's floor missing. It's tough to get a crane or a dolly in there, but we wouldn't have it any other way, we like the trade-offs we get with Neil's beautiful set. These scenes aren't taking place in some standard warehouse with a concrete floor—it really feels like things are taking place in a Manhattan pier that's sinking. [Any] difficulties are the results of this being a massively

cool set. It's also fun to be here, there's a lot of history in this stage."

When the scene of MJ attacking Ock was completed and the production moved on to the next setup, the Edge FX crew repaired to their two trailers on a side street down from Stage 30, pulling out more of the tentacles they'd created for the show. They'd come up with their own techniques—even their own language—for the tentacles and their animation. And to make four mechanical arms come to life, they had every kind of rig designed to meet the specifics of various shots and tentacle action, including tentacle gloves that worked like sock puppets, elaborate cable-operated and pneumatic arms, and handheld rod tentacles.

There were also carts outfitted with camera-boomlike rigs for holding tentacles and steering their heads around and up and down to a portable grid system for puppeteering four tentacles simultaneously. There was the "Octo-Lounger," also known as the "throne," in which a puppeteer could sit and operate dual joystick controls and foot pedals to articulate the death flower heads.

Eric Hayden explained that when all four arms were in play it took sixteen puppeteers to make it work, four operators for each tentacle. The complex orchestration could involve two thrones, an operator for the boom cart, a "wrist" operator cable controlling the piece connecting the tentacle and claw, and a hands-on tentacle operator. Radio operators could operate pincers by remote control, to come out of the open death flowers, and other radio controllers worked points of light deep within both the death flowers *and* the feet.

"The lights we call the 'camera eye' and Sam called them the 'heart light,'" Hayden explained. "The camera eye is a lens, and behind are color shifting LEDs [light emitting diodes] which can cover the color palette from red to blue to green, all to produce a sense of emotion for the arms. When Ock is interacting with the tentacles they have pincers that come out like an insect's mandibles, little motions a radio operator is doing. The head claw is operated by one guy

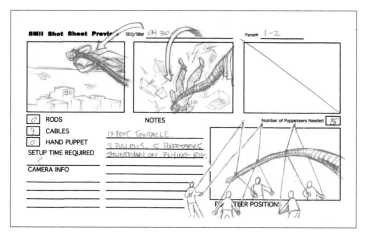

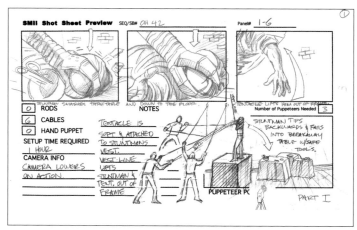

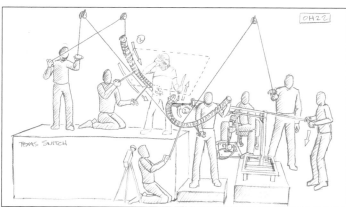

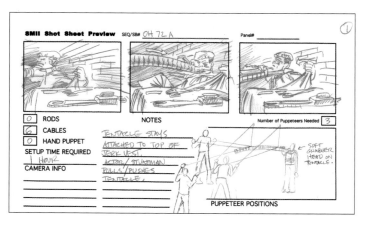

These "shot sheets," using story-board panels, work out the Doc Ock arm rigs required for the Edge FX puppeteers. Art by Michael Bayouth.

who's in control of steering it up and down and left and right, another guy in a chair is closing them off, another guy on a radio is operating the lights. Getting one claw to perform together is its own little symphony and takes a lot of rehearsal."

Hayden's thoughts were already on the next day's shoot, when Ock would be sitting in the pier and talking with his tentacles. It would be "moody, very creepy," Hayden promised. It would be a high point of some six months of collaboration with Raimi and Bill Pope and other production principals. But Edge's work stretched back to many months of conceptual design and preparation for principal photography.

"Some people on this crew have celebrated their second birthday since we started," Hayden reflected. "These days, that's a long run for one project in this town. We had an unprecedented amount of R and D time, as opposed to a lot of shows where you drag something on a set and you've

been building it right up to the shot. On this show we rehearsed for weeks just with stunt choreographers, doing full-on kung fu fights on top of the train roof for the fight sequence between Ock and Spider-Man. The stunt performers kicked the arms, they were brutalized, but the tentacles took it. These things are tanks.

"This has been the most amazing form of collaborative artwork I've been a part of. It has been a great opportunity to have worked on a set with Sam Raimi, Bill Pope, John Dykstra, and all involved. It will be hard to beat this experience. I think one thing that's gotten lost in our end of filmmaking is they don't build a lot of things practically, and when they do it's usually only in one scene. But we've been part of the everyday shooting of the production, as opposed to being an ancillary unit. I'll definitely miss it. I don't expect to ever have this type of film again."

Back inside Stage 30 art director Tom Wilkins was similarly reflecting on the com-

ing end of the production as he took a break behind the thick black curtain that partitioned off the pier from a backstage area of cables and machinery. "I do feel a weight off my shoulders." He smiled. "I can't wait for next week to come and this will be done. It's been a long fourteen months and this has been a long, stressful sequence, because it's a dangerous set with all kinds of broken boards and pits of water and damaged scenery."

Wilkins noted that part of his duties during the final days of filming was to keep track of all the props and set pieces that the special-effects department had wired and rigged to go flying. "We made maps of the ground plan of the stage, to track all the different things that occur, that get pulled into the device: lights, trusses, columns, brackets," Wilkins explained. A miniature pier, Wilkins added, would be built by Grant McCune Design to execute the illusion when major set pieces—such as gigantic standing pillars—went flying into oblivion.

At one point during the night's filming, after a safety update for the entire crew, the camera rolled as some heavy pieces of machinery and debris were pulled across the stage at top speed, ending with a terrific crash. The action included a major set piece—a pier wall that was rigged via a giant crane stationed outside Stage 30, with cables running into the stage and up to the permanents, all of which would unspool and create a controlled fall.

It was an ironic touch, really, a grand set that disassembled piece by piece, actually destroying itself. Within another week or two the set would be destroyed for real. "Unfortunately all of this beauty and artistry gets torn down and some other film comes in and makes something equally fabulous," Grant Curtis said, staring at the crane and shrugging.

But the *Spider-Man 2* production journey wasn't over yet.

There was the post-production phase, eight months of finalizing CG shots produced by John Dykstra's crew, of creating unique sound effects such as the sounds of the tentacles, of music and editing, and

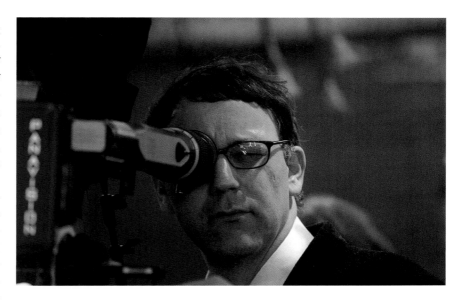

Director Sam Raimi. Photo by Melissa Moseley.

scores of other details. "There's all this other stuff that's gearing up now," Curtis reflected. "When the camera stops rolling there's a whole other world of production that evolves."

Still, at least for this night, the decaying ruin of a pier was still standing; there were still actors and crew running about. At one point Sam Raimi rallied his troops, exhorting them with the full meaning of the dramatic decay that surrounded them. "This is the *moment*," he said. "The pinnacle. The peak of the drama . . ."

As they were seizing the moment, it seemed crazy, this business of dreams, of working to exhaustion to conjure up an epic fantasy. But those visions would soon flicker bigger-than-life across the screens of theaters and multiplexes around the world; the next chapter in the *Spider-Man* saga would capture the imaginations of millions of moviegoers. It was heady stuff for a band of filmmakers putting on a show in the soundstages of a movie lot in Culver City.

This grand, outsized chunk, part of the stuff that dreams are made of, had materialized within the confines of a soundstage, and Raimi was filming to have a fantastic Super Hero and an outlandish super villain facing off within its confines. He and the crew were living Orson Welles's classic adage, that studio moviemaking was "the biggest electric train a boy ever had."

It was nearly the night before Christmas in 2003 and a new bit of *Spider-Man* movie magic was coming together on Sony's Stage 30. The dilapidated pier had been broken down and swept away and replaced by two miniature models built by Grant McCune Design, Inc. (GMD): a perfect miniature replica of Doc Ock's lair that had recently filled the stage and an exterior miniature of the dock and pier, set up in the water tank. The tank was filled with water that would represent the East River itself.

Though they were called miniatures, there was nothing small about these quarter-scale models, and it would take a crew of nearly seventy to shoot them. The exterior model alone filled the water tank at an estimated 12 feet high, 18 feet wide, and 84 feet long, which is why John Dykstra, who was helming the miniatures unit, and Tim Angulo, who was heading a special camera crew, took to calling them *maxiatures*.

According to Dykstra, creating a computer-generated simulation of Ock's lair would have been a nightmare. "It would have been very difficult to create the chaos of this broken-down pier in the computer," Dykstra explained. "Computers do perfect, even things very well, but the more variation and chaos—the more things are dirty, bent, and broken—the more difficult for the computer."

Chaos was what Dykstra's crew had to get on film, carrying to the final, destructive conclusion the centrifugal force Ock's fusion reactor would create, sucking in pieces of the pier that finally implodes into the river. The live-action work of a few weeks before had accomplished some of those effects physically, with props rigged and wired to fly across the stage, but it would have been far too dangerous to toss about the larger pieces of the set, as many beams weighed upward of a thousand pounds. So a combination of digital visual effects and miniatures would ultimately be required to create the accelerating destruction. "This is a complex deal," Dykstra said

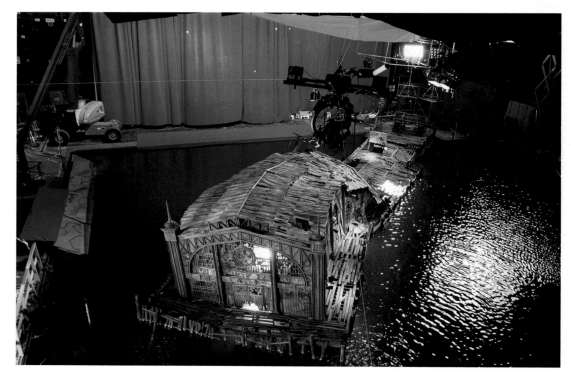

This page and opposite: The "miniatures" of Doc Ock's lair—or "maxiatures" as visual-effects designer John Dykstra dubbed them—are made ready for filming on Stage 30, the same stage where the full-size pier set was built. Photos by Melissa Moseley.

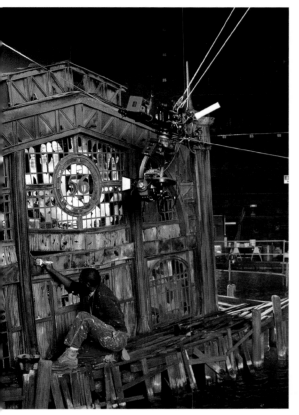

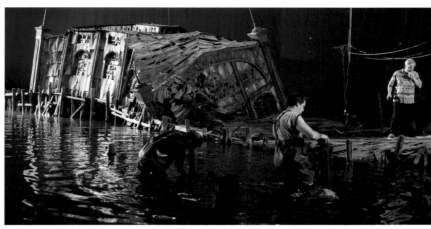

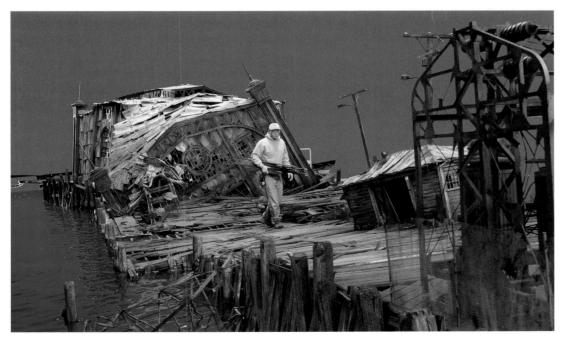

during the shoot. "All the [miniature] pieces we're shooting have to be finished in the CGI world."

Dykstra pointed out that the "basic road map" for the shoot had been provided by the storyboards, a very exacting animatic, and feedback from Sam Raimi, who was by the time of the shoot busy with his editor cutting the movie into its final form. "We're [following] a blueprint that's sort of broad strokes, and being much more specific about the individual shots as we shoot them and they get cut into the sequence," Dykstra explained. "It's evolving because we're overlapping our director's cut right now as we're shooting these pieces."

"The needed miniatures effects made for an intense shooting schedule," noted production executive producer Joe Caracciolo. The production had always planned on a single miniature model to duplicate the exterior view of Ock's lair, and Caracciolo had initially planned to shoot the miniature at Falls Lake, a permanent outdoor "lake" on the backlot of Universal Studios. But they doubled their difficulties by deciding to also replicate the spectacular interior lair

set. "When [it became clear] we needed the interior set, we devised a method to put *both* onstage," Caracciolo added, explaining that instead of using two separate stages, it made more sense logistically to use the cavernous soundstage for both miniature setups.

As far back as September 1, 2003, Caracciolo issued the miniatures contract to the Grant McCune Design effects house. From the outset it was a race for GMD to get them ready by December 22, when the twenty-two-day scheduled miniature shoot had to begin. The process started with effects company head Grant McCune huddling with Dykstra to discuss everything from camera speeds and frame rates to the particular requirements of the models, including the need to build the exterior pier and dock so they would fit the dimensions of the Stage 30 water tank and scale to the water.

GMD was flooded with every possible bit of data from the *Spider-Man 2* production to assist the model making: conceptual art and architectural plans, hundreds of photographs taken from the full-scale interior pier

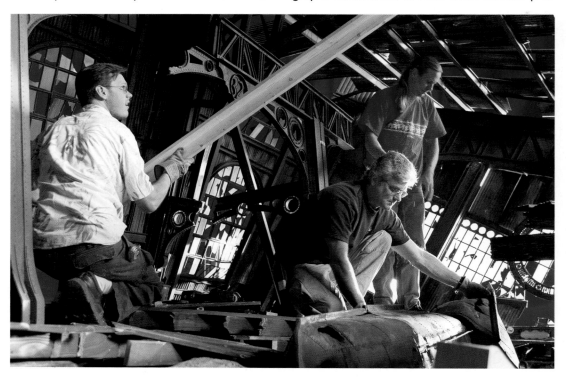

GMD model makers Corey Burton (left) and Ray Moore (standing) with model shop supervisor Monty Shook (middle).

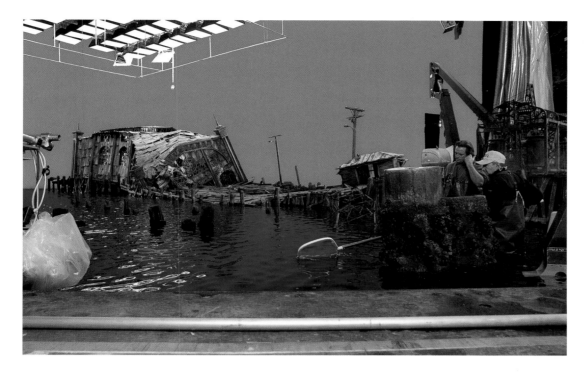

built on Stage 30, and mock-up models that had been built by the *Spider-Man* art department modelers. Production principals Neil Spisak, Joe Caracciolo, and others made regular visits to the GMD facility in nearby Van Nuys, California, to check the model-making progress.

According to Eric Durst, supervisor of miniatures visual effects, the major inspiration for the interior model had been the full-scale set. The exterior view, however, was based purely on art department sketches and a mock-up of the dock and pier. "The exterior hadn't existed on a real set, so the construction was facilitated by the foam-core mock-up, while the production art inspired the emotional impact of the design," Durst said. "We then took measurements off the exterior model and built a virtual version at Imageworks for animatics that would help work out where the camera would be placed."

Tom Valentine, helping supervise the miniatures work for Neil Spisak, marveled that there was virtually no difference between the final film images of the live-action set and the miniatures. The miniature model crew had even incorporated

many of the same techniques that had been used on the full-scale set. "It's one of the great things about working with really big miniatures," Valentine explained. "The painters could actually walk inside these models to apply the very same paint finishes and textures we used on the full-scale set, giving us an identical match."

Valentine and Durst further prepared the miniatures by shooting digital still references taken from the view of the camera eye. "[We'd] put these pictures in the computer and work on them in Photoshop to show the art department and guide the model makers on how to detail things to camera, how to age or detail specific areas before they had to be filmed," Durst said.

There were still differences between a miniature and a live-action set, of course—parts of the miniatures were prone to *melting* from hot stage lights, requiring wooden braces on the models and plenty of air-conditioning. Each miniature necessitated the full range of complex camera techniques, from motion control to locked-off shots to "pan and tile" photography for purposes of reconstructing a scene in the computer. Elements ranging from fully com-

puter-generated characters to blue-screen photography of live actors could be realistically composited *within* a model scene.

"A lot of the miniature work was driven by the live-action photography that was shot [using blue screen]," noted Durst. "Once we had the blue screen we had to match that perspective back to the miniature." Some of the final composite image elements would also integrate cranes and piers shot at the shipyard and shoreline at San Pedro harbor, south of Los Angeles.

"For every one of these miniature shots there's a blue screen outside and behind, for which we'll use a plate of New York City that's been shot from Roosevelt Island, so there's a live-action piece behind everything," Dykstra explained. The beauty of a miniature was the number of passes they could shoot and layer into a final composite—lighting pass, pass for rigged objects flying into the fusion machine, passes for the fusion effects. The final "high dynamic

range image" of the final composite environment, Dykstra added, allowed for the visual-effects artists to control all of the details of shadow and light.

The miniatures were also rigged for spectacular implosion effects. The interior set—another "maxiature" at 28 feet long, 15 feet wide, and 12 feet high that was set on four foot-tall platforms on the side of the stage opposite the huge water tank—included "flex material" props, such as an interior column fashioned of soft lead. In one shot of Ock's deadly tentacles at work, the interior column was slowly crushed by a wraparound wire "noose" that provided the look of steel being squeezed, with Imageworks replacing the wires with CG tentacles.

The pier lair had some seventy elements of buttresses and gantries and pillars constructed of flexible resins and coatings and rusted up to look full scale and rigged to fly on wires (which would be digitally removed later).

Right and opposite: Miniature "maxiature" interior pier set. Photos by Melissa Moseley.

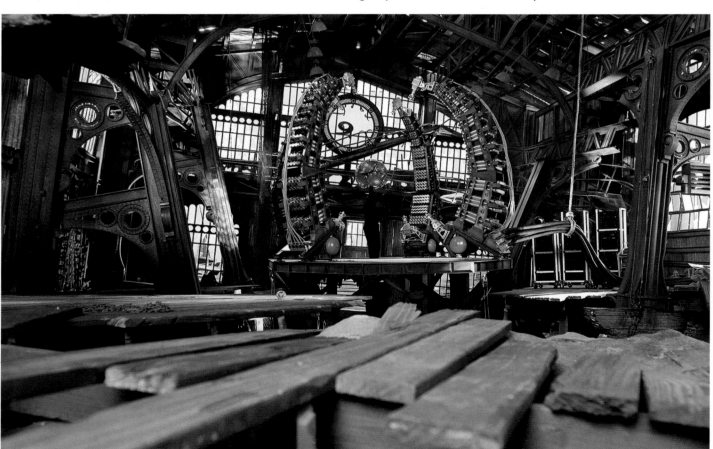

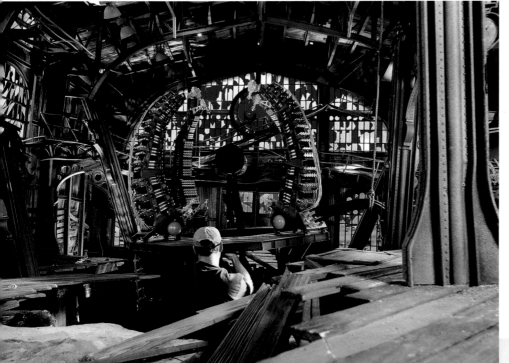

"With miniatures you can do chaotic things like explosions, destruction, flying debris, dirt, dust, and sprays of water better or more efficiently than what can be done currently in the CG world. I can set up one gag and put five cameras on it; in the CG world each one of those [camera angles] would have to be an individual shot."
—*JOHN DYKSTRA, VISUAL-EFFECTS DESIGNER*

Spydercam rig in action. Photo by
Melissa Moseley.

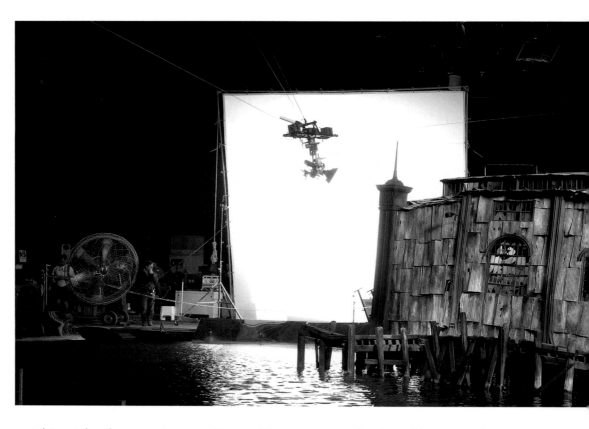

Ultimately the exterior would provide
the establishing views of the dock and pier,
as well as the destruction and chaos during
the Spider-Man versus Doc Ock battle. The
eighty-four-foot-long model was set in the
middle of the ninety-by-ninety-foot tank
on platforms and a hydraulic lift. Durst
pointed out that the exterior model was in
the exact section where Ock's fusion reac-
tor had been erected for the full-scale lair
set. "The whole setup has a lot of mechan-
ics underneath so it can go down twenty-
five feet below water," Durst added. "The
hydraulics are physically operated so that
the speed can be adjusted, and we're shoot-
ing at frame rates from seventy-two to
ninety-six frames per second."

The hydraulic lift, powered by high-
pressure hydraulic and pneumatic rams, pul-
leys and cables, was designed from scratch by
GMD's John Stirber. Nicknamed the goalposts
by the model makers, the lift was further
described by model shop designer Jack
Edjourian as looking like an *H,* with the minia-
ture itself mounted on the middle bar and

the outer "goalpost" bars providing support.

Details in the water tank included blow-
ers and fans and a manifold with an esti-
mated forty high-pressure air jets the size of
water-hose nozzles, each hitting the surface
and creating ripple effects that crisscrossed
to simulate the East River (with Dykstra and
director of photography Tim Angulo even
shooting tests to plan the look of the river
currents).

"The exterior is a very different situation
from the interior, especially when it
implodes," Durst noted. "There are many,
many, wires that are attached to the pull
prescored pieces of the set into the center.
It's like a spiderweb inside, but since we are
shooting from the outside, the cameras are
out of the way from the mechanics."

The shoot also utilized a spydercam, a
commercial camera rig in which wires
attached to different points on a set
allowed for speed and freedom of move-
ment that would have been too difficult for
a crane. It was used for a scene in which Ock
flings Spider-Man hundreds of feet into the

air and our hero uses his web to pull himself back into the building, a shot created by dropping the camera down to the roof of the pier, following Spider-Man's point of view. "The spydercam is an ingenious set-up, allowing the camera to move very fast while being completely positionable in 3-D space," Durst explained. "We could get the camera really high up and bring it right down on the miniature and stop on a dime and repeat that action. With blue screen all around the tank, the image could then be matched and composited with a scene of the city as Spider-Man falls back."

The punishing deadline and logistics did provide the saving grace of forcing the production to focus tightly on only the miniature shots that were vital for the storytelling. "We always have more work than we can achieve in the time we have," Dykstra said with a shrug. "So it's an issue of priorities and being flexible."

Toward the end of the shoot, Valentine stood by the water tank on Stage 30, where John Stirber was rigging the seaward wall. "Right now it feels like a moonshot, getting ready to film the wall imploding," Valentine said. "Just looking at a picture of these models doesn't capture the sheer energy of the moviemaking process. What we're attemping here seems almost impossible."

Valentine laughed—he wouldn't have it any other way. "It's the climax of the picture, for crying out loud!" he exclaimed.

Spider-Man 2 executive producer Joe Carocciolo.

Joe Caracciolo, a pro who had begun in the film business as chief property master on such classic 1970s productions as *Love Story* and *The Exorcist*, seemingly had seen it all—but he'd never worked on a fantasy blockbuster on the scale of *Spider-Man 2*. "It's gotten wild!" Caracciolo chuckled, noting the sometimes overwhelming impact of modern visual effects. "This is new to me, but my approach is, you have to know how to make films and be good enough, and then you can tackle anything. You have to put the effects and action beats where they make sense. But everything about this film has a sense of *reality* to it."

Indeed, the hallmark of the two *Spider-Man* movies was its mix of reality and amazing fantasy. It was the characters and storytelling potential, as much as the promise of Super Hero action, that had drawn the stellar cast and crew into Spider-Man's web. And it had all begun some forty years before, in the pages of a 12¢ comic book where Peter Parker suffered the bite of a radioactive spider and himself began drawing a cast of enduring comics characters into his increasingly tangled web.

Those comic-book dreams, drawn and published in the 1960s in New York, form a line stretching to the Hollywood art departments that would take up pen and brush—or settle in at computer monitors—to create the conceptual art and models that would represent Spider-Man's world. This artistic effort would serve the vision of the director and be channeled through producers and production staff, through departments for costume design and set building, visual effects and special effects, makeup and stunts, the sound effects and score. Actors would inhabit the world that had been prepared for them, the cinematography producing the visual material the final editorial work would piece together into a grand mosaic.

Through it all, the great challenge—the *fun* of it—had been in creating a fully realized world, breathing life into compelling characters that had been bursting with vigor even when they existed only as lines on comic-book paper.

"I tried to make the picture as personal as possible," Sam Raimi concluded. "But maybe more than any other picture, *Spider-Man 2* is created through the work of a tremendous team of individuals, and the huge scope of it demands great contributions from all departments. I'm thankful to the cast and crew who brought their heart and soul to this thing. But this is also the whole world's picture because Spider-Man, like it or not and for good or for bad, belongs to everybody."

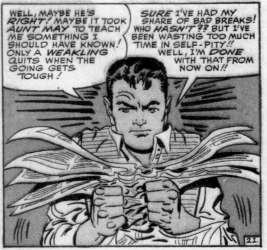

Indomitable Peter Parker rises to the challenge and accepts the power and responsibility of being Spider-Man in this classic comics scene. But we never had any doubts, did we, True Believers? *The Amazing Spider-Man*, #18, 1964, "The End of Spider-Man, select panels. Artist: Steve Ditko.

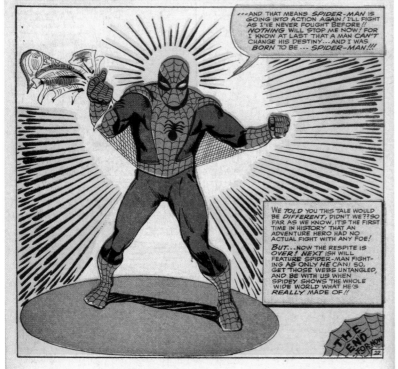

"And so we leave our friends dangling in a web far more powerful than any which Spider-Man can weave—the mysterious, dramatic web of *FATE!*"

—THE AMAZING SPIDER-MAN *#10*, MARCH 1963

Ock, down on his luck.

Ock, down on his luck.

Ock, down on his luck.

Storyboard artist David Lowery amuses the production with these humorous Doc Ock drawings.

Ock's final experiment effects New Yorkers...

Mark Cotta Vaz is a *New York Times* best-selling author of seventeen books (including this one). He wrote *Behind the Mask of Spider-Man,* which chronicled the making of the first film in the *Spider-Man* series. Vaz's book *The Invisible Art: The Legends of Movie Matte Painting* (co-authored with filmmaker Craig Barron and published by Chronicle Books) won the Theatre Library Association of New York award for outstanding book on film in 2002 and the United States Institute for Theatre Technology's "Golden Pen" book award. He's currently completing a biography of Merian Cooper, legendary adventurer and creator of *King Kong.*

Photo by Dick Sullivan.